Anthology Film Archives Series

P. ADAMS SITNEY
Editor

THE CUBIST

CINEMA

Standish D. Lawder
Yale University

New York: New York University Press
1975

for Katy and Cynnie

Preface

I should like to explain at the outset what this book is, and what it is not. It is not, strictly speaking, a history of cinema, nor is it an orthodox art-historical study. Its principal concern lies inbetween, for it focuses on the interrelationships between film and modern art, predominantly painting, from 1895 to about 1925; that is to say, from the inception of film to that moment when Cubism and its derivative styles began to lose supremacy within the tradition of European modernism. I have sought to examine these arts of film and painting to discover and document similarities of expression, common sources, and the mutual interchange of talent and ideas.

This study in the early history of film as modern art answers, at least in part I believe, a number of questions I have asked myself from the beginning of my researches some eight years ago. How did modern artists perceive the earliest commercial films, the so-called "primitive" cinema, and in what ways might these perceptions have influenced the development of modern art during the Cubist era? What can be discovered about the form and meaning, the circumstances of production, and the immediate critical reception of that body of avant-garde films of the 'twenties which, by their nature and artistic intent, belong more properly to that tradition we call

"modern art" than to the history of the "movies"? And in what ways are these films integral to the history of modern art?

Film was a relatively uncomplicated and reasonably accessible medium in the beginning. For the general public, it was yet another miraculous invention which, like the telephone, the radio, and the airplane, irrevocably altered one's perception of the world. But for the modern artist, its technology offered a unique promise: film could extend the art of painting into dimensions of movement through time. In the 1920's the extraordinary potential of the medium was seized upon by a number of major modern artists whose work is the central subject of this book.

For the art historian—indeed, for anyone who wishes to go beyond a "romance" viewing—the study of films is an elusive business. When a screening is over, all that remains is a fading recollection of what we think we have seen. Films must be studied on the run, so to speak, and to study any film in depth, several runs through the projector are essential. Yet even when complete familiarity is attained through repeated screenings, how can one describe in words this complex experience of continuously changing image content and visual design? The best solution I have found is frame enlargements and these have been specially prepared whenever possible. A number of key films are studied in detail, most notably Léger's *Ballet mécanique;* a shot analysis of this film with 300 frame enlargements is included as an appendix. Hans Richter's *Rhythm 21* and *Rhythm 22,* Viking Eggeling's *Diagonal Symphony,* and Walter Ruttmann's early abstract films also receive close examination through extensive use of frame enlargements.

The shot analysis of *Ballet mécanique* derives from the archival print at the Museum of Modern Art which was brought to this country by Léger himself in 1935. There is at least one other known version, apparently of similar vintage but less likely to be original, held by the British Film Institute; it is distinguished by the inclusion of numerous short shots of Léger's paintings. The frame enlargements from the films by Hans Richter, Viking Eggeling and Man Ray were made from prints generously loaned to me by Hans Richter.

I am indebted to many scholars of film and painting, and to artists of both media, for advice, assistance, and encouragement. In particular, I would like to thank Willard Van Dyke (formerly of the Museum of Modern Art), James Card (George Eastman House), and Henri Langlois (La Cinémathèque Française) for their kindness in screening archival films at their respective institutions. To Hans Richter I owe a double debt of thanks, for his constant encouragement and for his considerable store of information. I thank Jay Leyda for the wisdom which he has always shared so generously with me. Spencer Berger has allowed me access to his film collection and has helped me in many other ways as well.

In the course of this work, there were many people whose help has been invaluable. They will each, I hope, recognize their contribution and accept my thanks: Margareta Akermark (Museum of Modern Art), Walter Alberti (Cineteca Italiana), Freddy Bauche (La Cinémathèque Suisse), Eileen Bowser (Museum of Modern Art), René Clair (Paris), Guy Coté (La Cinémathèque Canadienne), Lotte H. Eisner (La Cinémathéque Française), Bernard Karpel (Museum of Modern Art), Wolfgang Klaue (Staatliche Filmarchiv, East Germany), Peter Kubelka (Österreichisches Filmmuseum, Vienna), Gerhart Lamprecht (Deutsche Kinemathek), Ernst Lindgren (British Film Institute), Mary Meerson (La Cinémathèque Française), Annette Michelson (New York University), George Pratt (George Eastman House), Aaron Scharf (London), Jan de Vaal (Nederlands Filmmuseum, Amsterdam), and Herman G. Weinberg (New York).

Within my Department at Yale, it was Prof. Robert L. Herbert, during a ten-minute conference many years ago, who started me on this project. Prof. George Heard Hamilton, now Director of the Sterling and Francine Clark Art Institute, guided my initial research. And Prof. Sheldon A. Nodelman has helped me in more ways than I can acknowledge. Finally, I should like to express a measure of gratitude to my editor, P. Adams Sitney, for his patience and assistance in the final preparation of this book.

Contents

Introduction

There is scarcely a university in America by now that does not encourage the study of film as a major aspect of modern art. It has been interesting, and for some frustrating, to see how study of the cinema slowly developed in one school out of the English department, in another from Drama, in a third from History, in still others from sociology, or science, or audio-visual studies. Yale was the first place where it developed out of History of Art, when Standish D. Lawder wrote the first Ph.D. dissertation on film for the department of the History of Art. At Harvard, film study sprang up in every corner of the university at once; from dozens of independent house groups and courses, from general education, from the science departments and history departments, from the foreign language areas. Suddenly it was a flood, a new field with vital links to almost every branch of learning, and still so popular that all the neighborhood theatres drew crowds, the more arcane the program the better.

The Harvard Film Committee asked Lawder to be the first Henry R. Luce Visiting Professor of Film Study because he was trained in a discipline that an academic group composed of men and women from a dozen different fields trusted and respected: history of art. But he was also invited to Cambridge because, although he began exclusively as a scholar, he had become so interested in film as an

expressive medium that he was equally devoted to making his own movies.

The great interest of the study he presents in this book is that it develops a basis for systematic history of the independent film. This is what one would reasonably expect an experimental film-maker to do. Standish Lawder surveys the evolution of avant-garde painting in both Germany and Fance, demonstrating that the painter's attitude toward pictorial structure and subject matter found a parallel and provided an inspiration for certain early film-makers who worked without narrative scripts. These film artists felt that they were realizing the pure potential of the cinema, and according to Lawder they constituted a movement within film, as well as within "modernism," at about 1925. Thus there was already a small international group of film-makers who were jealous indeed that there should be any cinematic considerations apart from the purely visual, and who—for a time at least—would scorn other factors in films.

In documenting the history of pure cinema and locating it within the major concerns of the history of modern art, Lawder does more than merely acquaint us with the carefully researched circumstances that reveal the depth of interest modern artists had for the new medium. He shows the tantalizing fulfillment cinema seemed to offer various artists before the first world war, how to both French and German modernists, with their roots in symbolism, the new medium appeared a logical and inevitable culmination of their major aesthetic concerns.

The study specifically examines Picasso, Kandinsky, Survage, Richter, Eggeling, Ruttmann, Duchamp, Dulac, Chomette, Moholy-Nagy—and above all—Fernand Léger; these are the artists Lawder shows to be the most profoundly involved with the consciously new concept of "filmic expression, disregarding narrative interests. . ." For these visual artists, treatment of time and sequence were never related to plot. Regardless of whether their images were realistic or abstract, they were led to develop modes of pictorial movement, internal and external, wholly unique to film.

One of the most telling elements to emerge in Lawder's study is the degree to which the so-called independent concerns of the artist-film-makers were in fact contingent on dominant developments in two other branches of the young film industry. First, it appears that early trick films, phenomennally popular with the general public for the sheer entertainment value of seeing the visually impossible happen, had a tremendous influence. This should not surprise us, for

it accords perfectly with the mannerisms favored by the Montmartre Cubists, for example, love of low life, of sensational newspaper stories, of general identification with the non-bourgeois world.

More surprising, however, is the use the artists made of the sentimental narrative film itself, especially those visual parts that were themselves imperfectly derived from pure plastic art. The story of the intricate relationship between Abel Gance, Blaise Cendrars, and Léger in connection with the film *La Roue* is extraordinary, for if Léger's postwar painted imagery was the ultimate source of the most visually exciting material in the film, Cendrars' editing of a banal script is shown to have stimulated Léger to join the adventure of film more directly. Lawder's study of the prewar concerns of the Cubists of Orphist persuasion, notably the Delaunays (with whom Cendrars had developed what was debated to be the first simultaneous poem), finally culminate in a definitive study of *Ballet Mécanique,* which Lawder subjects to the most detailed and rigorous formal analysis, examining visual changes frame by frame.

Commercial films, trick films, poetry, and drama all made important contributions to the conscious development of the experimental film. The only ingredient that was consistently unassimilated by the advanced visual artists, however, was content. And, curiously, perhaps the careful study of early avant-grade film will put it back. Lawder is thoroughly familiar with the traditional understanding of early twentiety century art, especially Cubism, that sees it not so much rejecting content, as not specifically concerned with it. Like most art historians, he does not think there was anything uniquely modern about the subject matter of Cubism. Encouraged by Léger, who once said of his *Nudes in the Forest* (1910) that it was only a battle of volumes, and who also said "l'erreur pictorale c'est le sujet; l'erreur du cinéma, c'est le scenario," most students of modern painting have ignored the fact that Cubism's revolutionary pictorial treatment of images and space sprang from the conviction, or at the least a hope, that at the beginning of the twentieth century a new sensibility had produced a radically new content.

The fragmented, simultaneous visions of the Cubists, their concerns for multiple facets of reality and for resolution of the claims of conflicting points of view, first found sympathetic interpretation when one concentrated almost exclusively on technical accomplishments, a new formal language indistinguishable from intentions. Painters, dizzy with the conviction that at last they had freed their medium from the conventions of the other arts, eagerly embraced

doctrines critics invented to demonstrate how pure, finally, painting had become. Out of the same impulse came the concept of pure cinema and not surprisingly, the painters loved it and practiced it.

The serious study of early independent cinema now begins to take its place as a crucial aspect of the history of art. Lawder's book is the first of what one hopes will be many careful probes into the delicate and complex relations between the different arts that believed themselves on the threshold of a new age—indeed that were. For the traditional art historian, especially of painting, the effects of such studies may be profound. Surely, it will no longer be possible to codify the recent past into simple and rigid categories, some altogether purged of content, when film analysis uncovers examples of calculated mixtures of abstraction and realism, mimesis and animation, all willfully succeeding each other frame by frame in wholly new combinations of cubism, abstraction, surrealism, expressionism. The study of the early independent cinema, then, will also teach us about painting at the outset of the twentieth century; for we shall see many familiar images free from the weight of the historical framework we were forced at first to build in order to be able to accept and even to admire, without understanding, the new art.

Daniel Robbins
Director, Fogg Art Museum
Harvard University

Chapter 1

Modern Painters
Discover the Cinema

The years immediately preceding the outbreak of World
War I were marked by accelerated activity in all the arts. The
climactic year was 1913. In painting, poetry, music, theater and
the film there appeared a deluge of new ideas, new
experiments, and new theories. Vorticism was born in London,
Suprematism in Petrograd. Tatlin made his first constructions
and Larionov brought out his *Rayonnist Manifesto*. In Paris
and Milan, the Italian Futurists issued a record number of their
outspoken manifestos. Apollinaire published his poetic
apologia for Cubism, *Les peintres cubistes,* even while dis-
covering in Delaunay's *Fenêtres* and *Formes circulaires* a new
art that reached beyond Cubism. In Munich, the *Blaue Reiter
Almanach* was between its first and second printings. Kan-
dinsky and Marc were at the height of their powers.

Two key exhibitions of 1913 proved decisively that
modern art was an international phenomenon: the 360 works
assembled in Berlin by Herwarth Walden for his first *Der
Sturm* exhibition represented nearly every significant figure of
modern art, and almost three times this number were included
in the Armory Show, its impact on a culturally isolated
America profound and far-reaching. Stravinsky's *Sacre du
printemps* performed by Diaghilev's ballet at the Théâtre des

Champs-Elysées and Schönberg's continuing experiments in duodecophonics changed the sound of modern music. Erik Satie resumed composing after a long self-imposed silence, and Paul Valéry reappeared among the avant-garde after an even longer hibernation from creative activity. In French literature in was an *annus mirabilis,* with important new books by Proust, Apollinaire, Colette, and Gide. Jacques Copeau established the Vieux Colombier theater, a decade later to be an important showcase for avant-garde films, and, in Berlin, the Expressionist drama was just emerging from the wings of the Deutsches Theater.

And what of film in this fertile and crucial year of 1913? What was its status as a cultural or artistic phenomenon on the eve of the war? The question hinges on its development as an industry and as an art, for, in film, the two are always intertwined. The mechanics of production, distribution, and presentation of films are the *sine qua non* of film art, commercial necessities to which the medium owes its very existence. And quite obviously, the influence of film and filmic techniques on the more established arts could not have been felt until film itself had been established, hence the question of its early commercial development is not beside the point. Film as an art is closely keyed to its growth as an industry, and the former cannot be understood without some knowledge of the latter.

The commercial cinema maintained a steady and rapid growth from its inception in 1896 right up until 1914 when the war virtually stopped European film production. Before 1900, films were most frequently shown at fairs, vaudeville shows and other such travelling or impermanent entertainments. These fairground novelty attractions were generally considered a vulgar amusement whose appeal was directed at the large and uncritical audience of the lower classes.

At the turn of the century the world "film" generally called to mind a scratched and battered reel of travelogue or crude melodrama, continuously projected in a travelling tent show with dirt floor and wooden benches. The hand-cranked

projector stood exposed in the middle of the room no more than twenty-five feet from the screen. A variety of light sources were employed. The screen was of canvas, painted white, and sometimes would be periodically sprayed with water to increase its reflective properties. A phonograph or piano provided music to drown out the noise of the crowd and the projector, and to accompany, in a loose fashion, the images of the screen.

A number of factors hampered the cinema's rise to re-spectability. From the very beginning it was argued that film would ruin eyesight, corrode public morals, foster juvenile delinquency, and precipitate countless other vaguely defined evils. That this new invention was a tool of Satan seemed to receive certain justification from a disastrous event on May 4, 1897. A film program had been organized as part of the annual Charity Bazaar, one of the most fashionable and elegant events of the Paris social season. During the screening a faulty ether lamp in the projector ignited the highly combustible celluloid film and soon the entire auditorium was ablaze. One hundred and eighty people perished in the holocaust, of whom the great majority were of nobility or high social prominence. As might be expected, public outrage was enormous. The new enter-tainment medium was hysterically attacked and the blame for the disaster incorrectly laid to the inflammable film. For several years thereafter the danger of fire served to emphasize, however illogically, the other supposed evils inherent in film.

Thus persecuted, the cinema existed for the following decade on the fringes of respectable society. There is little indication that any artist or intellectual took it very seriously. Few considered it art at this time, except possibly a reproduc-tive one at the service of the theater. But if not yet an art, film certainly was a business and a very good one at that. As more and more fortune hunters extracted quick profits from this new optical amusement, it soon became apparent that the cinema was not the passing novelty its earliest promoters feared it might be. Gradually, permanent cinema houses were es-tablished; the first in Germany (*Ladenkinos,* or reconverted

small stores) date from about 1903, and elsewhere in Europe, too, the film was evolving from a fairground side show into a more durable and respectable form of entertainment.

In the following decade the growth of film throughout Europe was enormous, and by the eve of the war it was well established as a cultural phenomenon of paramount importance. In 1914 George Bernard Shaw reluctantly agreed that film had been a much more momentous invention than printing.[1] In sheer figures of attendance, it far surpassed the popularity of the theater. Available statistics vary in their reports of the number of film theaters that existed in 1913, but even the most modest estimates are impressive. In Germany, one source put the number at 1,529; another at 2,446. In Paris alone there were reportedly more than 200 cinema theaters, and for New York the incredible figure of 460 has been cited. René Doumic, the influential director of the *Revue des Deux Mondes*, wrote an illuminating account of the pervasive presence of cinema in pre-war society. His essay on the subject, "L'âge du cinéma," opens with the observation that "the *cinématographe* has taken its place in our culture. It is popularly called 'cinema' for short. One goes to the cinema, one even goes a lot, everybody goes. It's all over the place." [2]

If, as Doumic has suggested, the modern world had entered "l'âge du cinéma" by 1913, was it the same world of film we know today? That the cinema was well established at that time, there is no question—but what of the form and content of these films? On a Sunday in Paris in 1913 more than 10,000 people would visit the movie houses. What did they see there?

Rather than a single feature film they would most probably see a program of many short films. A typical evening at the movies in 1913 would consist of a number of "photoplays"—that is, melodramas, comedies, mysteries—none of which were likely to exceed two or three reels in length, a reel being the equivalent of ten minutes screening time. There would be a considerable amount of non-fiction film in the form of travelogues (occasionally taken by the enterprising theater

owner while on vacation!), documentaries or actualities, scientific or nature films, newsreels, topical films, and the like.

Film gradually overcame the onerous birthright of its folk art tradition and rose, over the years, to the status of what most people call art, at least in insolated examples if not in the production of the industry as a whole. The process is quite the reverse of the usual, for, as a rule, folk art derives from what is known as "higher art." But with film, the present and presumably elevated state of the art derived from very folkloristic beginnings. The point is interesting, for it not only sheds light on the development of film as an art, but also on the nature of the *history* of the film as we normally understand it.

In dealing with the pre-war or "primitive" cinema (a telling word, revealing more the historians' prejudice than the actual nature of things), historians have concentrated almost exclusively on the beginnings of the dramatic art. For example, it is universally agreed that a "monumental" breakthrough occurred in 1903 when Edwin S. Porter first used film to narrate a story in his *Great Train Robbery,* the great-grandfather of today's "Westerns." Yet, Porter seems to have been strangely unaware of his tremendous discovery, for his subsequent films failed to advance the tradition of narrative film art he is supposed to have founded. The short-lived "Film d'art" vogue (1907-08), in which famous talents from the Comédie Française, Sarah Bernhardt among them, gave mute performances before a static movie camera, has rightly gone down in cinema history as a snobbish experiment, an attempt to raise films to higher cultural respectability, the films themselves tedious and "uncinematic."

By the eve of the war, the cinema had already changed from a vaudeville show type of program, with numerous short films on various subjects (a type of program commercially shown today only in railroad station cinemas, particularly in Europe) into film essentially as we know it today, that is, one long fiction film with "selected short subjects." A record length was established in 1914 by *Cabiria,* the largest of the Italian pre-war "superfilms," its fame partly due to its extraordinary length (about two hours and twenty minutes) and partly to the

poet Gabriele D'Annunzio, who lent his name as dramatic advisor to the production. In the following year, there began a new chapter in the history of film with David Wark Griffith's *The Birth of a Nation.* Film had arrived as a powerful dramatic art form in its own right, and to Griffith more than any other single man must go the credit for establishing this new art.

However, for a great number of viewers, film was little more than a diverting optical amusement. Like the other pre-war miracles of technology that signaled the arrival of the future—the automobile, the airplane, the wireless—the film too was regarded as a scientific wonder and, at the same time, a deeply poetic experience. But its unique poetry was not that of drama. Even the so-called dramatic or fiction films were poor in those elements which make up the stuff of drama; the psychological interaction of clearly delineated characters within a well-constructed plot was, in those early films, a crude caricature of the theater.

Early film programs, particularly before about 1908, were loaded with short non-fiction films of every imaginable description. One might see familiar sights of the city through the eye of the camera as in *Railway Ride over the Tay Bridge* (1897) showing railway tracks, station platforms and waiting passengers, passing trains and the bridge supports as the train-mounted camera raced along; or such ordinary home-making activities as the semi-educational *Baby's Toilet* (1905) showing the proper way to wash, powder, dress, and bottle-feed an infant; or the hidden wonders of nature as in *Pond Life* (1908) showing microcinematographic views of the innards of water fleas, hydra, and amoeba during digestive activity; or the exotic life in far-away places as in *Modern China* (1910) showing colorful views of downtown Peking; or the pride of local industry as in *A Visit to Peek Frean and Company's Biscuit Works* (1906) showing everything in the biscuit business from the factory boiler room to the dispatching station; or rank sensationalism as in *Electrocuting the Elephant* (1903).

Quite obviously, these films had nothing to do with cinema

as a dramatic art. Rather they were an eye open onto the world. Their closest counterparts were the popular illustrated weeklies like *Le Figaro Illustré* or *L'Illustration,* but how much easier to absorb, how much more fascinating and realistic on film! Any interesting visual phenomenon, commonplace or exotic, was material for such films, and indeed almost every conceivable subject was tapped.

One special variety of early non-fiction film merits further consideration: the scientific film. These films extended the powers of vision into the normally invisible and the geographically remote. Largely due to the pioneering investigations of the experimental physiologist Jules-Etienne Marey (1830–1904), the French took an early lead in the development of the scientific film.

Marey was to the science of movement what Chevreul had been to the science of color and vision, and both have left their mark on modern art: Chevreul's studies, through Seurat, formed the basis of Neo-Impressionist color theory, and Marey's investigations into the patterns of bodily movement in human and animal locomiation were no less important for modern art.

A large measure of the attempts to analyze motion in Cubist and Futurist painting in the eve of the war can be traced to Marey's well-known experiments. Marcel Duchamp has acknowledged his debt to Marey,[3] and indeed this debt becomes graphically obvious when his *Nude Descending the Staircase* is compared with Marey's multiple-image photographs of men in motion (figs. 1, 2 and 3). The Italian Futurist painters, in their fascination with capturing the sensations of physical movement, have frequently been linked with the methods of film; Roger Allard's reference to the Futurists, "who all have movie cameras in their stomachs," in 1911 is perhaps the first of many such observations. But if the medium of film was a stimulus for these painters, it was Marey's chronophotographs that provided the model, images that were truly simultaneous, not, as in film, sequential. Of all the Futurist painters, the closest to the spirit of Marey's stop-motion pho-

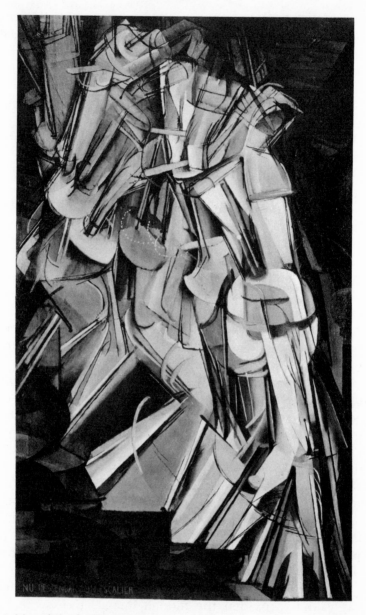

Fig. 1. Marcel Duchamp, *Nude Descending a Staircase*, 1912 (Philadelphia Museum of Art). Courtesy Philadelphia Museum of Art: The Louise and Walter Arensberg Collection

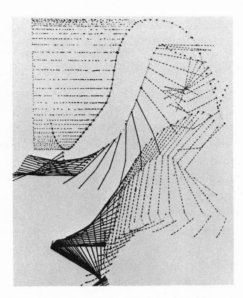

Fig. 2. Jules-Etienne Marey, *Diagram of a Jumping Figure.* From a Chronophotograph, about 1885.

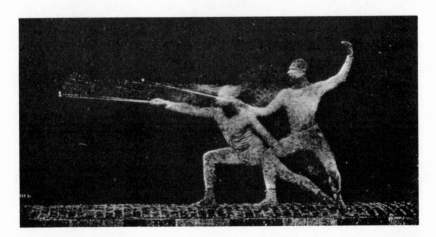

Fig. 3. Jules-Etienne Marey, *Chronophotograph of a Fencer,* about 1882. From J.-E. Marey, *Movement,* London, 1895

tography was Giacomo Balla, whose stroboscopic-like paintings would have been inconceivable without the precedent of Marey's experiments.

Balla's friend and fellow-Futurist, the photographer Anton Giulio Bragaglia, borrowed Marey's experimental photographic techniques to produce the first multiple-image photographs for aesthetic rather than scientific ends. In Balla's paintings, *Rhythm of the Violinist* (1912; fig. 4), the sensation of movement created by multiple overlapping images almost certainly derived from Bragaglia's experimental series "Fotodinamismo Futurista," and specifically the photograph entitled *Le due note maestre* (also of 1912; fig. 5). Another photograph from this series by Bragaglia (fig. 6) is a splendid document of the Futurists' interest in photography and dynamism, for in it can be seen Balla's painting, *Dynamism of a Dog on Leash* (Museum of Modern Art, 1912), and next to the

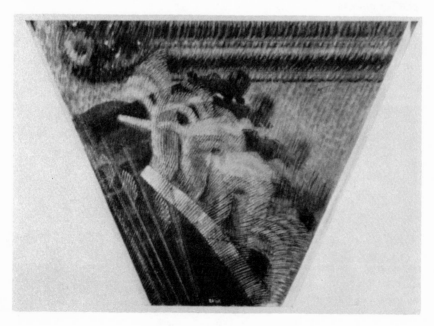

Fig. 4. Giacomo Balla, *Rhythm of the Violinist*, 1912 (Collection Eric Estorick, London).

Fig. 5. Anton Giulio Bragaglia, *Le due note maestre*, Futurist Photograph, 1912. From A. G. Bragaglia, *Fotodinamismo Futurista*, Rome, 1913

painting stands its artist, like the little dog he had just painted, his face and body blurred through movement.

Later, in the twenties, Man Ray paid his homage to Marey by including a brief motion study of a leaping man in his semi-surrealist film *Emak Bakia* (1926), and here, in this new and strange context, Marey's seriously scientific study, used by Man Ray as a kind of *objet trouvé*, comes out looking as surrealistic as any scene in the film. In his own way, Marey's studies of human and animal locomotion attracted the interest of a number of painters, most notably Jean-Louis Meissonier and probably Degas as well, who saw in his work and similar experiments performed by Eadweard Muybridge a valuable aid in achieving the correct representation of figures and animals in action.

For Marey, cinematography was a research tool that enabled him to observe and analyze patterns of movement normally imperceptible to the human eye. His many inventions in rapid-fire photography led to the development, in about 1890, of a motion-picture camera, a device that henceforth became increasingly important in the activities of the Institut Marey. This research center continued to develop experimental scientific cinematography after Marey's death in 1904 under the guidance of Lucien Bull, formerly an assistant director of the Institut, and George Deméry, an inventor of extraordinary ingenuity (whose brother, Paul Deméry, incidentally, was one of the few intimate friends of Arthur Rimbaud—this fact suggests that the experiments of the Institut Marey were not unknown to the leading painters and poets of the day). It did not take long before the commercial film producing companies— Pathé Frères in France, Charles Urban in England, Thomas Edison in America, and Eduard Liesegang in Germany—recognized that scientific films held an intense fascination for the public. Indeed such films had a double appeal for they exhibited the wonders of nature through the wonders of modern technology.

Among the most common variety of these popular scientific films were studies of plants and animal life under magnification. Similar to the world of still photographers whose earlier studies, particularly of plants and crystals, had revealed natural forms of astonishing beauty, these films added the dimension of movement, and hence the illusion of life itself under intimate observation. Tiny crustaceans and insects, magnified enormously on the screen, were transformed into prehistoric monsters. Beetles, bugs, and houseflies could be observed as easily as one watches a dog or a horse. By means of extreme slow-motion photography, a kind of close-up in time was created, elongating, as it were, a split-second happening into a slow visual drama, as in, for instance, early slow-motion studies of bullets shattering soap bubbles.

Films made for purposes of medical research constituted yet another genre of the scientific film. Probably the first

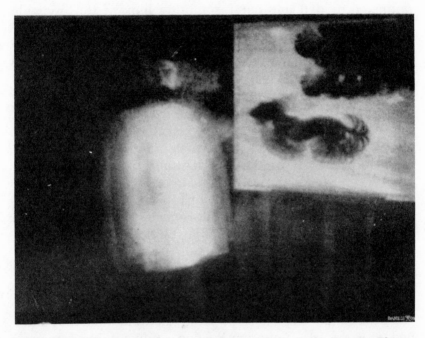

Fig. 6. Anton Giulio Bragaglia, *Il Pittore futurista G. Balla,* Futurist Photograph, 1912. This time-lapse photograph represents the artist Giacomo Balla whose face and body is blurred through movement. On his easel is Balla's famous painting, *Dynamism of a Dog on Leash* (Museum of Modern Art), in which movement is similarly suggested through the multiple overlapping forms of the dog's feet and tail. From A. G. Bragaglia, *Fotodinamismo Futurista,* Rome, 1913

example of experimental medical cinematography was the filming in 1898 of a surgically exposed pulsating heart by Dr. Ludwig Braun, a Viennese physician, and, by the eve of the war, such films were widely shown in commercial film theaters (fig. 7). The development of X-ray cinematography, again first developed by scientists, but soon thereafter shown to the public, provided another fascinating look at the invisible world of nature.

Perhaps the most astonishing of these medical films were the experiments in microcinematography. Working with Pathé Frères in 1909, the French physiologist Dr. Jean Comandon had succeeded in photographing bacteria and microbes, so that these tiny organisms appeared on the screen, alive and moving, magnified 100,000 fold, in images described by one viewer of 1912 as "startling to such a degree as to be incredible." These films, no less than the pre-war paintings of Kandinsky, must have been experienced by sensitive minds as profound and uniquely modern revelations of an unknown world —images of organic forms in movement recalling telescopic views of swirling galaxies, full of the flux and flow of life itself, touching at the core of secret meanings of the universe, and, at the same time, paradoxically, palpably real, that is, objectively verified by moving photographic images of a biological, if not spiritual, inner life (figs. 8 and 9).

The impact that these popular scientific films may have had upon the arts of pre-war Europe is difficult if not impossible to evaluate; the influence of technology on art is never this direct or obvious. The modern artist does not record the sources of his feelings so close to the surface of his painting, nor is he always consciously aware of the full catalogue of technological and social forces affecting his inner vision.

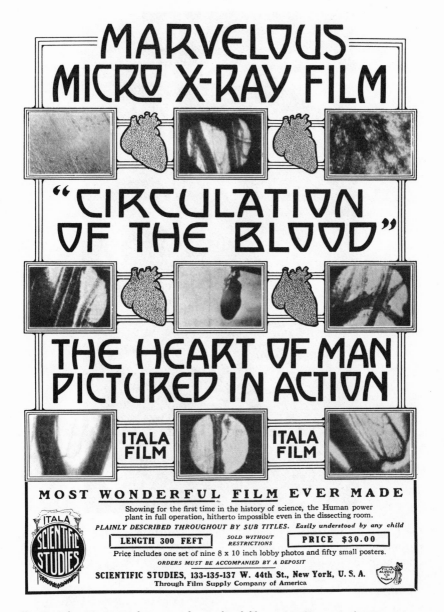

Fig. 7. Advertisement for an early medical film using X-ray and micro-cinematography, 1913. From *The Moving Picture World*, XV, no. 9, March 1, 1913, p. 856

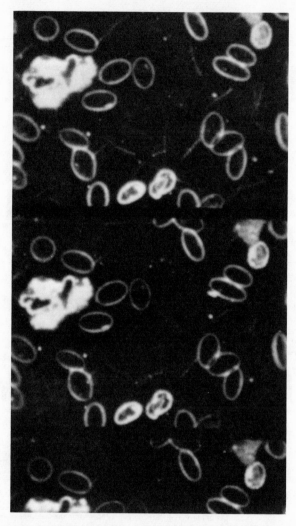

Fig. 8. Two frames from a scientific film of about 1910 showing microbes in movement under extreme magnification. From F. A. Talbot, *Moving Pictures*, London, 1912

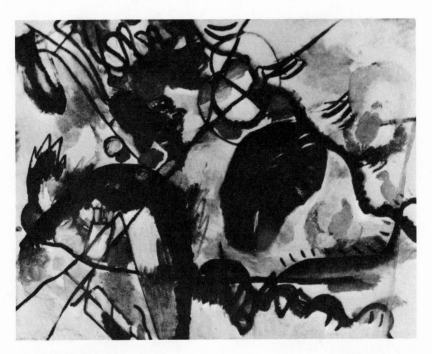

Fig. 9. Vassily Kandinsky, *Black Spot I, no. 153*, 1912 (Russian Museum, Leningrad).

Chapter 2

Film as Modern Art: Picasso, Survage, Kandinsky, Schönberg

By about 1913, several modern artists had begun to consider film seriously as a medium of expression worthy of exploration. Just before the outbreak of the war, that alliance between film and modern art generally known as the avant-garde film movement made its hesitant beginnings.

The fundamental characteristics of film accounted for the fascination it held among modern artists: 1) its kinetic dynamism, the very fact that film was a *moving* picture, and 2) its fantasy, that is, its effortless manner of conjuring up a world of strange and unexpected happenings, vividly real and yet without logic or meaning, a world normally accessible only through dreams or hallucinations. While these two elements of filmic expression may, of course, exist side by side in the same film, they provided nonetheless the major poles of attraction that drew modern artists to the medium, and hence may be discussed separately.

Film as Movement: Cubism

It is easy to see that the *image écranique* of the cinema with its multiplicity of viewpoints, its restlessly moving image formed quite literally from the patterning of light, has a close

correspondence to the flickering surfaces of Cubists and Futurist paintings of the immediate pre-war years, paintings which explored, like film, the phenomenon of movement, both with the Cubists' concern for vision in motion and in the Futurists' obsession for capturing the sensation of objects in motion. Yet to extract a causal relationship between film and Cubism or Futurism is a more difficult matter, and in any event, the influence of film here, to whatever degree it existed, was certainly not a simple matter of direct transposition of ideas from one medium to the other. The presence of film was pervasive, and its influence felt through many indirect channels.

For example, Henri Bergson, whose theories of duration and simultaneity surely left their mark on Cubism, found in film a working model for his construct of fluid time and the perception of form. His notion of "what is real is the continual *change of* form: *form is only a snapshot view of a transition,*" [4] was extended to embrace a system of processes by which the mind of modern man fused short-term memory of the immediate past, the awareness of the instant present and the anticipation of the immediate future into a working perception of knowledge. "We may therefore sum up what we have been saying in the conclusion that the *mechanism of our ordinary knowledge is of a cinematographical* kind" (Bergson's italics). Bergson's theories had a strong appeal in those years, "not only to professional philosophers, but to the ordinary cultivated public" (as noted in the preface to the first English translation of his *Essai sur les données immédiates de la conscience,* 1910). That the Cubists, in particular, were aware of his writings, if indeed not influenced by them in their paintings, is pointed out by Gleizes' and Metzinger's idea of movement in a Cubist painting "around an object to seize several successive appearances, which, fused in a single image, reconstitute it in time," almost an exact paraphrase of Bergson's cinematographic model for the "mechanism of our ordinary knowledge." Both film and Bergson's theories were an integral, and interdependent, part of the intellectual milieu of modern European painting at the eve of war.

Are there Cubist films? To what extent did the Cubists use the medium to release the implied movement of their paintings into an actual passage through space and time? Two examples of this intention may be cited; neither, however, was realized.

Picasso, in about 1912, had toyed with the idea of using film for the representation of movement, not altogether surprising for this artist, who was an avid movie-goer in those years,[5] who had painted from still photographs a few years earlier, and was the modern artist who has dealt most intelligently with the problems of movement. Daniel-Henry Kahnweiller has written of Picasso's search for a mobile art capable of creating a sequence of visual impressions:

> Is there such a possibility?
>
> There exists, in fact, two possibilities, both of which Picasso had indicated in conversations, without even suspecting their scientific basis; nor has he as yet applied them in practice.
>
> The first corresponds to the actual movement of the body. This would involve imparting movement to the work of art by means of a clockwork mechanism. . . .
>
> There is still another way of bringing about the impression of movement in the mind of the spectator—the stroboscopic method, upon which the cinematograph is based ... This method has already been employed for animated cartoons. By painting various pictures on a transparent material and showing them through a cinematograph projector, a new field with immeasurable possibilities would open for painting.[6]

Another Cubist painter, Léopold Survage, was not of Picasso's genius, but he made more tangible progress toward the creation of a painting-in-motion through film.

Survage (Moscow, 1879-Paris, 1969) settled in Paris in 1908, earning his living as a piano-tuner while he painted on the side. He began exhibiting with the Cubists in the Salon des Indépendants in 1912, and about this time conceived the idea of

using film to create an autonomous art of forms in movement. His description of the project, which he called *Le Rythme coloré*, was published by Apollinaire in the last issue of *Les Soirées de Paris:*

> *Colored Rhythm* is in no way an illustration or an interpretation of a musical work. It is an art in itself, even if it is based on the same psychological facts as music.
>
> *On its analogy with music.* It is the mode of succession in time which establishes the analogy between sound rhythm in music, and colored rhythm—the fulfillment of which I advocate by cinematographic means. Sound is the element of prime importance in music . . . The fundamental element of my dynamic art is *colored visual form,* which plays a part analogous to that of sound in music.
>
> This element is determined by three factors:
> 1. Visual form, to give it its proper term (abstract);
> 2. Rhythm, that is to say movement and the changes visual form undergoes;
> 3. Color.[7]

A brief examination of some of the extant drawings for his *Rythme coloré* provides an even clear understanding of Survage's intentions. The film was conceived as a series of separate sequences, each one a clearly defined and self-contained exercise of abstract forms in movement. Apparently the film was to be about three minutes long, and even for this modest length, between two and three thousand drawings were required. These were to be executed by draftsmen who, by a process of visual interpolation, would fill in all the intermediary stages between the major moments of each sequence designed by Survage. Gaumont, a major French studio, expressed interest in the experiment, but the war intervened and prevented its completion.[8] All that remains today are seventy-one gouache drawings by Survage, fifty-nine of which

are in the Museum of Modern Art—they represent five different sequences for the film—and twelve drawings in the Cinémathèque Française represent another sequence.

Survage, in his manifesto in *Les Soirées de Paris,* noted that the draftsmen who were to help him with the project would be able "avec un peu de bon sens," to deduce the transitional steps between his key drawings. The dozen drawings at the Cinémathèque Française demonstrate one complete sequence envisioned by Survage, and from them, we, like his prospective draftsmen, can read this outline evolution of form by supplying the intermediary stages between each drawing (fig. 10, nos. 1–12).

Out of a field of blackness, two curving rainbow-striped bands emerge from either side; they join together forming a single vertical band which then splits down the middle, and pulls apart to reveal a deep black cleft (nos. 1–3). As the edges of this cleft float diagonally apart, two brightly colored sawtoothed forms enter from opposite corners, advance toward each other (no. 4), then shift course, as if to avoid collision, by rotating in opposite directions, leaving behind a curving trajectory (no. 5). These saw-toothed forms merge with the curving ones (no. 6) to create two diagonally opposed bullet forms whose outlines then tighten into clean edges. Their points come together and touch; from this contact, two diaphanous undulating forms are emitted (no. 7). The bullet forms dissolve somewhat, slide past each other, merge together, and rotate around each other (nos. 8 and 9). Now, tightly clamped together into a single form, like a swirling comet with two tails, it cartwheels backwards through space (no. 10), and as it recedes from view, it again cleaves apart. Its two halves float away (no. 11), leaving behind a deep black space, an empty stage ready to receive the visual drama of the next sequence.

The sequences of movement sketched by the Museum of Modern Art drawings differ in form, but not, generally speaking, in feeling from the one just examined. All of them grew out of a black void and then, at the end, retreated into it. The colors were single hues of yellow, orange, green, blue, red,

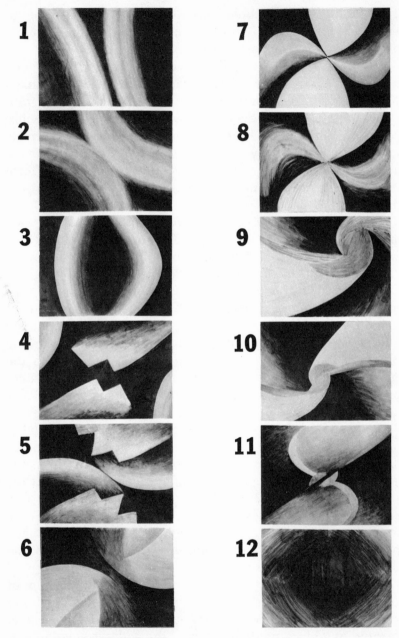

Fig. 10. Léopold Survage, Twelve designs for a sequence in his abstract film, *Le Rythme Coloré*, about 1913 (Cinémathèque Française). Courtesy Cinémathèque Française, Paris

and purple. The forms varied from hard-edged, though rarely rigidly geometric, to softer, blurred areas of color, shapes that were frequently rounded, curving or pointed, sometimes dissolving into the omnipresent black background. Nowhere was there to be a sense of gravity or density. The forms floated weightlessly, without regard to up or down, transforming themselves at will, following no predictable pattern of development, suggesting at times biological growth or other organic processes, but never in an explicit or deterministic manner.

From his drawings we can easily imagine how Survage's film would have looked. One of the most inventive aspects of the proposed film was Survage's extraordinarily rich choreography of movements, including:

1. Plastic transfiguration of one form into another
2. Integration and disintegration of form
3. Movement of color changes
4. Movements of forms in and out of the field of vision
5. Kinetic activity within the field of vision
6. Movements towards and away from the camera, like the effect produced by a modern "Zoom" lens.

Through the analogy of music, Survage regarded his film as an exercise not in movement but in rhythm. Purely abstract forms of color, set in motion and kinetically interacting, were to evoke in the spectator's mind a rhythm of melodic and harmonic relationships moving through time. Survage's reasoning is spelled out in greater detail in his *Soirées de Paris* manifesto:

> A static abstract form is still not expressive enough. Whether round or pointed, oblong or square, simple or complex, it only produces an extremely confused sensation; it is only a simple graphic notation. Only when set in motion, undergoing change, entering into relations with other forms, is it able to evoke *feeling* . . . it is in this way that visual rhythm is analogous to sound rhythm in

music. In both domains, rhythm plays the same part. As a consequence for the plastic world, the visual form of any body is only valuable to us as a starting-point, as a means of expressing and evoking our interior dynamisms, and certainly not to render the meaning or import such and such an object might have, in fact, in our lives . . . So much for form and rhythm, which are inseparable.

The theory bears close comparison with the artistic intentions of other painters of this period. Kandinsky and Delaunay followed essentially the same path of abstraction, using music as their model for an autonomous art. And like Survage, both equated musical notes with chromatic vibrations. But unlike Kandinsky, Survage did not seem to have developed a precise correspondence system between specific colors, musical notes, and emotional overtones. Nonetheless, color, "the very essence of abstract form" was to be a major expressive element of his *Rythme coloré.* But complications of producing a film in color, in 1913, undoubtedly discouraged other painters from experimenting with the medium and were probably responsible for the abandonment of the project.

Film as Fantasy: Surrealism

Survage's ill-fated film projects and Picasso's passing thoughts on mechanized art are two examples of the desire for a mobile art through the marriage of painting and cinematography. Yet film was regarded by other artists as more than a mechanical device to create images in movement. It was seen by them as a powerful magic force, as a means of creating a world of fantasy, intensely real through the vivid presence of its surface appearances, and yet, paradoxically, unrealistically drained of color and sound. Unlike the real life it photographically represented, film was utterly devoid of the immediacy of the moment—hence the fantasy inherent in even the

most realistic of films. Georg Lukacs, in an article of 1913, incisively delineated these basic affinities of film with fantasy:

> The lack of this "present" is the essential characteristic of film. Not because films are still unperfected, not because even today their moving forms remain mute, but simply because they are only the acts and movement of people, and not people themselves. This is no deficiency of film, it is its limitations, its *principium stilisationis*. Hence the weirdly lifelike character of film, not only in its technique, but also in the effect of its pictures, identical in character, and, unlike those of the stage, every bit as organic and lively as nature; film brings forth a totally different kind of life; its life becomes—in short—a life of fantasy. Fantasy, however, is not opposed to living life, it is a new aspect of it, a life without present, without destiny, without reasons, without motives, a life that the innermost of our soul neither can nor wants to identify with ... The world of film is a life without background and perspective, without distinctions of weight or quality. For only the immediate present endows objects with destiny and gravity, light and levity; film is a life without measure and order, without reality and value; a life without a soul—a life of pure surface appearances.[9]

In the pre-war years there are indications that film was already regarded by major artists, most notably Kandinsky, as a means of visualizing fantasy. Kandinsky's name has been linked to two pre-war film projects; neither were realized. The first was a proposed collaboration with Arnold Schönberg for the filming of his second operatic composition, *Die Glükliche Hand*.

In the fall of 1913 Schönberg discussed his ideas for the film in a letter to Emil Hertzka, the managing director of Universal Editions, a music publishing house in Vienna. After settling several points about the musical score for the film ("No

change is to be made in the music."), Schönberg turned to the
question of its visual design:

> What I think about the sets is this: the basic
> unreality of the events, which is inherent in the words, is
> something that they should be able to bring out even
> better in the filming (nasty idea that it is!). For me this is
> one of the main reasons for considering it . . . And there
> are a thousand things . . . that can be easily done in this
> medium, whereas the stage's resources are very limited.
> My foremost wish is therefore for something the
> opposite of what the cinema generally aspires to: I want:
> *The utmost unreality!*
> The whole thing should have the effect (not of a
> dream) but of chords. Of music. It must never suggest
> symbols, or meaning, or thoughts, but simply the play of
> colours and forms. Just as music never drags a meaning
> around with it, at least not in the form in which it
> (music) manifests itself, even though meaning is
> inherent in its nature, so too this should simply be like
> sounds for the eye and so far as I am concerned
> everyone is free to think or feel something similar to
> what he thinks or feels while hearing music.
> What I have in mind is therefore the following:
> A painter (say: I, Kokoschka, or II, Kandinsky, or III,
> Roller) will design all the main scenes. Then the sets will
> be made according to these designs, and the play
> rehearsed. Then, when the scenes are all rehearsed to
> the exact tempo of the music, the whole thing will be
> filmed, after which the film shall be coloured by the
> painter (or possibly only under his supervision) accord-
> ing to my stage-directions. I think however mere
> colouring (will) not suffice for the "Colour Scene" and
> other passages where strong colour effects are required.
> In such passages there would also have to be coloured
> reflectors casting light on the scene.[10]

Schönberg's choices for painters to design the sets, with

the exception possibly of Roller, make it doubly lamentable that the project was never realized. Kokoschka he had known from his earlier years in Vienna; both had come to Berlin from that city, which, by 1910, was increasingly indifferent if not downright hostile to modern art. The influence of Kokoschka's fiery expressionistic style is clearly discernible in Schönberg's own works in painting. Moreover Kokoschka's own activities as a playwright might have made him a sympathetic collaborator for Schönberg's film project, for, like Barlach, he was an Expressionist in both playwrighting and painting.

Schönberg's choice for artistic collaboration with Kandinsky had even more compelling reasons. First of all, they were close friends and held similar views of the nature and function of art. Kandinsky was a painter who took inspiration from music; Schönberg was a composer who saw in modern painting a spiritual counterpart to his music. In 1909–11 Kandinsky translated into Russian an article by Schönberg on octaves and fifths for the Odessa International Exhibition of Art. Possibly on the basis of this, Kandinsky insisted that Schönberg write on modern German music in the *Blaue Reiter Almanach* which he was then preparing for publication with Franz Marc. "Schönberg *must* write on German music," he wrote in a letter to Marc of September 16, 1911. "The first number without Schönberg! No, I won't have that." Schönberg responded to the invitation by contributing an important essay, "Das Verhältnis zum Text," in which Schönberg's concluding remarks on the source of meaning in music—"the visible ramifications on the surface plane owe their existence to a parallel movement on a higher level"—echo Kandinsky's thoughts on painting in *Uber das Geistige in der Kunst*. Kandinsky, it should also be added, had great respect for Schönberg as a painter—three of whose works were included in the first *Blaue Reiter* exhibition at the Thannhauser Gallery in December, 1911—and the following year Kandinsky wrote a short flattering note on Schönberg's works in this medium.

Thus Kandinsky and Schönberg knew and respected each other. This alone is sufficient reason for their proposed collaboration in film-making. A deeper reason, however, stems

from their common belief in the synthesis of the arts, a belief that held that music and color touched identical responses in the human soul through different sensory receptors. Schönberg's subscription to synthetic theory is revealed in this letter to Hertzka where he says the sets "should simply be like sounds for the eye." And without question, the notion of corresponding sounds and colors underlay Kandinsky's formulation of a purely abstract visual art in the years 1909 to 1913. In *Uber das Geistige in der Kunst,* he wrote that yellow is in the sound of the trumpet; blue suggests the flute, a cello, a double bass, or an organ; vermillion is like a tuba; and orange resembles the sound of a church bell. Using his palette as a kind of orchestral keyboard, Kandinsky would compose his paintings, many of which were entitled as if they were musical works: *"Composition VII"* (1913), with its composite forms clearly marked out and colors labeled, resembles less a preparatory drawing for a painting than a blueprint carefully organized, like a musical score, according to the desired arrangement of tones and rhythms. Kandinsky was not a gifted musician like Paul Klee or Franz Marc, and yet, more than these two other key members of the *Blaue Reiter,* he found in music both an inspiration and a model to help him find his way into an unexplored world of abstract pictorial imagery. Again, in *Uber das Geistige in der Kunst:*

> A painter who finds no satisfaction in the mere representation of natural phenomena, however artistic, who strives to create his inner life, enviously observes the simplicity and ease with which such an aim is already achieved in the non-material art of music. It is easily understandable that he will turn to this art and will attempt to reciprocate it with his own medium. From this derives some of the modern search in painting for rhythm, mathematic abstract construction, color repetition, and manner of setting color in motion.[11]

"Setting color in motion"—although the term recalls Sur-

vage's intentions in *Le rythme coloré*, Kandinsky was less concerned with the pure play of forms in movement than with the fantastic effects created this way. For this was the basis of Kandinsky's stage composition, *Der gelbe Klang*, written as early as 1908 or 1909, and which, according to Gabriele Münter, was intended to be filmed by Kandinsky.[12]

It is difficult to know exactly what to call *Der Gelbe Klang;* its *genus proximum* is opera, yet this is not a very helpful descriptive category. Its essential ingredients—sound, color, and movement—are combined in measured quantities to produce a synthetic work. Kandinsky's analysis was somewhat more complex. The inner value of *Der Gelbe Klang*, he wrote, derived from three elements:

1. Musical tone and its movement
2. Material-psychic sound, expressed through movement of people and objects
3. Colored tone and its movement[13]

These clues to the meaning of *Der Gelbe Klang*, rather vague in themselves, are more helpful when considered in relation to the work itself. Fortunately, the piece is sufficiently short so that the first of its five acts can be given here in translation:

Act One:

> The stage must be as deep as possible here. At the extreme rear, a wide green mound. Behind the mound, a smooth, dull blue rather deeply colored curtain.
>
> Soon the music begins, first in high registers. Then directly and quickly it drops to lower ones. At the same time the background becomes dark blue (simultaneously with the music) and has black wide edges (as in the picture*). Offstage a chorus singing without words

* *"Wie im Bild."* Does Kandinsky refer here to an illustration? None was published with the text. Possibly he intended to indicate, "as in [the wide black frame of] a picture."

becomes audible. It sings without feeling and sounds completely wooden and mechanical. After the end of the choral singing, a general pause; no movement, no sound. Then darkness.

Later the same scene is lit up. From right to left five shrilly yellow giants (as large as possible) are pushed out onto the stage (as if gliding above the ground).

They remain standing next to each other at the back of the stage—some with shoulders lifted high, others with drooping shoulders. Their strange yellow faces are indistinct.

They turn their heads toward each other *very* slowly and make simple motions with their arms.

The music becomes more exact.

Soon, the *very* deep singing without words of the giants becomes audible, and *very* slowly they move up towards the ramp. Spirits *(Wesen)*, red and indistinct, quickly fly in from left to right. They look *somewhat* like birds and have large heads that appear vaguely human. Their flight is reflected in the music.

The giants sing on, ever more faintly. They also become more and more indistinct. Behind, the mound grows slowly upward and becomes lighter and lighter. At the end, white. The sky is completely black.

Offstage, the same wooden chorus is audible. The giants can no longer be heard.

The proscenium becomes blue and more and more opaque.

The orchestra fights the chorus and conquers it.

A thick blue vapor makes the whole stage invisible. (End of the first act)

It is a strange world which Kandinsky has created here—timeless, ethereal, with no reference to material reality, nor to theatrical convention, yet not altogether surprising from the artist who was creating an equally abstract and spiritual universe in painting at that time. We well might wonder how *Der Gelbe Klang* would have been staged. The magical effects

and strange apparitions so difficult to create with convincing illusionism on the stage would have been comparatively simple for film, but, like Schönberg's proposed filming of *Die Glückliche Hand,* this project, too, came to nothing.

What was the significance of these two proposed film projects? They were, in fact, remarkably similar.

Both Schönberg and Kandinsky wished to create on film a highly personal, anti-naturalistic, and dematerialized art. (Kokoschka, whose paintings and drama were essentially expressionistic, is a separate case; and Roller may quite justifiably be disregarded.) Kandinsky's eerie apparitions in *Der Gelbe Klang* were echoed in Schönberg's cry for "*the utmost unreality!*" Both works were spectral fantasies speaking directly to innermost feelings, and both attempted to communicate within a realm of poetic feeling without recourse to either psychic emotions or the intellect of vision, hence their fundamental distinction from expressionism or formalism.

This world of feeling was shaped by form, and its mood charted by color. Both Kandinsky and Schönberg sought to embody feelings through personal color symbolism. Most of Kandinsky's stage directions in *Der Gelbe Klang* were to chart the complex and shifting pattern of color. The intensely yellow giants, red spirits, green hills, and blue vapors of the first act were followed by an even more bizarre array of color fantasies in the following ones. Likewise, in *Die Glückliche Hand,* color was to be a keynote to mood.

Color then was a major expressive element. As in a pre-war Kandinsky painting, color was to be intense in value, richly varied in its range of hues, and arbitrary and anti-naturalistic in its application. It was not, however, an independent and isolated element, but was to appear inexorably linked to sound and movement. Herein lies the fundamental significance of *Der Gelbe Klang* and *Die Glückliche Hand.* Both were attempts at truly synthetic works of art in which color, movement, and sound would fuse in the spectator's mind to form a single expressive phenomenon, and through their successive interaction would arise a new order of aesthetic experience.

That neither of these film projects was realized, nor even came close to realization, need not dilute their significance. Film, after all, was a foreign and complicated medium for those not initiated into the secrets of its techniques. The desire alone to film these experimental operatic productions stands as a signpost pointing to several key aspects of pre-World War I European art: its unfettered experimentation, its poetic aspiration to mood and feeling, and its faith in the synesthetic correspondence of the arts.

Chapter 3

The Abstract Film: Richter, Eggeling, and Ruttmann

The avant-garde film movement of the 'twenties is that chapter in the history of film created, for the most part, by painters and poets whose principal medium of expression was not film. Their films were non-commercial undertakings, and usually non-narrative in form. Through the medium of film, they sought to give concrete plastic shape to inner visions rather than manipulate images of external reality for dramatic effect. In its broadest outlines, the avant-garde film movement followed a course similar to modern painting in the 'twenties, that is, from a rigorously geometric and abstract style, as in De Stijl or the Bauhaus aesthetic, to the hallucinatory content of Surrealism in the late 'twenties. Although it found its greatest activity in Paris, the movement was born in Berlin with the abstract films of Hans Richter and Viking Eggeling working together, and, independently, Walter Ruttmann.

Hans Richter (Berlin 1888, lives today in Locarno and Connecticut) came to film through painting. His first contact with modern art came through the *Herbstsalon* of 1913, where he experienced the work of the Fauves, the Futurists, and Picasso and Braque, and where Herwarth Walden put him to work distributing Marinetti's manifestos—an excellent apprenticeship to Dada. His painting of 1914, as in *Cello Player* (fig.

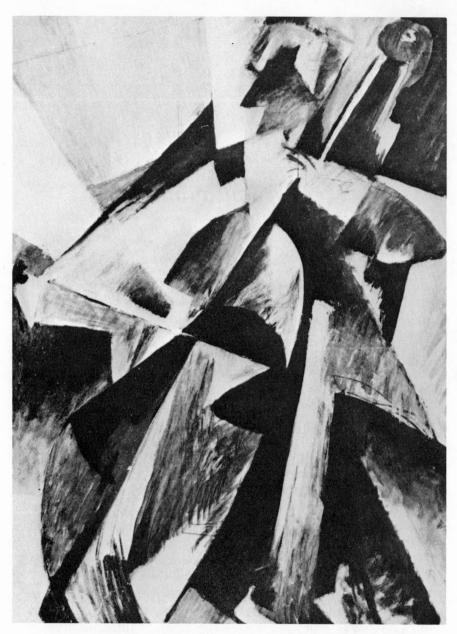

Fig. 11. Hans Richter, *Cello Player*, 1914. Courtesy Hans Richter

11), clearly acknowledges a debt to Cubism in its prismatic fracturing of Picasso and Braque. For Richter has used their Cubist vocabulary not to analyze structure or explore pictorial space, but to rhythmically articulate the surface of the canvas. Like the musician subject of his painting, Richter's concern here is orchestration—that is, the patterning of form according to tonal variations of black and white, set in movement by cross-diagonal axes, and marked out by a rhythm of periodically repeated sharp and angular accents—elements of pictorial expression that were to lead Richter to film for their most logical articulation.

Richter deepened his association with Expressionism through a two-man show with Erich Heckel in 1916 at the Hanns Goltz Gallery in Munich, and in the following year, working with the Dada movement in Zürich, his painting erupted into the vivid colors and fluid forms of his so-called "visionary portrait" series. This euphoric release, however, was short-lived, and by 1918, Richter had returned to an art of even more rigorous order. For instance, in his *Dada-Köpfe* drawings of 1917/18 (fig. 12), a series of studies of heads increasingly abstract in configuration, Richter was less interested in the psychology of his sitter than in exploring a contrapuntal figure-ground relationship in which measured areas of contrasting black and white alternated in their pic-torial function of defining form and space. Again, this polar system of contrasting black and white, representing either solid or void according to position and proportion on the sheet of paper, was a fundamental principle behind his first film, *Rhythm 21*. These experiments were encouraged by Ferruccio Busoni, the Italian-born pianist, composer, and friend of the Futurist painters, who saw a process analogous to musical counter-point in the alternating play of black and white of Richter's *Dada-Köpfe*.

Paradoxically then, it was during Richter's Dada period that his art attained its most precise control in the manipula-tion of form, partly, no doubt, in reaction against the anarchistic liberties of Dada art and partly due to the influence

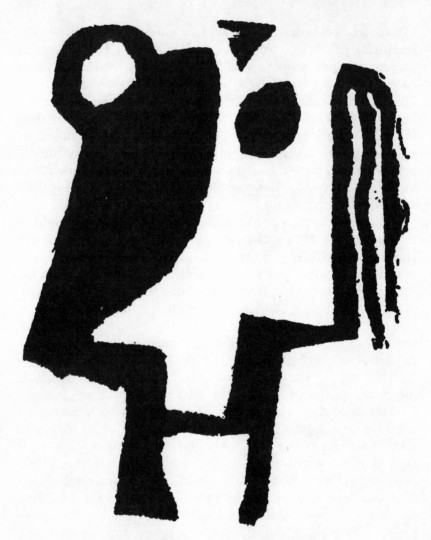

Fig. 12. Hans Richter, *Dada Head,* 1918. Courtesy Hans Richter

of his collaboration beginning in 1918 with the Swedish
painter, Viking Eggeling.

Eggeling (b. Lund, Sweden, 1880; d. Berlin, 1925) had come
to Zürich in 1917. The Dada movement was in full swing. Hans
Arp, whom he had known earlier in Paris, introduced him to
Tristan Tzara, the ringleader of the Dada group. Eggeling

painted very little in those years, and instead occupied himself
with the formulation of a theory of art based on a language of
linear forms. Arp has described his method:

> I met him again in 1917 in Zürich. He was searching
> for the rules of a plastic counterpoint, composing and
> drawing its first elements. He tormented himself almost
> to death. On great rolls of paper he had set down a sort
> of hieratic writing with the help of figures of rare
> proportion and beauty. These figures grew, subdivided,
> multiplied, moved, intertwined from one group to
> another, vanished and partly reappeared, organized
> themselves into an impressive construction with
> plantlike forms. He called this work a "Symphony."[14]

Those "Symphonies" that Arp so admired for their plantlike
forms were the result of a long, intensive, and systematic
research by Eggeling. With a persistence and single-minded-
ness no less formidable than Seurat or Mondrian's, he had
distilled a vocabulary of pictorial forms out of the chaos of
nature. This process is most clearly charted by his own art.

A landscape of about 1916 (fig. 13) shows forms of na-
ture—rocks, grass, trees, even clouds and leafy foliage—all
simplified into the hard geometry of man-made architecture.
Nothing could be further from a spontaneous revelation of the
natural world. Here, all is reduced to a basic form and, with a
certain dogged insistence, submitted to a pre-determined
compositional scheme of contrasting opposites. Thus, for in-
stance, the foreground rocks all point down, those behind them
point up. The pattern of the grass conforms to the same play of
curve and reverse curve. Similarly, one tree is stiff and upright,
the other curved. The open fields (or water?) are horizontally
striated, the buildings beyond are predictably vertical in their
emphasis. The clouds above, like flattened lumps of concrete
hanging in the air, are again horizontal. If, admittedly, the
painting has little grace, the clarity of its structural logic and
the firmness of its expression cannot be denied.

Eggeling surely realized that such a painting was an un-

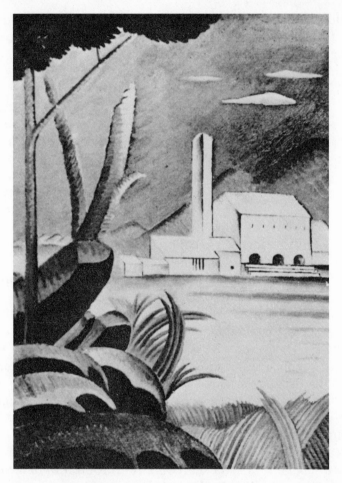

Fig. 13. Viking Eggeling, *Landscape*, 1916. Courtesy Yale University Art Gallery

comfortable compromise between an image of the natural world and the will of his own intellect. The way out of this dilemma was through abstraction. By transforming natural forms into graphic notations, Eggeling freed them from all mimetic responsibility and then used them to formulate a new language of pictorial expression.

In drawing after drawing, Eggeling took stock of this new language. A typical sheet of 1918 (fig. 14) shows how he systematically analyzed several categories of these linear

elements: at the top are three varieties of *Begrenzung mit Linien,* as his notes indicate, and below are thirteen different examples of *Strahlenformungen,* in radiating, striated, and feathered forms, all neatly arranged on the sheet like a page from a dictionary of pictorial ideograms. Eggeling intended to develop a vocabularly of abstract forms and then to explore its grammar and syntax by combining these forms into "con-

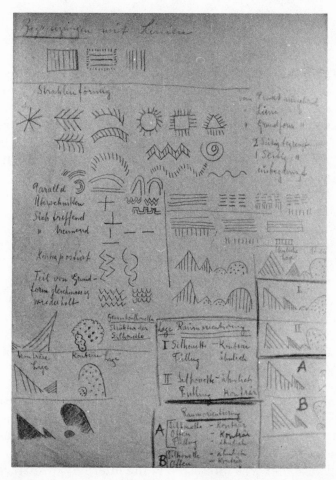

Fig. 14. Viking Eggeling, *Sheet of Studies of Abstract Forms from Nature,* about 1916. Courtesy Yale University Art Gallery

trapuntal pairs of opposites, within an all-embracing system based on mutual attraction and repulsion of paired forms."

Eggeling's notion of counterpoint of linear elements, already highly developed by 1918, had obvious affinities with Richter's attempts at counterpointing positive and negative in the black and white areas of his *Dada-Köpfe*. Hence their recognition of mutual artistic interests when they met, as recalled by Richter:

> One day at the beginning of 1918 ... Tristan Tzara knocked at the wall which separated our rooms in a little hotel in Zurich and introduced me to Viking Eggeling. He was supposed to be involved in the same kind of esthetic research. Ten minutes later, Eggeling showed me some of his work. Our complete agreement on esthetic as well as on philosophical matters, a kind of "enthusiastic identity" between us, led spontaneously to an intensive collaboration, and a friendship which lasted until his death in 1925 ...
>
> Eggeling's dynamics of counterpoint, which he called *Generalbass der Malerei,* embraced generously and without discrimination every possible relationship between forms, including that of the horizontal to the vertical. His approach, methodical to the degree of being scientific, led him to the analytical study of the behavior of elements of form under different conditions. He tried to discover which "expressions" a form would and could take under the various influences of "opposites": little against big, light against dark, one against many, top against bottom, and so forth[15]

For the next three years, Richter and Eggeling lived and worked together at Klein-Koelzig, with Richter's parents near Berlin. Despite their close collaboration and common interests, the basic differences between their two styles did not merge into one; Richter was interested in the interplay of surfaces, of areas, while Eggeling's principal concern was with line. Nonetheless their research carried them along similar paths.

Both wished, first of all, to reduce art to simple elemental units of design, to rectangular surfaces (Richter) and linear notations (Eggeling). These severely constrained units, however, were not studied in isolation but rather in their interplay with each other, in their mutual interaction based on laws of counterpoint and analogy. Again, as Richter has recalled:

> For both of us, music became the model. In musical counterpoint, we found a principle which fitted our philosophy: every action produces a corresponding reaction. This, in the contrapuntal fugue, we found the appropriate system, a dynamic and polar arrangement of opposing energies, and in this model we saw an image of life itself: one thing growing, another declining, in a creative marriage of contrast and analogy. Month after month, we studied and compared our analytical drawings made on hundreds of little sheets of paper, until eventually we came to look at them as living beings which grew, declined, changed, disappeared—and then were reborn . . .
>
> It was unavoidable that, sooner or later in our experiments, these drawings, which were spread about on the floor of our studio, would begin to relate systematically to each other. We seemed to have a new problem on our hands, that of continuity, and the more we looked, the more we realized that this new problem had to be dealt with . . . until, by the end of 1919, we decided to do something about it. On long scrolls of paper Eggeling developed a theme of elements into "Horizontal-Vertical Mass," and I developed another into "Preludium."[16]

Eggeling's scroll, *Horizontal-Vertical Mass,* consisted of many separate moments, of which part of the middle section is shown here (fig. 15). The powerful vertical form of the opening moment is repeated right through until the very end of the scroll. On either side of this form are clusters of lines, first to the left, then more to the right, growing upwards, turning in on

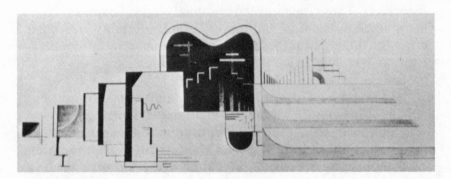

Fig. 15. Viking Eggeling, *Horizontal-Vertical Mass*, 1919. Courtesy Hans Richter

themselves, in a constant dialogue with one another, always dominated by the dense black vertical form, the stabilizing accent for each of these opening moments. Then, out of this interplay of strict linearity, Eggeling introduces in the fifth moment a heavy double curve. With that same determination that willed the formal organization of his early paintings (fig. 13), here too, a deliberate, methodical articulation of form is revealed. Curve against rectilinearity, vertical against horizontal, small and intricate activities against bold simple gestures. In the end moment of his *Horizontal-Vertical Mass,* the scroll is terminated with a sprawling composition of multiple contrast-analogies. Each line, each form serves a functional pictorial purpose. Each gesture is countered or answered by another within this all-embracing system.

Richter, in his first major symphonic scroll, *Preludium,* while using equally abstract forms, orchestrated them in a looser, less deterministic manner. His scroll, unlike Eggeling's, was not a diagram of a theory of art but an artistic improvisation controlled by theory. It grew out of a search for the visual adjustment of one constellation of rectangular forms to the ones preceding and following. His method tempered dogmatic theory with intuition. These long working sketches were expanded into larger sketches of more complicated movements,

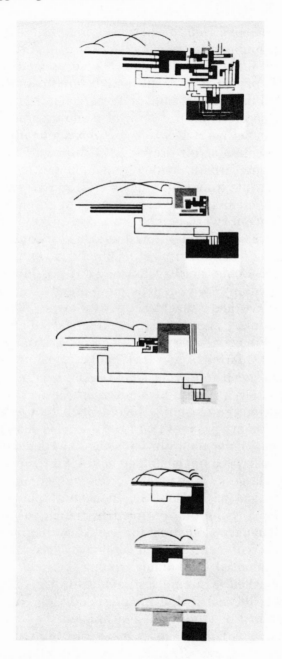

Fig. 16. Hans Richter, *Preludium*, section of scroll drawing, 1919. Courtesy Yale University Art Gallery

each one an active grouping of sub-divided, interacting surface areas, predominantly rectangular in configuration. These sketches, in turn, were clarified, cleaned up as it were, in the final scroll, of which the final sections are illustrated (fig. 16). Here, a ten-part procession of these groupings leads, as in Eggeling's scroll, from the germ of a simple graphic gesture, through progressive stages, to a complex summation.

In these two scroll drawings, Richter and Eggeling had formed a new artistic syntax in which the eye traveled a prescribed route from beginning to end, and in which sequential imagery created an art of becoming, of unfolding, of constant reference forward and backward in space and time. The next step was inevitable—film, the logical medium to extend this dynamic potential into actual kinetic movement.

Neither Richter nor Eggeling had any previous experience with the medium: "we knew no more about cameras and film than what we had seen in shop windows." What they did know, of course, was that film-making was an expensive undertaking. Financial assistance appeared, fortunately, from an unexpected quarter. A wealthy banker neighbor named Dr. Lübeck had been following their research with interest, and although totally ignorant of modern art, he was intrigued by the semi-scientific reasoning behind their film-as-art project. He offered them a grant of DM 10,000—a generous sum but still insufficient to make their films. Instead, they decided to use the money to wage a campaign to persuade UFA (Universum-Film, A. G., the largest German film-producing company) to give them technical assistance. So, in a short pamphlet called *Universelle Sprache,* they outlined their theory of an elemental pictorial language of abstract form and its articulation through counterpoint of contrast and analogy. These were sent to various influential individuals, among them Albert Einstein, who were asked to submit testimonials to UFA in support of the project. UFA consented and provided Richter and Eggeling with an animation studio and a technician.

But now, with the means to make their films at hand, a host of questions arose. Exactly how was this program of movement to be orchestrated, at what speeds, in what ratios

between the various parts, in what relation to the total
frame—these details had previously not concerned them. Their
technician was exasperated, and not very friendly either. A
number of test strips were made; one of them, a play of lines
from Richter's *Preludium* scroll, was later incorporated into
his film *Rhythm 23.* But, on the whole, their anticipated
alliance between art and industry was not very successful—the
results, when they finally came back from the laboratory, were
utterly unlike their expectations. Nonetheless, the UFA
experiment contained a valuable lesson, namely that film is
governed by laws which do not necessarily operate in painting,
that, in film, the orchestration of time may be more important
than the arrangement of form.

At this time their experiments came to the attention of
critics and other artists who were sympathetic to their hopes
for the creation of animated paintings through film. Dr.
Adolph Behne, an influential Berlin critic, had been aware of
Bruno Taut's designs for a film,[17] and he supported the
Richter-Eggeling project with equal enthusiasm. A newspaper
article by Behne on their work was read by Theo van Does-
burg, then living in Amsterdam, and he immediately recog-
nized the artistic implications of abstract film. In December of
1920, van Doesburg sent Richter a telegram announcing his
visit to Klein-Koelzig. He was invited for a three-day visit and
stayed three weeks, over Christmas. Van Doesburg's report on
their project, published in *De Stijl,* in 1921, provides a helpful
introduction to their films:

> Hans Richter and Viking Eggeling did not come to ab-
> stract film totally unexpectedly. The notion of conquer-
> ing the static character of painting by the dynamic
> character of film already existed in the minds of many
> modern artists who have wanted to solve problems of
> visual arts with the help of a well-developed film tech-
> nique, to bring together the dynamic and static in an
> aesthetic way. However, satisfactory results were not
> found, nor did the attempt to express the dramatic
> content of a decadent ideology in the so-called expres-

sionistic film (with its laid-on tragedy) provide a solution to speak for the new era. I could add many other compromises but these have nothing to do with abstract film form, a form which has introduced a new era of possibilities for dynamic expression. It is generally known that the Futurists sought dynamic effects in their paintings, but, because their art remained static, these effects remained only suggestive.... It is helpful to compare abstract film-making with visual music, because the whole composition develops visually, in its open field of light, in a manner more or less analogous to music. The spectator sees the composition (already worked out by the artist in a "score") come into being, attain a clearly defined form, and then disappear into the field of light, from which a new composition of totally different structure is built up again. This abstract dynamic plasticism is mechanically realized, and will be accompanied by musical compositions in which the instrumentation as well as the content would have to be totally new. It seems that many artists, working independently, were concerned with this concept of creating images by mechanical means. When the artists Richter and Eggeling turned to "De Stijl" to realize this concept, I hastened to visit them in [Klein-Koelzig] because I felt an artistic kinship there and I wanted to get to know their work and progress. Although they had not yet attained extreme purification of form, it seemed that they had found the general basis for dynamic plasticism and also had researched the possibilities for its technical realization for more than a year with good results at UFA in Berlin. Drawings were needed for the mechanical realization of the composition. Those consisted of long scrolls, or "scores," upon which the compositional development was shown in sequence and in such a way that the various stages in between were developed in a mechanical way. Still, these carefully worked out drawings in black, white, and gray, proved to be insufficiently exact, in spite of their precision. The

enormous enlargement by the lens in a field of light,
some 10 x 6 meters in size, betrays each weakness of the
human hand. And as it is not the hand anymore but the
spirit which makes art, and, as the new spirit demands
the greatest possible exactitude of expression, only the
machine in her extreme perfection can realize the
higher demands of the creating spirit. Thus, the need for
these very rigorously precise drawings demand that the
area—that is, the space—and the proportions of color of
these drawings be mechanically produced. Here again,
the helplessness of primitive handwork is revealed.
When one realizes that three-hundred drawings are
needed for a film "score," one can understand that ab-
stract film-making is an area where mechanical means
of drawing can render important services. Therefore,
the artists Richter-Eggeling are trying to find a solution
here. This will not be difficult as they are assisted by the
best talents in the technical and scientific field (for
example, by Einstein).[18]

It is easy to understand van Doesburg's admiration for
their work. His own painting used similar forms in interacting
dynamic relationships, full of visual tensions and potential
movement. In Richter's work in particular, van Doesburg
recognized a similarity to the spirit and forms of De Stijl, even
though Richter had previously been unacquainted with this
movement.

Richter's first film, *Rhythm 21*, was a kinetic composition
of rectangular forms of black, grey, and white. Perhaps more
than in any other avant-garde film, it uses the movie screen as
a direct substitute for the painter's canvas, as a framed rec-
tangular surface on which a kinetic organization of purely
plastic forms was composed. For, normally, the movie screen is
perceived as a kind of window, more or less arbitrarily cir-
cumscribed, and behind which an illusion of space appears; in
Rhythm 21, by contrast, it is a planar surface activated by the
forms upon it. Thus, its forms, like those of an abstract paint-
ing, seem to have no physical extension except on the screen,

Fig. 17. Hans Richter, frame enlargements from *Rhythm 21*, 1921.

nor do we sense their lateral extension beyond the limits of the screen as is usually the case in images created by camera vision. The film is a totally self-contained kinetic composition of pure plastic forms.

A number of sequences from *Rhythm 21*, illustrated here as figure 17, demonstrate some of its patterns of movement. In the opening passages, the screen is divided into large dynamically interacting areas of black and white. Thus, a black screen is closed over by two white rectangles sliding in from either side, a white screen splits in the middle to reveal a black background, a white square in the center of a black void advances and recedes, expanding and diminishing in size (fig. 17a, b). By eliminating image content and greatly simplifying

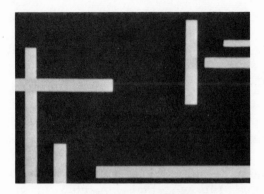

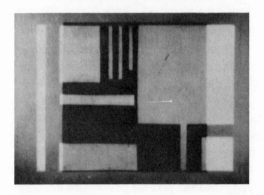

pictorial composition, Richter created a work of pure visual rhythm in which these large areas of light and dark fill the screen with movements of an almost mathematical precision and maximum graphic clarity.

One of the surprising elements in the opening exercises in *Rhythm 21,* unfortunately rather difficult to perceive from stills alone, is the complex spatial illusionism that derives from the dynamic interplay of contrasting areas of black and white. Which forms are foreground figures, which are background elements? At any given moment, these spatial relationships are purposefully ambiguous and constantly changing. To underscore such operations of "contrast-analogy" as Richter called them, pieces of negative film were also used in the film so that

their reversed values enriched the contrapuntal play of black and white.

The remaining sections of the film (Fig. 17c, d) use a larger number of design elements, all rectangular in configuration, and introduce dissolves of one composition into another. By expanding and diminishing the size of these individual forms, a pictorial composition of constant imbalance is created. As one form swells to the foreground, another sinks into the distance, others merge, interpenetrate, or overlap. No single form seems to move in isolated activity, for the compositional interdependence of these formal elements is far greater than in static paintings of similar design—the movements of each form seem inexorably linked to movement elsewhere on the screen. "Rhythm," as Richter has observed, "is not definite, regular succession in time or space, but the unity binding all parts into a whole." In these passages of *Rhythm 21,* such rhythms of kinetic imagery are perfect examples of Neo-Plasticism in motion.

Thus, in his first film, Richter created a work in which the content was essentially rhythm, the formal vocabulary was elemental geometry, the structural principle was the counterpoint of contrasting opposites, and in which space and time became interdependent. These problems occupied him for the next five years, and during this time he continued with scroll painting and found the means to make three more abstract films, *Rhythm 23* (1923), *Rhythm 25* (1925; no longer extant), and *Film Study* (1926).

Both Richter and Eggeling agreed that their original experiments at UFA were a disaster, but whereas Richter abandoned his initial ambition to animate his scroll drawing, *Preludium,* and instead used the screen itself to orchestrate the rhythm of his scroll, Eggeling, as he would, refused to be swayed from his original desire. With the help of a girl friend, Erna Niemeyer-Soupault (later the wife of the poet Philippe Soupault), who learned animation technique for the purpose, he succeeded in animating his second scroll drawing into the film, *Diagonal Symphony* (fig. 18).

Fig. 18. Viking Eggeling, *Diagonal Symphony*, drawing, 1921-23. Courtesy
Hans Richter

The film must be regarded as much a demonstration of a theory of art as a work of art in itself. This is by no means to disparage his accomplishment, which remains an impressive one, but only to point out the importance of theory as the underlying basis of his art. As we have seen already in his landscape painting of about 1916 (fig. 13), his theories, applied with certain brutal determination, had yielded a simplification and rearrangement of the forms of nature. Subsequently he abandoned nature altogether to abstract from it his own set of graphic notations which, when developed sequentially, formed the basis of his scroll drawings. Two major scroll drawings were executed by Eggeling, *Horizontal-Vertical Mass* (fig. 15), and *Diagonal Symphony*. There are indications that he may have attempted to film his *Horizontal-Vertical Mass*, but at any rate his only film known today is *Diagonal Symphony*.

The film is very much like a moving drawing. One motif follows another, each presented with the diagrammatic clarity of a blackboard drawing, all arranged along a diagonal axis. A pair of comb-like forms, first angular and then curved, perform a kind of mechanical dance, one growing, the other shrinking, each moving in perfect response to the gesture of the other. Or, in more complex compositions, curved and straight lines sprout and retract in a regular rhythm, one answering the other.

As in Eggeling's drawings, many of these exercises lead the eye through a development from simple to complex patterns of growth. One sequence, for instance, alternates the diagonal axis of a simple rectilinear form with clockwork regularity, and each time it flips back and forth, pointing first one way and then the other, an additional curved line grows from it, transforming and elaborating the original germ of the design.

Thus in *Diagonal Symphony*, the emphasis is on objectively analyzed movement rather than expressiveness, on the surface patterning of lines into clearly defined movements, controlled by a mechanical, almost metronomic tempo. The spatial complexities and ambiguities of Richter's film are almost non-existent here, even when, as in *Rhythm 21*, pieces of

negative film are inserted for contrapuntal effect. Above all, a sober clarity of rhythm articulation remains the most pronounced quality of the film and the basis of Adolf Behne's enthusiastic critical note published in 1921, probably the first mention of Eggeling's film in print:

> ... now for Viking Eggeling's film. It is only a fragment four or five minutes long. The effect was powerful, despite evidence of certain technical limitations. Here is a pure lesson in film as an independent art. It is characteristic that the film, a technical collaboration between Eggeling and Hans Richter, not only exists without musical accompaniment but quite rejects the need for one. A logical unfolding of abstract forms of geometric precision, this film is quite certainly an original work, one which is formed fully complete within itself. The artistic law of its movements appear in fullest clarity and techtonic strength, obvious to anyone of artistic sensitivity.[19]

Richter and Eggeling, working together, developed a language of purely abstract forms in which the implied movement of graphic gestures brought them face to face with the need for a kinetic art. Although their vocabulary of form was based on a rigorously simplified geometry, they were only vaguely aware of other experiments in formal purism such as Malevich's Suprematism, the De Stijl paintings of Mondrian and van Doesburg, or the work of Will Baumeister who, working independently in Stuttgart in 1920, also arrived at a similar geometricized art of rhythmically interrelated rectangular forms.

This widespread and independent subscription to a spartan art of elemental forms was more the result of the spirit of the times than the influence of artistic cross-influences or mere *Kunstwollen*. World War I had changed the culture of Europe overnight; life, and art too, was to start anew, from the very beginning, using the simplest means of expression. Cubism, it

was thought by these artists, had not "gone far enough"; it had pointed the way by emphasizing the structure of an autonomous image liberated from representational responsibilities, but it still retained a vestige of the cluttered surfaces of Impressionist painting. Friedrich Kiesler spoke for his generation when he explained their desire for formal purism: "[Art] had to be put on a diet. And the rectangular style did it."[20]

Likewise, the desire for a mobile art was very much "in the air," and film was the obvious means for its realization. The German critic, Bernhard Diebold, was probably unaware of Survage's attempts at a filmed art of free forms in movement when, in a newspaper article of 1916, he called for a new art based on the forms of modern art, the movement of film, and the structure of music:

> The film painted by an artist, on the other hand, deals freely with forms as if they appeared in nature itself. As in music, masculine and feminine forms dance and fight, come and go; their continuously moving forms appear to distort, always according to the prescribed ways of the most exact theories of all arts, through dissonance, variations, succeeding again to primeval form by divinely frozen organ notes and archaic cadences; thus the linear or painted storms, flames, winds, and waves all move about, all bound together in rhythmical order, against, over, and behind one another: battling, entangling, playing one another out, and, finally, dissolving or drowning the figuration of a red major element into the enemy blue minor.[21]

Diebold's notion of film-as-painted-music was a rather romanticized one, expressing the nineteenth-century yearning to give visible form to the emotional moods created by music, and based on the theory of synaesthetic correspondences, which presumed the existence of specific auditory and visual stimuli to elicit identical inner emotional states. Kandinsky's pre-war painting came under the spell of this theory, and of the

post-war film experiments that were actually realized, Walter Ruttmann's provided its clearest demonstrations.

Walter Ruttmann (1887–1941) studied as an architect, was self-taught as a painter, and was an accomplished violinist. All three of these arts were important sources for the series of short abstract films he produced in Germany during the years 1920 to 1925.

According to his friend Albrecht Hasselbach, who served with Ruttmann during World War I, Ruttmann executed many small water-colors at the front, and at this time, began to grow dissatisfied with the limitations inherent in the static medium of painting. A large abstract (fig. 19) was his last major work in this medium, and after its execution in 1918, he is reported to have said, "It makes no sense to paint any more. This painting must be set in motion."[22]

Whether apocryphal or not, the remark points to the representation of movement as a prime concern in Ruttmann's art. In this painting, forms are dissolved, their fragments set in motion—this clearly was Ruttmann's intention. A series of small curved and rectangular forms seem to have detached themselves from a solid centralized core. They lift and float, gliding upwards and backwards in space, propelled by the expanding arcs from below, their movements marked out by diagonal trajectories.

All this has rather little to do with Analytical Cubism. True, this painting, like the pre-war style of Léger and Delaunay, was composed of nervously repeated patches of chiaroscuro and fragments of hard-edged forms, but unlike their work, Ruttmann's does not explore the complexities of vision in motion through multiple viewpoints, but instead expresses visible motion through the suggestion of forms in movement. And to extend these implied patterns of movement into actual kinetics, Ruttmann also turned to film.

While Richter and Eggeling were working towards an animated art through film near Berlin, Ruttmann, in his studio-workshop outside Munich, totally independently, began work towards the same goal, but guided by a very different underlying aesthetic.

Fig. 19. Walter Ruttmann, *Composition, 1918*. Courtesy Albrecht Hasselbach

Fig. 20. Walter Ruttmann, *Design for an Abstract Film*, about 1923. From R. Kurtz, *Expressionismus und Film*, Berlin, 1926

Precisely how Ruttmann made his first film *Opus I* is not known. Apparently he constructed some sort of an animation table in which designs were painted on sheets of glass, then distorted and made to move by mirrors. Color, probably applied by stencil, was an important expressive ingredient of the film. A musical accompaniment was composed for the film by Max Butting, and it was first shown in Frankfurt, then soon after to a larger gathering in Berlin on April 27th, 1921.[23] *Opus I* seems to have perished long ago—most likely it existed only in a single hand-colored print—yet from Herman G. Scheffauer's vivid account of its premiere showing in Berlin we can visualize its original form:

> This visible symphony was recently performed in Berlin before a small group of artists, musicians, and film adepts. Expectancy and skepticism were in the air.
>
> The room faded away. Darkness. A few moments' impressive pause, as though to wash away the last clinging contacts with the external world. The machine began to purr, letters and titles flickered for a moment phosphorescently. Then—the opening notes of the symphony—iridescent atmospheres surcharged with an intense and vibrant light, burned and dissolved upon the screen. These served as backgrounds, melting and flowing into one another—dawnlight and sunburst and twilight, infinite reaches of space, and the caroling blue of morning or the dark saturated stillness of the night sky with a gray *terror vacui.*
>
> The separate notes and cadences of the symphony darted and floated into these luminous fields, as though the notes of the composition had shaken off their schematic disguises of black dots and lines and broken through the bars of the score and the sound waves of the instruments, and converted themselves into a river of flamboyant color . . .
>
> Some of the forms these colors assumed were already familiar to us in the restless paintings of the Cubists and expressionists—triangles, trapezoids, cubes,

circles, spirals, squares, disks, crescents, ellipses—all the usual fragmentary and activist geometry. But here the writhing, shifting, interlacing, interlocking, intersecting elements were fluent and alive, moving to the laws of a definite rhythm and harmony, obedient to an inherent will and impulse . . .

Bubbles and foams of color danced and wallowed across the screen, fountains and jets of light and shadow shot into infinity, waves—great thundering beach-combers of brilliant sound—came galloping on, heaving, palpitating, rising to a crescendo, throwing off a serpentine of pearls or a thin glittering spray that floated away like some high note, piercing, sustained, ecstatic. Globes and disks of harmonious colors came rolling into the field, some cannoning furiously against others, some buoyant as toy balloons, some kissing or repulsing or merging with one another like white or red blood corpuscles. Triangles sharp as splinters darted across the rushing torrent of forms. Clouds rolled up, spread, dissolved, vanished. Serpents of flame blazed through this pictured music, a colored echo, no doubt, of some dominating note.

From time to time, flickering and wavering in and out, over and under this revel of *Klangfarbe,* or sounding color, the *Leitmotif* appeared in playful, undulant lines, like lightning over a landscape or a golden thread through a tapestry. Then the color equivalents of the strong, clear finale poured themselves like a cataract upon the scene—masses of oblongs and squares fell crashingly, shower upon shower. The silent symphony was over.[24]

Scheffauer's flamboyant review serves to identify the major expressive characteristics of Ruttmann's *Opus I,* and to distinguish the film from the experiments of Richter and Eggeling. It was, quite literally, an exercise in visible music, fulfilling the nineteenth-century urge for a *Gesamtkunstwerk* by means of twentieth-century technology. In contrast to Eg-

geling's film, in which, as Behne remarked, "Any musical interpretation would only be a debasement," Ruttmann's film of pictured music depended upon a sensual fusion of image and sound. And whereas Richter and Eggeling used music as a structural model to analyze the movement through time and space, Ruttmann was more interested in translating the emotional overtones of music into moving colored images.

Ruttmann's films as well developed from his own painting with an undeniable clarity of logic. This is clearly evident from a comparison of his painting of 1918 already examined (fig. 19) with his designs for an abstract film, probably of about 1923 (fig. 20). Three stages of movement are charted here. In the uppermost, we see three distinct elements of design: vertical black bars at the left, an Albers-like series of squares in the background, and, at the right, a curved form with stripes along its bottom. The middle and lower designs of the sequence demonstrate how these forms evolve, mix and flow together: the black bars thicken and spread out towards the right, the background squares lift and float away, and the curve swells into a great wave which rolls across the screen, sliding behind the oncoming procession of black bars. Thus, the screen becomes a liberated canvas on which a play of curved and rectangular forms move freely about in patterns of movement already suggested by Ruttmann's painting.

Ruttmann produced three more abstract shorts which he christened *Opus II, III,* and *IV* (figs. 21 a, b, c) and these, too, were apparently colored in their original form. Only black and white prints seem to have survived, yet, even so, his sense of rhythm is clearly evident in the organic flow of forms across the screen. According to Victor Schamoni, these later films were more precisely structured in the orchestration of their movements and rhythm than *Opus I,* possibly reflecting the influence of Richter and Eggeling.

Ruttmann is best known today for his lyrical documentaries of city life, especially *Berlin, Symphonie einer Grossstadt,* his first and best such film. Just as the lyrical aesthetic evident in his painting had determined the stylistic content of Ruttmann's abstract films, so too, in *Berlin,* his feeling for the

Fig. 21. Walter Ruttmann, Four different sequences from his abstract films, *Opus II, III,* and *IV,* 1924-25. Courtesy Museum of Modern Art

liquid rhythms of gently undulating forms and his predilection for the visual play of curve against line inspired his choice of suitably expressive settings and objects in modern Berlin. His unpublished note on *Berlin* draws attention to the significance of his abstract films in its genesis: "During the long years of my development through abstractionism, I never lost the desire to build from living materials and to create a film symphony out of the myriad moving energies of a great city."[25] *Berlin* is full of images of modern machinery in motion. They are viewed, however, with Ruttmann's lyrical eye and express a fundamentally impressionistic aesthetic, in contrast to the so-called "machine aesthetic" of the 'twenties characterized by percussive rhythms and sharp-edged forms. This major component of twentieth-century art found perhaps its most complete expression in Fernand Léger's *Ballet mécanique*, the subject of the following chapter.

Chapter 4

Léger and the Film

"Le Cinéma, c'est l'âge de la machine. Le Théâtre, c'est l'âge du cheval."

—Léger

Fernand Léger's experimental film, *Ballet mécanique,* made in 1923–24, is the classic example of a fully developed painting aesthetic transposed into film by a modern artist of major significance. Whereas Richter and Eggeling came to film in order to solve problems of painting, to test their theories for the development of a new aesthetic of painting, Léger's film is an "end development." It does not represent the search for a new beginning, but rather the logical conclusion of a well-developed and clearly formulated style, his so-called mechanical period of 1919–1924.

This is why the film speaks with such clarity. It sprang directly from a long series of paintings in which Léger explored elements of formal design and thematic content that were perfectly suited for translation into film. Moreover, during this period Léger developed a clear understanding of the uniquely expressive potential of filmic language, so that when the opportunity arose to make his *Ballet mécanique,* the film had already been formed in his mind's eye.

Thus, broadly speaking, there are two major artistic ingredients in *Ballet mécanique*. One comes from Léger's painting, the other from film, or more accurately, his awareness of film at the time of his creative involvement with the medium. His painting of this period is already so well known that it need be dealt with only in a summary fashion.

Quite obviously, there are profound differences between the arts of painting and the cinema. Even when these two image-forming arts attempt to represent the same image—let us say, in the hypothetical case of a highly naturalistic painting of a still-life and the motionless cinematographic recording of precisely the same image, that is, two images as nearly identical as is mechanically possible—even here, we would hardly mistake one for the other. Why? Partly because of our awareness of the obvious differences in appearance due to means of formation, one painted on a planar surface, the other projected with a steady beam of light, partly because our perceptual equipment for the viewing of painting and film is drastically different, formed through an understanding of the aesthetic underlying these different arts of visual communication, and partly, perhaps most importantly, because we realize the filmic image has had an *a priori* existence while the painted one need not have. For a film (silent, and black and white), before it is a moving image of monochromatic tonal values projected on the screen and endowed with movements and rhythms, is first of all a photographic recording of the surface appearance of objects for the duration of its exposure to the camera.

There have been very few films that can properly be called "non-objective" in the sense that they contain no recognizable imagery. The first films by Richter, Ruttmann, and Eggeling are, but very few others in these decades. Léger never abandoned the subject in painting, and, significantly, he insisted that his *Ballet mécanique* was "objective, realistic, and in no way abstract." A brief examination of Léger's painting up to 1924 will identify those thematic elements that he carried over into film.

Léger's pre-war painting, like that of the other Cubists,

incorporated the most traditionally French subject matter. His earliest paintings were portrait heads and modest landscapes in a neo-impressionist style. The titles of his Cubist canvases of 1910–1913 sound like a list of works by a minor 19-century salon painter: *La couseuse, Nus dans la forêt, La femme couchée, Le passage à niveau, La femme en bleu,* and so forth. The artistic revolution of Cubism did not embrace a revolutionary content, and indeed there was nothing uniquely modern about the subject matter of Analytical Cubism. Twenty years after the celebrated academic master Albert Besnard (1849–1934) had covered the ceiling of the Salon des Sciences in the Hôtel de Ville with swirling allegories on the spirit of ultra-modern scientific discoveries, other painters like Picasso, Braque, and Léger were painting the most old-fashioned subjects imaginable—landscapes, still-lifes, portraits. The explanation for this apparent paradox touches at the very root of the meaning of Cubism. It was a revolution in the manner of seeing. The real content of the Cubist painting was an analysis of vision. The object, that is, what was seen, became virtually unimportant. To focus their attention on this new process of vision, the Cubists deliberately used a subject matter devoid of emotional or intellectually associative values, and hence the most neutral and familiar objects were chosen.

It was during the war, when Léger served with the artillery and the medical corps, that the aesthetic and formal preoccupations of Analytical Cubism no longer seemed to be a valid concern against the vivid realities of war. His experiences at the front were a "total revelation to me, as a man and as a painter . . . Once I bit into this reality, the object never left me." Léger executed very few paintings during the war years. Instead, the images of his environment, of men and machinery of war, were etched in his memory, to reappear as the content and structure of his later paintings and of his *Ballet mécanique.* "I never made drawings of cannons, I had them before my eyes. During the war I stood on solid ground. In the space of two months, I learned more than I had all my life."

Léger's first major post-war painting was *La Partie de Cartes* (Rijksmuseum Kröller-Müller, Otterlo: 1917), a work

Fig. 22. Fernand Léger, *Cylindres Colorés*, 1918 (Collection Louis Carré, Paris).

that stands between the past and the future of Léger's art. Typical of Analytical Cubism, its surface was a nervous and fluttering pattern of fragmented forms. Yet, here for the first time in Léger's art, the subject matter is contemporary and topical—"the first painting where I deliberately took my subject from the spirit of the times"—and expressed by forms which reenforce its meaning. A group of soldiers are playing cards, and like their machines of modern warfare, their bodies are made of gleaming metallic cylindrical forms. To capture this contemporary scene, to render it in forms of the modern mechanical world about him, was a trying experience for Léger. "How difficult that was! How many canvases I destroyed!" The struggle Léger underwent in the painting of *La Partie des Cartes* to reconcile his old manner of painting with his new passion for the expressive force of commonplace industrial objects forced him to decide between the old and the new, for

Fig. 23. Fernand Léger, Frame enlargement from *Ballet Mécanique*, 1924.

he found the loose and impressionistic style of his pre-war
Cubist canvases incapable of rendering this new subject mat-
ter. His difficulties with this pivotal painting proved to Léger
that a compromise solution was impossible, and so, as he later
recounted, "I said to myself, well I haven't kept a single trace.
Later, when I returned to Paris in 1918–19, I made the paintings
which have been called my 'mechanical period.' "

Once Léger broke with Analytical Cubism, the way lay
open for him to create bold and graphic designs in which a
sense of the physical presence of the object seen at close range
becomes increasingly important. In a painting of the following
year, *Cylindres colorés* (1918; Collection Louis Carré; fig. 22),
Léger shows us a floating arrangement of large cylindrical ob-
jects, diagonally disposed in space. These forms are perceived
as real objects, part of the physical world. It is an image formed
by Léger's new fascination with the beauty of the com-
monplace and machine-made object. The simplified
cylindrical forms surely refer to the artillery cannons which so
impressed him as a soldier, and of which he wrote, "the breech
of a cannon, the sun beating down, the rawness of the object
itself. That's where I was formed."

More and more, Léger's paintings were composed of
images representing "the rawness of the object itself," pic-
torially rendered with maxium graphic force. Chiaroscuro
disappears entirely, space is flattened, patterning of form
becomes geometrically ordered, edges tighten into crisp lines
of color demarcation. These drastic modifications in Léger's
style were enlisted towards his goal of celebrating the plastic
force and beauty of objects he found about him, objects taken
not from the diffuse chaos of nature but rather from the hard
industrial urban world of post-war Paris.

The key painting of this development is Léger's *The City*
(1919; Philadelphia Museum of Art; fig. 24). Rendered in the
high relief of flat color and bold silhouette are flashes of ad-
vertising and traffic signs, glimpses of anonymous pedestrians,
the hard-edged presence of urban architecture, all of this per-
meated with the sounds and incessant activity of city life.
Throughout this restless composition are a series of in-

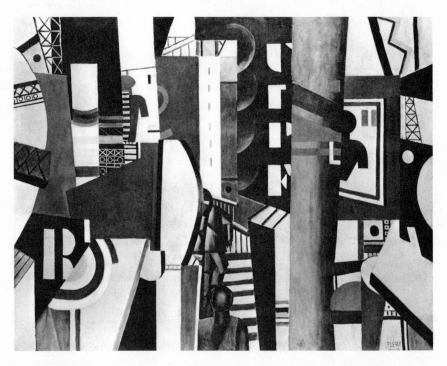

Fig. 24. Fernand Léger, *The City*, 1919. Courtesy Philadelphia Museum of Art: The A. E. Gallatin Collection

terlocked and linked discs recalling the wheels of traffic which keep the city alive. With *The City,* Léger has broken completely and decisively with his pre-war manner of painting. His vow of renouncing Analytical Cubism, "... eh, bien, je n'ai gardé aucune trace ...," was realized with one stroke in this single monumental composition.

The City is essentially a portrait of modern life in which Léger has used the Cubist visual vocabulary of sharp-edged flattened forms to create a simultaneous image of the many characteristic faces of the city. The constant shift of scale and viewpoint, the rush of images assaulting the eye simultaneously, the confusion of the senses, the disjointed space, the depersonalization of the individual, the vision in motion—all of these sensations that so incisively describe city life are realized by Léger here. The painting has a consciously modern note, for Léger was highly sensitive to the images and rhythms of urban life. He attempted to transpose those sensory impressions directly and immediately onto his canvas.

Léger announced his so-called "mechanical period" of 1919–24 in his painting *The City* as a kind of manifesto. After this grand painting, he embarked upon a long series of smaller and less ambitious paintings, generally classical in form, geometric in composition, and composed of machine-like elements. Whereas *The City* was a complex space-montage of many disjointed and fragmented images, these paintings usually focused on a single object or set of objects. Thus they have the character of individual studies in which various thematic and formal ideas presented in *The City* are worked out.

In 1924 Léger closed his "mechanical period" with another work that rivals *The City* in scope, invention, and visual richness, adding to it the additional dimension of actual movement. This was his film, *Le ballet mécanique.*

As we can see from the preceding examination of Léger's post-war painting, his art tended toward the conditions of film. But when, we must ask, did Léger actually commit himself to working with this new medium? What factors influenced this

decision? To answer these questions, one must first understand the critical attention that was given to film by Léger and his circle in the years during and after the war.

During wartime and other periods of social stress, frequency of film attendance goes up, even if, for obvious economic reasons, the production of film does not.[26] It was during World War I and immediately thereafter that so many of the French avant-garde artists and intellectuals discovered film. Their energetic spokesman, Guillaume Apollinaire, was so enthusiastic about film that when asked in an interview published in *SIC*, in 1916, for his opinion on the future of the *theater*, he replied:

> The question is too complicated, perhaps. Plays which take place in one room will become less important than before. Perhaps a more violent or more burlesque circus theatre will be born, also simpler in form. However, the great theatre which can produce a total dramaturgy is the cinema.[27]

Huntly Carter, an English journalist and traveler with special interests in the theater and film, who visited Paris during the war later recalled:

> French intellectuals and aesthetes were very eager to evolve an aesthetic of the Cinema in spite of the obvious fact that the Cinema was, at bottom, a mechanical toy which could never be dissociated from mechanics. It did not matter to them what the war conditions were, that for instance the Germans were but fifty miles off doing their best to persuade Big Bertha to reduce Paris to dust, the avance-guard were up and doing with their constant cry, "Now for the Cinema." Often I sat on one or other of the well-known café terraces, the Café Floré on the Boulevard St.-Germain, the Café Lilas at the corner of the Boul' Mich', the little Café Lapin l'Agile on the heights of Montmartre, while bad Bertha dropped her eggs and spoilt the scenery, human as well as architec-

tural. It was always in the company of enthusiasts, the
pick of the young painters were Picasso, Juan Gris, Fer-
nand Léger, Irene Lagut, Othon Friez, Derain, Braque,
Severini, Modigliani, Favory, and Herbin. Among the
sculptors were Archipenko, Chane Orloff. Among the
poets were Jean Cocteau, Blaise Cendrars, Henri Hertz,
Alexander Merceau, Paul Dermé, editor of "Nord-Sud,"
Max Jacob, Reverdy, and Albert Birot, editor of the
provocative "Sic." And till the time of his death after
returning home from the war, there was Guillaume
Apollinaire, the acknowledged leader of the Left to
whom one invariably went for news of all the "revolu-
tionary" movements. Finally, there were musicians and
composers, Erik Satie and I think, Darius Milhaud, and
others. To all these fell the self-imposed task of taking
the Cinema as an intellectual not emotional medium of
art expression, of discussing its conditions and pos-
sibilities, writing articles in little avance-guard sheets,
of founding little propaganda journals, and of realizing
ideas in out-of-the-way places what time the Censor
was not looking.[28]

After the war, film ideas were very much "in the air," for
the earlier undercurrent of fascination with this modern
medium had now swelled to the surface.[29] From the plethora of
post-war writings on film by painters and literary figures,
mention of a few titles will indicate how widespread was their
interest in the cinema.

For example, Margaret Anderson's *Little Review,* the
voice of American expatriate arts and letters in Europe,
frequently touched on film, with poetry and articles on film
appearing as early as 1914, and in 1924, Léger contributed a
note on his *Ballet mécanique,* of which more will be said later.
In almost every issue of *Le Crapouillot*[30] there appeared serious
writing on the film, and also in *L'Esprit Nouveau.*[31] The art
historian Elie Faure wrote enthusiastically in *L'Esprit
Nouveau* (1921) on Chaplin—"a poet, indeed a great poet, a
creator of myths, of symbols and ideas, the midwife of an

unknown world"—and by 1923 had published a series of essays on film, translated that year into English as *The Art of Cineplastics.* In *Broom,* references to film were numerous, from Léger's drawings of Chaplin to Moholy-Nagy's theorizing about light as a medium of plastic expression.

Not surprisingly, the Surrealists-to-be were fascinated by film: Louis Aragon's first poem, in 1918, was about Chaplin; Philippe Soupault's first writings on the film appeared the same year in *SIC;* and, in 1920, Paul Eluard contributed a poem to Picabia's *391* entitled "Ecoutez, Ecoutez, Ecoutez—Vitraux de bel avenir—Tout va bien dans tous les Cinémas." [32] Picabia as well produced a short article on film,[33] full of praise for the American movies, published in *Cinéa* in 1922. The painter and poet Georges Ribemont-Dessaignes composed a film scenario in 1920, *The Eighth Day of the Week,* a weird disjointed narrative more Surrealist than Dada in form and feeling.[34]

Other members of the Dada rebellion saw film as a mirror of the absurd. In Paris, Tristan Tzara's poem "Cinéma Calendrier du coeur abstrait" appeared in 1920 with illustrations by Arp. In New York, the Dada poet Else Baroness von Freytag-Lorinhoven, in her poem "Moving-Pictures and Prayer," 1919, unleashed a torrent of vivid cinematic images. In Berlin, Raoul Haussmann's cover to the first issue of *Der Dada,* 1919, was a photo-montage entitled *Synthetisches Cino der Malerei,* George Grosz made drawings of Chaplin, and John Heartfield composed collages full of veiled references to American movies and containing bits of film strips.[35] Man Ray, still in New York in 1919, revealed his fascination with the film through one of his major paintings of that year, *Admiration of the Orchestrelle for Cinematograph.* And, of course, in 1919, Hans Richter and Viking Eggeling had defected from Dada to develop a language of form that soon led them to film for its articulation. Yet most of these painters and poets, and others of the modern movement, frequently regarded the cinema as a source of poetic inspiration.

Almost all of the avant-garde *cinéastes* of the 'twenties, especially in Paris, came from painting and literature. Léger, Man Ray, Duchamp, Picabia, Gromaire, Survage, and other

painters made films or wrote about them. From literature even a larger number of avant-garde film-makers and film critics were recruited. René Clair, Jean Epstein, Germaine Dulac, Marcel L'Herbier, Louis Delluc, all were established as writers before they turned to film-making. Poets such as Robert Desnos, Blaise Cendrars, Ivan Goll, Philippe Soupault, Antonin Artaud, and Jean Cocteau wrote for and about the cinema. "The cinema," as Jean Epstein noted while making his first film in 1921, "saturates modern literature."

During the spring of 1919, Marcel Gromaire published an important series of articles, "Idées d'un peintre sur le cinéma," in *La Crapouillot.*[36] Although perhaps not a painter of first rank, Gromaire's thoughts on the film are nonetheless worth examining. With clarity and eloquence, he called for a creative alliance between modern painting and cinema.

Gromaire saw film as a kind of visual music, an art of moving imagery in which the expressive distortions of modern painting could form the basis for a new art of the film, an art of animated plasticity continually unfolding in orchestrated patterns of movement as planes are gathered, superimposed, opposed to each other, varied in scale and light values. The cinema, Gromaire asserted, was essentially modern in its free manipulation of time and unlimited in its possibilities. If its images had plastic value, a narrative story and commonplace realism would no longer be necessary, for any scene in life contains immense riches and can satisfy our need for an art more closely related to modern dynamism than painting. The eye of the camera can look into everything, can select isolated expressive details which speak with greater force than larger settings. And the techniques of animation, perhaps combined with photography, provide another promise of the film's potential. But what contemporary cinema lacks most of all is the powerful brain of some creator of images: the cinema, he concluded, is still awaiting its poet.

Five years later, Léger developed so many of these "idées d'un peintre sur le cinéma" in his *Ballet mécanique* that it is tempting to see them as a contributing factor to the formulation

of Léger's film. In any event, Gromaire's writings remain an impressive document of serious critical thought on film as modern art.

Two French poets were particularly sensitive to the presence of film and its evocative powers. They were Philippe Soupault and Blaise Cendrars.

Soupault wrote critical studies of film as early as 1918, and the same year his poem "Photographies Animées," obviously inspired by film, was published. His poem, "Cinéma Palace," written in 1920 and dedicated to Blaise Cendrars, celebrates the magically effortless manner in which thematically unrelated shots follow each other on the screen, the mystery of their meaning hanging suspended between the images:

> ... l'auto volée disparaît dans les nuages et l'amoureux transi s'est acheté un faux-col mais bientôt les portes clauquent ...

Countless other examples could be cited to demonstrate how strongly Soupault was under the influence of film. Fortunately, however, his own critical writings supply the most convincing proof. In 1923, he confessed how he and his friends "walked in the cold and deserted streets looking for an accident, a chance meeting, life." The movie-house, with its endless supply of American melodramas and adventure films, fulfilled this yearning as if designed to feed the poets' dreams. "We began to understand finally that the cinema was not a perfected mechancial toy, but the terrible and magnificent flag of life. The little dark halls where we sat became the arena of our laughter, our rage and our great expressions of pride." Soupault recognized in the film a powerful artistic force: "The influence of this new power made itself felt immediately. I thoroughly believe that all French poetry, which is always a little behind poetry, will yet learn to know the conditions imposed by the cinema." In 1927 the American film critic, Harry Alan Potamkin, wrote an article echoing Soupault's sentiments

with the assertion that, "the cinema in France has influenced French letters before it has influenced itself." Soupault, for whom art meant Surrealism, had to wait until 1930 when the cinema finally delivered a film which was consciously derived, through literature, from those earlier films he so admired. The film which completed this circuit was, of course, Buñuel and Dali's monumental *L'âge d'or,* a film born out of Surrealism, the movement which had been spawned, at least in part, by film a decade before.

Chapter 5

La Roue, Cendrars and Gance

If Soupault was a Surrealist spellbound by cinema, a poet whose automatic writing and free association of words attempted to reveal inner fantasies with the ease and vividness of film, Blaise Cendrars saw in the medium essentially a cataclysmic social force, a force in which the very spirit and symbol of modernity was embodied:

> And here comes Daguerre, a Frenchman, who invents photography. Fifty years later, the cinema was to come. Renewal! Renewal! The eternal Revolution. The latest scientific findings, world war, the concept of relativity, political convulsions, everything seems to indicate that we are on the road toward a new synthesis of the human spirit, toward a new humanity and that a new race of man will appear. Their language will be that of the cinema. Look! The magicians of silence are ready. The image is at the primitive source of emotion. Worn-out formulae have tried to conceal it. Now at last the healthy combat between white and black is going to begin on the screens of the world. The flood, the gates of the new language are open. The letters of the new alphabet jostle each other in their multitude. Everything becomes possible! Tomorrow's Gospel, The Spirit of Future Laws,

Scientific Drama, The Anticipatory Legend, The Vision
of the Fourth Dimension of Existence, all the In-
terferences. Look! The Revolution.[37]

Excepting possibly Apollinaire (who died in 1918) no other
poet was closer to the Paris painters in the 'teens and 'twenties.
At the very vortex of the modern movement in these years,
Cendrars was an intimate friend of Delaunay, Picasso, Chagall,
Braque, and Modigliani. In terms of personal friendship and
inner artistic affinities, he was, however, closest to Léger.

It is quite probable that Léger would never have made his
Ballet mécanique had it not been for Cendrars' infectious
enthusiasm for the cinema. Although the poet's name has never
been associated with the film, nor has Léger acknowledged that
it was Cendrars who inspired him to work with film, the
following account of their artistic and personal relationship
supports this conjecture.

Léger and Cendrars had been friends as early as 1912. They
met again, in 1916, outside Paris where they were both
recovering from war injuries. Léger had been gassed and
Cendrars' right hand, shattered by machine-gun fire, had been
amputated. For both the painter and the poet, the war had been
a profound experience—but even more spiritually than
physically. Léger's remark, "The war had been a tremendous
event for me. At the front there was a super poetic atmosphere
which thoroughly excited me. That's when I was formed," is
echoed by Cendrars: "The war marked me deeply. It's true . . .
since then, I've been a part of it." For both, the world had
changed overnight, drastically and irrevocably, and so too
their relation to the world as revealed by their art. They
realized immediately that their earlier work was obsolete and
ineffectual in the post-war modern world. Both sought, above
all, to capture the rhythmic pulse of the urban experience,
those same sensations that so impressed Ilya Ehrenburg when
he returned to the Paris he had known before the war:

What struck me was the mechanization of life, the speed
of movement, the advertisements in lights, the stream of

cars. Of course there were a hundred times fewer cars
then than now, there were no television sets, radios were
only just coming into use and in the evening no discor-
dant voices on different wavelengths poured out of open
windows into the street. But I felt that the rhythm of life
and its pitch were changing.[38]

Léger, in his painting, systematically rejected his previous
manner of painting and developed a new style, a new
vocabulary of form, color and rhythm to embody the spirit of
the "New Realism." Cendrars' poetry, too, followed the same
course. When he returned to Paris in 1917, dissatisfied with the
state of poetry which, he felt, "seemed to become the basis of a
spiritual misunderstanding and a mental confusion," Cendrars
turned to the vibrant images and the accelerated rhythms and
movements of mechanized city life, in short, "l'actualité . . .
seule source éternelle de la poésie." Since the end of 1917,
Cendrars had become increasingly absorbed in the cinema as
an expression of modern life, and under his this influence, his
poetry developed into a supple rhythm of successive images,
each one containing in a single shot, as it were, a separate and
self-contained statement. As in film it is the position or "mon-
tage" of these cellular verbal units that creates the meaning of
the poem and its pulsating rhythm. His poem "Construction,"
written in 1919 and dedicated to Léger is typical:

> . . . Et voici
> La peinture devient cette chose énorme qui bouge
> La roue
> La vie
> La machine
> L'âme humaine. . . .[39]

The same year Cendrars composed a short essay on Léger
and his art. Here, Cendrars praises the extraordinary sensi-
tivity of Léger's eye in its ability to seize upon commonplace
objects of the modern world and, by contrasting their form and
manipulating their scale, recreate from them a new image of

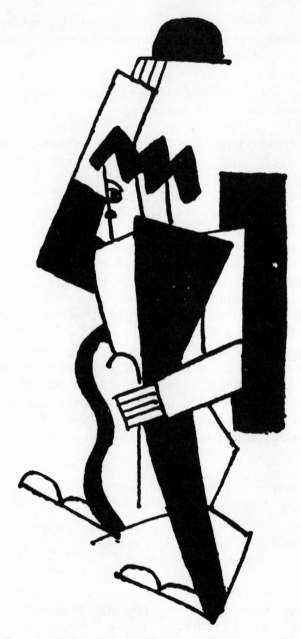

Fig. 25. Fernand Léger, *Drawing of Charlie Chaplin*, 1920. From Yvan Goll,
Die Kinodichtung, Dresden and Berlin, 1920

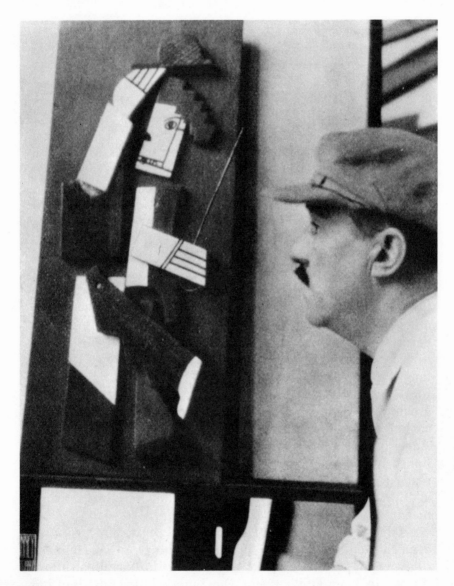

Fig. 26. Fernand Léger and his wooden model of Charlie Chaplin, 1920-23.
From *Der Querschnitt*, IX, no. 8, Aug., 1929

"la création et l'activité humaine." Cendrars' essay, written almost five years before Ballet mécanique, could almost be taken as a montage list for Léger's film:

> His eyes goes from the toilet bowl to the zeppelin, from the caterpillar to the little spring of a latch. A traffic light. A sign. A poster. Squadrons of airplaines, convoys of trucks, Pan pipes as cannons, American cars, Malaysian daggers, English preserves, international soldiers, German chemicals, and the breech of a 75mm artillery all have an impressive unity. Everything is contrast.[40]

Still another event of 1919 stands to document the friendship of Léger and Cendrars, the artistic sympathies they mutually shared, and their common belief that the lens of the motion-picture camera was the eye of the truly modern man. Cendrars had written a short novel, La Fin du Monde—filmée par l'Ange N.-D., which Léger illustrated with a series of color lithographs.[41] It is difficult, however, to understand this book as a novel (un roman, as Cendrars calls it). As its title implies, it describes the end of the world, not as it happens, but as it is filmed, as recorded by the mobile eye of the camera. Hence its language is synoptic and graphically descriptive, its syntactic form that of a movie-scenario. Many of the scenes—and they are numbered as in a film script—are described in only a single sentence; some of them were, in fact, filmed later, not by the Angel of Notre-Dame, but by Léger in his Ballet mécanique. For example, scene number forty-one from La Fin du Monde reads in its entirety: "A dark eye closes on all that was," exactly as Kiki's enormous single eye performs in Léger's Ballet mécanique.

Film held a certain fascination for Léger, and probably even exerted a discernible influence on his painting. He made drawings of Charlie Chaplin executed in 1920 as illustrations (fig. 25) to Yvan Goll's poem, Die Kinodichtung.[42] Sadoul has suggested that Léger intended to create an animated cartoon on

the basis of these drawings. Such a film was apparently never made, unless perhaps Sadoul had in mind the introduction to *Ballet mécanique* in which a cubistic figure of Chaplin appears. This section of *Ballet mécanique* is not, properly speaking, an animated cartoon but simply the filmic recording of the movements of this flat wooden marionette (fig. 26) which Léger had fashioned after his drawings for Goll's *Kinodichtung*.

But to return to Léger and his association with Cendrars—the assertion made earlier that Cendrars provided the stimulus for Léger's creation of *Ballet mécanique* is not yet justified. Up to this point, Léger's activities involving film constitute no more than a flirtation with the medium—but as Cendrars became increasingly more involved with film, so too did his friend Léger.

Cendrars' first work in film came through his association with Abel Gance, a director whose early work in film should be introduced here for two reasons. First of all, as we shall see, Léger became interested in film through *La Roue,* a major film of Gance, and secondly, the first film directed by Gance, *La Folie du Dr. Tube* (1915) is an important but little-known example of the many trick and fantasy films of the 'teens.

La Folie du Dr. Tube was considered too experimental by its producer, Louis Naplas, and was never commerically released. Its story is very simple. A mad scientist with a bulbous cranium named Dr. Tube discovers a magic potion that alters his vision. He and his youthful assistant drink it. Dr. Tube instantly falls unconscious, his face twitching spastically. Meanwhile, four young men and women wander into his laboratory, and Dr. Tube wakes up to find his field of vision weirdly distorted (fig. 27). Forms become grotesquely elongated, as if seen through the undulating mirrors of an amusement park. A dachshund grows impossibly long, his young visitors become almost unrecognizably stretched out of shape. Finally a cure is found and their eyesight is restored to normal. As the film ends, champagne and flowers are brought in to celebrate their liberation from this hallucinatory visual aberration.

La Folie du Dr. Tube belongs to a tradition of the fantastic

Fig. 27. Abel Gance, *La Folie du Dr. Tube*, 1915. Courtesy Cinémathèque Française

trick film of the pre-war period. Georges Méliès was the originator and the master of this form of film, and, even before his studio went bankrupt in 1913 from commercial mis-management, he had a host of followers. In France, the early trick films by Pathé, especially those with André Deed, the films of Ferdinand Zecca, Jean Durand, and Emil Cohl; in Spain, the films of Segundo de Chomón; and in America, J. Stewart Blackston, E. S. Porter and others, all used the medium in highly imaginative, or, with the hindsight of history, one could say proto-surrealist ways. These films were not interest-ed in recording reality for its own sake as in documentaries, nor in telling stories as in the dramatic film. Rather, they used film as a kind of magician's wand to conjure up images that could delight, astonish and bewilder their audiences. Unfor-tunately, relatively few of these films have survived. Unlike the

Fig. 28. Abel Gance, *J'accuse*, 1919. Courtesy Cinémathèque Française

larger, more ambitious and pretentious productions of the
purely dramatic film, they were not regarded as very elevated
works of art. And yet in their free experimentation with
camera techniques, in their flow of eerie inexplicable happen-
ings and wonderfully weird visual effects, they constituted an
undercurrent tradition which linked the studio-made fairy-
tales by Méliès with the post-war resurgence of the fantastic
film such as *Caligari* in Germany, and the Dada and Surrealist
films in France. This point should not be forgotten, for much of
the fantasy of Léger's *Ballet mécanique* has strong ties to this
period of early film.

Gance continued to experiment within a traditional for-
mat. His first major commercial success was *J'accuse,* a lengthy
and monumental anti-war film. Blaise Cendrars assisted Gance
in this production, working with him on the script and helping
also in the direction. The première of *J'accuse* was only a few
days after the armistice, in March of 1919. Some notion of its
bombastic and theatrically tragic overtones can be perceived
in a still from the final scene (fig. 28) in which the hero, once a
brilliant and sensitive young poet, now stands dazed and alone
after the holocaust, in a vast Tanguy-like landscape strewn
with countless bodies and crucifixes, his soul brutalized by the
hideousness of war, the pathetically haunting look in his eyes
indicting all humanity for this outrage.

Gance's next film, *La Roue,* was an even longer epic which
took two years to produce and several hours to project in its
entirety. After reading *Le Rail,* a romantic novel by Pierre
Hamp about life on the railroad, Gance became obsessed with
"la poésie des machines," and envisioned a film to celebrate the
power and drama of the locomotive. *La Roue* was made in
collaboration with Cendrars, with the poet also playing a role
in the film. Its story spans the entire life of a locomotive en-
gineer, and, for the most part, is permeated with a mawkish
nineteenth-century sentimentality. A young girl, rescued from
a train accident in which her parents are killed, is adopted by a
railroad engineer who takes her home and teaches her the joys
to be found in the railroad way of life. She soon learns to share
his profound romantic attachment to locomotives. But, alas,

because of their desperate financial straits, the girl, now blos-somed into lovely womanhood, marries not a poor-but-honest locomotive engineer but the wealthy manager of the railroad company. As times wears on, her foster father becomes half-crazed from his increasing obsession with locomotives and half-blinded when a steam boiler explodes in his face. In the fading years of his life, feeble, alone, and nearly blind, he can only find work operating a tiny narrow-gauge railway in the Alps. The film ends happily, in his tiny mountain cabin where the faithful adopted daughter returns to live with him and care for him.

Despite the syrupy and maudlin substance of this tale, the film contains moments that speak unmistakably of the post-war aesthetic of kaleidoscopic imagery and fascination with the forms of rhythms of modern machinery. Indeed, the film could only have been received by the public in one of two ways, depending on their awareness of modern art. The tradi-tionalists must have seen *La Roue* as a kind of old-fashioned nineteenth-century novel made into film with a few touches of "modernistic" abstract imagery to heighten dramatic moments. On the other hand, those in the audience with a deeper understanding of the post-war artistic sensibilities would have overlooked the sentimentality of the story, regarding it as an unfortunate but perhaps commercially necessary thematic justification for the real substance of the film, namely the cinematographic celebration of the modern machine aesthetic. Léger, of course, was one of those who embraced this second attitude towards *La Roue:*

> The cinema turned my head around. In 1923 I had some friends who were in film and I was so captivated by the movies that I had to give up painting. That began when I saw the closeups in *La Roue* of Abel Gance. Then I wanted to make a film at any cost and I made "Ballet mécanique."[43]

Undoubtedly the "coupains qui étaient dans le cinéma" of whom Léger speaks here were Blaise Cendrars and the film director Marcel L'Herbier.

Cendrars created those parts of *La Roue* that turned Léger's head. He worked as film editor on this production,[44] and, in this capacity, brought forth, in the beginning of the film in particular, a splendid montage that must have impressed and influenced Léger. Specifically, there are three short passages that speak of the energy and dynamism of modern machinery in motion.

The film opens with a close-up shot of a man's face (that of Abel Glance) on which is superimposed a constantly moving pattern of railroading images—endless ribbons of tracks slashing across the screen at great speed, dynamic shots of locomotives charging directly at the spectator, close-up shots of wheels and drive systems—in short, double exposures that are experienced both as the external field of vision, seen through the eyes of the man whose ghostly transparent face fills the screen, and, at the same time, as an inner psychological state, a flood of memories and mental sensations playing upon the age-old theme of "the road of life," or, in this case, "the railroad of life." Léger, in his *Ballet mécanique*, avoided such direct superimposition, a device he undoubtedly found too impressionistic in its general visual effect, but nonetheless, he developed in his film the underlying theme of this opening passage in *La Roue*—namely, the reaction of man to his mechanical environment. For instance, in two different scenes in *Ballet mécanique*, Léger shows us an enormous pair of eyes which slowly open in astonishment to view pieces of whirling machinery (appendix, nos. 180–187). These eyes were meant by Léger to be seen as reacting visually to the machinery they see, and indeed this sensation is effectively realized. Such moments in *Ballet mécanique* were intended to be understood as metaphors of vision, for Léger has explained how certain shots of his film, like these, were "used for the relation and reaction of the images which follow them."

There follows in *La Roue* a quick montage of shots that Léger must have seen with interest, so closely do they resemble his paintings (figs. 29 and 30) of this period. The images represent locomotive wheels and the mechanical elements of the drive system. They are seen in dramatically bold close-ups

that reveal these precise forms with maximum clarity. Above all, it is the movement of these mechanical elements, so difficult even to imagine from static photographs, that imbues these images with beauty and drama. Here, as the train gathers speed, at first slowly and heavily, then with increasing velocity, as the oscillating tie-rods dance faster and faster across the screen, as the wheels accelerate until their spokes dissolve into a halo of light, the image is transformed from an objective photographic rendering into a choreography of light. And here is the inspiration not only for Léger's *Ballet mécanique* but for another temporal work as well—in music. Arthur Honegger, when he was shown *La Roue,* responded to its powerful visual rhythms and from them composed his celebrated *Pacific 231.*[45]

This magnificent kinetic composition from *La Roue* is part of a tradition of machine-inspired art that extends forward and backward many decades from its focus in the 'twenties. It reflects the same sensibilities that regarded machinery, in addition to its meaning as technological accomplishment, as an object of plastic beauty, the same sensibilities that prompted the newest and most impressive pieces of machinery to be displayed at every *Exposition Universelle* since the first in 1855. Joris Ivens, the most important avant-garde film-maker in Holland, echoed the forms and rhythms of *La Roue* in his very first film, *The Bridge,* a short documentary made in 1927–28 on the railroad bridge over the Maas River in Rotterdam.

Finally, the next portion of this opening moment of *La Roue* must also have made its mark on Léger. The event depicted is the railroad accident mentioned previously in which the young girl's parents are killed. Cendrars recreates the shattering force of the train collision almost purely through film editing. The screen explodes with a torrential cascade of images—elements of locomotive machinery, tracks, smoke, signals, trees, quick glimpses of people, many totally unrecognizable shapes and forms, all rapidly intercut, interacting too fast for the eye to comprehend. Woven into this montage are shots of violent camera movement and even shots printed in negative, a technique almost unheard of at the time (although

Fig. 29. Fernand Léger, *Les Discs*, 1918 (Musée des Beaux-Arts de la Ville de Paris).

by strange coincidence, the first known use of a negative image also represented a locomotive, in a film of 1908, *The Ghost Train*). By this rapid alternation of disparate images, Cendrars generates a powerful visual impact, almost kinesthetic in its effect of dizzying disorientation. Such passages were not seen again in a commercial film until 1925, when Eisenstein first tested his techniques of rapid montage in *Strike* and perfected them in *Potemkin*.

Léger's *Ballet mécanique*—not a commercial film, we must remember—derives its major expressive force from precisely those devices of editing developed by Cendrars in this passage of *La Roue* just described. Quick cutting and powerfully contrasting imagery—this is the content of Léger's film. That is what creates its jarring rhythms that assault the eye with bursts of rapid fire imagery, as in such passages as the one (nos.

Fig. 30. Abel Gance, *La Roue*, 192-22. From *Cinéa-Ciné*, no. 83, April 15, 1927

137 and 138) where twenty-one different shots, none longer
than a quarter of a second in duration, bounce off the screen
like the sputtering blast of a machine gun. If such a rapid and
violent barrage of visual stimuli makes us uncomfortable, this
was Léger's intention, for, as he explained, "we persist up to
the point where the eye and spirit of the spectator will no
longer accept. We drain out of it every bit of its value as a
spectacle up to the moment when it becomes insupportable."

Before he tried his hand at film-making, Léger wrote an
interesting critical note on *La Roue*—"Essai critique sur la
valeur plastique du film d'Abel Gance, *La Roue.*" This essay
deserves attention, for it analyzes precisely those qualities of
film that were to form the substance of his *Ballet mécanique.*

La Roue, as Léger tells us, has three essential com-
ponents—the dramatic, the sentimental, and the plastic—of
which only the plastic presented innovations that interested
Léger. In the first part of the film in particular, plastic form
comes alive as the mechanical elements become the *"person-
nage principal, acteur principal"* (Léger's italics). The signal
innovation of *La Roue*, Léger found, was the discovery of a
new mode of vision. Through close-ups, moving and static
mechanical fragments, variations of rhythms, suggestions of
simultaneity, *un fait cinématographique* was created, rich
with significance for itself and for the future. And in *La Roue*,
Léger realized that film possessed a unique power of visual
expression. This was its power to direct and control the spec-
tator's vision, to make him see, by means of the close-up, ob-
jects which under normal circumstances, in his natural field of
vision, he would not even preceive. Moreover, since film is an
art of projected light, it presented to the eyes of the spectator,
not objects, but *spectacles:**

> The very projecting of an image qualifies the object so
> that it becomes a show. A carefully framed image is
> already improved by this very fact. Stick to this point of
> view. It is the pivot, the basis of this new art. Abel Gance

* French, meaning "sights" or "performances," not English, "eyeglasses."

felt it perfectly. He demonstrated it, he was the first to have imposed it on the public. You will see moving images presented as a tableau, in the center of the screen with a careful choice in the balancing of moving and static parts (contrast of effects); a stationary figure on a moving machine, a hand varied in contrast to a geometrical shape, disks, abstract forms, play of curves and straight lines (contrast of lines); dazzling, wonderful, a moving geometry to astonish you.[46]

La Roue was widely regarded as one of the most advanced commercial films of its time. From it, Abel Gance, its director, learned that "the subject of a film plays a lesser role, the eye and the lens are most important."[47] And indeed, in his next film, *Napoléon,* another huge epic two years in the making (1925-27), Gance further developed this tendency by placing the camera into the very heart of the action. When, for instance, in *Napoléon,* to make us experience in our own body the sensations of riding a horse, Gance strapped his camera onto the saddle and thereby duplicated the human visual response to this situation, he achieved perhaps the most extreme example of this subjective camera involvement. The field of vision recorded by his equestrian camera corresponded exactly to that of a mounted rider. On the screen, the horse's head and bridle held a fixed position while the landscape moved past, tilting and jerking in response to movements of the horse's gait. Elsewhere in the film he used radically subjective camera movements: the camera flies through the air from the point of view of a snowball thrown by the young Napoleon; it rocks back and forth over the French assembly as if during a storm when intercut with Napoleon's ship on a rough sea.

Léger's enthusiasm for *La Roue* was marred only by his annoyance at having to wait in suffering boredom for those isolated passages in which the railroading machinery became the *personnage principal.* "This mechanical element," he complained, "appears as the blows of projectors in a terrible, agonizingly long drama of relentless realism."[48] Others agreed. Another painter, Marcel Gromaire, noted that "in *La Roue,* by

Abel Gance, in the midst of the most appalling scenario, there
were wheels of a locomotive, signals, rails, possessing such
beauty." Ezra Pound's reaction was the same:

> Thanks, we presume, to Blaise Cendrars, there are
> interesting moments, and effects which belong, perhaps,
> only to the cinema. At least for the sake of argument we
> can admit that they are essentially cinematographic,
> and not a mere travesty and degradation of some other
> art. The bits of machinery, the varying speeds, the tricks
> of the reproducing machine are admirably exploited,
> according to pictorial concepts derived from contem-
> porary abstract painters ... These details are inter-
> polated in a story (of sorts); and the rest of the show
> remains the usual drivelling idiocy of the cinema sen-
> timent and St. Vitus.[49]

Pound used this critical appraisal of *La Roue* as a polemic
against *Caligari*. He noted that "one must dintinguish *La Roue*
from *Caligari*. *La Roue* is honest, and the 'art' portions frankly
in debt to contemporary art. *Caligari* cribbed its visual effect
[which] ... the inventors couldn't have thought of without the
anterior work of new artists." Cendrars, too, recognized
Caligari as a pseudo-modern work of art, as the commer-
cialization of an earlier avant-garde movement in painting. His
ten-count indictment of *Caligari* goes farther to explain his
intentions in making *La Roue* than they explain the failings of
Caligari:

1. Pictorial distortions are only tricks (a new modern
 convention)
2. Real characters in an unreal setting (nonsense)
3. The distortions are not optical and they do not
 depend upon the unique angle of the camera, nor on
 the lens, the aperture, or focus.
4. There is never any unity
5. Theatrical
6. Movement without rhythm
7. No purification of the art; all effects come from

techniques belonging to painting, music, or litera-
ture, etc. The camera plays no role.
8. Sentimental and not visual
9. Good pictures, nice lighting, suberb acting
10. Good box-office.[50]

Gance seems to have been convinced that the strength of
La Roue lay in those passages of brilliant machine imagery
which were edited by Cendrars and then sandwiched in
between the story line. The film was re-edited by lifting out
those passages, assembling them together, and disregarding the
rest. The long and sad life story of the locomotive engineer
went out the window, but the residue was as fresh and modern
as any experimental film ever made. This specially abbreviated
version is apparently no longer extant, although the entire film
is preserved at the Cinémathèque Française in Paris. It was
shown principally by *ciné-clubs*, those sometimes informal but
vital organizations that supported the entire avant-garde film
movement of the 'twenties. Probably the first public screening
of these semiabstract fragments from *La Roue* was organized
by a group called *Les Vendredis du Septième Art*. This was a
kind of programming committee of the pioneer *ciné-club*, the
Club des Amis du Septième Art (or, C.A.S.A.), of which Léger
was a member. They presented the film at their second meeting
on Thursday, April 25, 1924. This date falls right in the middle
of the period from October, 1923, to November, 1924, during
which *Ballet mécanique* must have been conceived and
completed.[51] Léger, of course, knew the feature-length version
of *La Roue* in 1922 when he wrote about its plastic value. The
presentation of these poetic mechanistic fragments by C.A.S.A.
in the spring of 1924 may well have been the catalyst to yield
the final form of *Ballet mécanique*. Besides, Léger had designed
a poster for *La Roue*, for which a sketch is preserved in the
Léger Museum in Biot. Clearly he had been more than an
interested, sympathetic viewer of this film; through his
friendship with Cendrars, his perceptive review of the film,
and his own minor contribution in the form of this poster,
Léger was intimately involved with *La Roue*.

Chapter 6

Léger, L'Herbier, and L'Inhumaine

If *La Roue* opened Léger's eyes to the filmic rhythms of
cutting and the expressive power of the close-up, it is through
his work in another film, *L'Inhumaine,* directed by Marcel
L'Herbier, that he first experimented with a second vital
ingredient of *Ballet mécanique:* Cubist imagery, pre-stylized
for recording on film (fig. 31).

Before we turn to an examination of *L'Inhumaine* and
Léger's role in its production, it is worth mentioning that both
films were heavily documented at the "Exposition de l'art dans
le Cinéma Français," held at the Musée Galliera in 1924. The
event, like the representation of the art of the film which
Canudo installed at the Salon d'Automne in 1922, stands as a
clear indication that film was increasingly regarded as a twen-
tieth-century art form.[52]

At the Musée Galliera exhibition, the most recent films of
the most important French directors—Epstein, Fescourt,
Delluc, L'Herbier, and Gance—were represented in various
ways, principally through the display of stills, but also with
costumes, props, and set designs in preparatory drawings,
models, or photographs, and the like. Gance's *La Roue* and
Marcel L'Herbier's *L'Inhumaine* were the stars of the show.
From *La Roue* there were photographs, film clips, Gance's
original manuscript, something listed in the catalogue under
"Décors" as "une locomotive et un disque pour le film *La*

Fig. 31. Fernand Léger standing in his set design for the laboratories in Marcel L'Herbier's film, *L'Inhumaine*, 1923. From R. Mallet-Stevens, *Le Décor au Cinéma*, Paris, 1928

Roue," undoubtedly a model although the "disque" is hard to identify, and, finally, posters for the film, perhaps the one designed by Léger. From *L'Inhumaine* there were photographs, costumes, as well as designs and models of the decor by the architect Robert Mallet-Stevens.[53] Léger's own remarkable sets for this film were apparently not represented. Nor is it known whether his contribution to *L'Inhumaine* was acknowledged the following year in L'Herbier's display at the "Exposition Internationale des Arts Décoratifs," that vast exhibition so successful in its almost instant global popularization of *le style moderne.*

Production on *L'Inhumaine* began in September, 1923, and it was released in the Spring of 1924, during which period, we should bear in mind, Léger had created his *Ballet mécanique.* In his contribution to L'Herbier's film can be seen many of the forms and images that are the stuff of Léger's own experimental essay on film-making.

Jacque Catelain, who took the leading male role in *L'Inhumaine,* has described Léger's work at the studio:

> Marcel L'Herbier asked Fernand Léger: "Make me two sets for my laboratories in 'L'Inhumaine.' " The next day the painter brought six watercolors showing the abstract volumes but no construction details. It was the representation of a single surface of a whole forest of mechanisms: streets like trees, cones like trunks, levers like branches. No floors, walls, or ceilings. Where does the frame go? Marcel stood there not saying a word. The next morning (what a surprise!), a man dressed like a mechanic brought strange pieces of wood, meticulously cut, to the studio; it was Fernand Léger. As a workman, he constructed his own vision of a laboratory with a saw, some nails, and his heart. Evidently he could only do it himself.[54]

It is easy to see why L'Herbier sought out Léger as one of the set designers for *L'Inhumaine.* From beginning to end, the film was infused with a spirit of deliberate modernism. Its

themes centered around internationalism in the arts and fascination with modern technology. Léger's Cubistic laboratories came to life in the final scene of the film, and to understand their function, the story of *L'Inhumaine* should be outlined briefly.

As the film begins, the credits are shown against a background of a Léger construction in motion. A wobbly circle spins eccentrically, long rods and rectangular forms pump back and forth in a motorized construction of cut-out wooden parts. Its composition is very similar to Léger's design for a poster for the film, now in the Musée Léger (fig. 32).

Then, we are introduced to Claire Lescot, the "inhuman one." She is a concert singer of formidable talent, but, alas, so highly civilized that she has lost all sense of humanity and humility. To amuse herself, she presides over an international

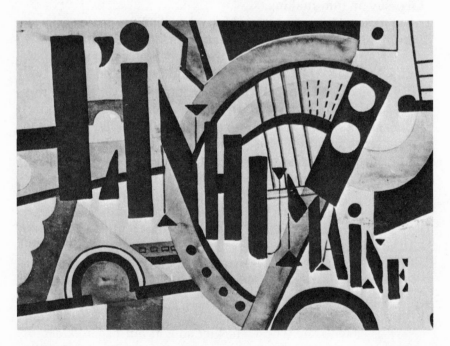

Fig. 32. Fernand Léger, Poster design for the film *L'Inhumaine*, 1923 (Musée Léger, Biot). Courtesy Musée Léger, Biot

salon of the arts where she dines nightly with world-famous artists, poets, diplomats, and maharajahs. Her servants all wear permanently smiling masks to avoid contaminating the elegant atmosphere with their commonness, and her banquet hall, designed by Alberto Cavalcanti—a Brazilian artist who later joined the avant-garde film movement with an impressionist documentary, *Rien que les heures*—contains a huge black and white marble platform surrounded by a moat of water (fig. 33), thus further emphasizing Clarie's withdrawal from the external world into her own rarefied realm of the arts.

There is, however, one member of Claire's salon who has not succumbed to the decadent frivolity of her way of life. He is, of course, a scientist, a brilliant young engineer named Einar Norsen, a humanist with boundless faith in a technologically determined future. He is, moreover, hopelessly in love with Claire. But she, cold-blooded and disinterested in love, rejects him by saying there is nothing to hold her interest in Paris—her cruel words literally hanging in the air like the suspended typography of *Caligari*, a film that influenced *L'Inhumaine* in other ways as well.[55] He tells her of his love, and she, in reply, coolly places a large knife in a sandwich and has it sent to his table.

So Norsen hatches a plot to break Claire of her inhumanity: he will fake suicide to test the depths of her cruelty, to determine if she will cancel her concerts to go into mourning for him. Norsen leaves the banquet hall and drives away at breakneck speed. This impassioned flight prompted L'Herbier to indulge in all sorts of visual effects to capture the sensations of a racing car hurtling into the night, its driver seething with emotion. We see superimpositions of Norsen's face over the road racing past, and then a quickened cascade of fragments—glimpses of road, engine, wheels, his face, and—possibly borrowed from *Entr'acte*, and later used in Vertov's *Man with a Movie Camera*, 1929—a split image of the road and the streaked pattern of overhead foliage, distorted by photographs at great speed. The end of this visual crescendo of rapid montage comes as Norsen's car races past a peasant woman in a donkey cart and plunges off the road into the sea.

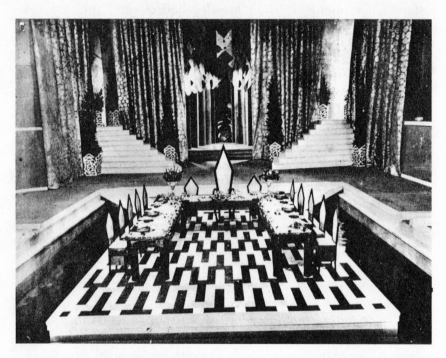

Fig. 33. Alberto Cavalcanti, Set design for *L'Inhumaine*, 1923. From R. Mallet-Stevens, *Le Décor au Cinema*, Paris, 1928

The terrified woman hurries to Claire's ultra-modern house, parks her donkey cart outside, and rushes in to report the tragedy. Claire is distressed at the news of Norsen's apparent death, but nonetheless eventually decides not to cancel her concert. This display of callous indifference to the memory of her dead friend precipitates a scandal. At the opening concert in the Théâtre des Champs-Elysées, the auditorium is packed, emotions are running high, and, as she starts to sing, a riot breaks out between those supporting her excellence as an artist and those condemning her behavior as a person.

After the performance, a stranger comes to her dressing room and asks her to come to the morgue to identify the body of Norsen. Left alone with his corpse, this heartless woman finally experiences "truly human agony and compassion," as the title informs us. Suddenly, the walls slide apart and Norsen appears—his "corpse" had been a dummy.

Claire, now reborn with the ability to love, showers her attention on Norsen, who invites her to his home where his laboratory is located. He lives, predictably enough, in a house of the most up-to-date style, like Claire's, designed by Mallet-Stevens[56] with heavy, if somewhat superficial, borrowings from the De Stijl experiments of J. J. P. Oud or Georges Vantongerloo.

In his laboratory, she is shown the marvels of science that Norsen has created. When, for instance, he switches on a microphone and asks her to sing, there miraculously appears on a screen, in televised image, the rapturous faces of primitive Africans, then Indians, as they are seen listening to Claire's voice.

But sadly, Claire is plagued by the evil ways of her past. An old lover, a mysterious Near-Eastern prince, is insanely jealous of her new love for Norsen and his technological wizardry, and takes revenge by planting a poisonous snake in a gift bouquet of flowers for Claire. She is fatally bitten, and arrives dying at Norsen's laboratory. He alone has a machine that can save her.

Claire's limp body is placed on a monumental platform of massive blocks. To one side is a steep flight of stairs, and

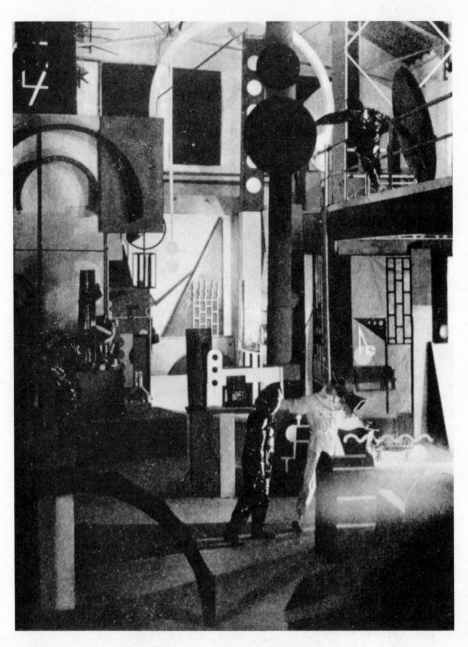

Fig. 34. *L'Inhumaine*, directed by Marcel L'Herbier, 1923. From *Bulletin de l'Effort Moderne*, no. 11, Jan., 1925

symmetrically placed on either side are blockish lighting fixtures that cast beams of light along the walls in zig-zag patterns. A number of vertical tensile cables create the illusion of a shaft of light falling on the body of Claire Lescot.

Then, with her body securely positioned for the experiment, Norsen goes into his laboratory to set his miraculous machinery in motion. The laboratory, as described earlier in the quote by Jacque Catelain (who, in the film, plays Einar Norsen), is a veritable mechanical forest, a labyrinthine space filled with so many geometric elements, growing from the floor, suspended from above, all of bold simplified forms in contrasting black and white, that a precise reading of the pictorial space is impossible (fig. 34).

A door opens to reveal Norsen's newest and most daring invention, a device to revive the dead, consisting principally of three huge shiny discs crossed by bent metal rods. It hovers in space, rotates, and vibrates, while beams of light play upon its forms. Photographed in close-up, this constructed composition fills the screen completely, thus transforming it into a moving Cubist image (fig. 35). Léger's paintings of a few years later (fig. 36) are remarkably close to these filmic images.

"Danger de Mort"—a sign flashes on as Norsen adjusts the controls at the switchboard of his machine. Technicians dart about, their shiny black boiler suits glistening amongst the clean geometry of the scientific equipment. Norsen, distinguished by his white rubber suit, runs here and there flicking switches, turning knobs, reading dials. Lights blink on and off. Objects spin through the air. Bodily movements occur at lightning speed. In rapid-fire cutting, as if the camera were suddenly thrust inside of a pinball machine, the screen crackles with visual activity.

The machine works. Claire opens her eyes, brought back from the dead. Instantly in good health again, she is no longer inhuman in spirit, and the film ends with her declaration of undying love for all humanity.

L'Inhumaine is, of course, something of a science-fiction film. In Italy it was billed as *Futurismo—Un Dramme Passionale nell'anno 1950,* and in New York, where it was first

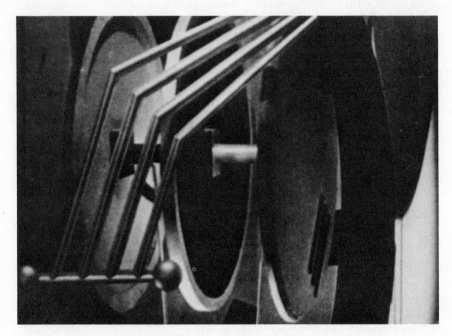

Fig. 35. Frame enlargement from *L'Humaine*, 1923.

shown on March 14, 1926 (together with *Ballet mécanique*), as *The New Enchantment*. Léger's laboratories in *L'Inhumaine* are closely related to two other experiments in "science-fiction" art of the twenties: Friedrich Kiesler's decor for the utopian drama by Karel Capeck, *W. U. R.* (for Werstand Universal Robots), and Otto Hunte's designs for Fritz Lang's well-known film of 1927, *Metropolis*—and both deserve mention, for Kiesler's represents a probable influence on Léger's designs for *L'Inhumaine* and Lang's film seems to have been influenced, in turn, by Léger.

Léger almost certainly would have known Kiesler's set design for *W. U. R.*, if not through his friendship with him then from the photograph of the design published in *Querschnitt* in

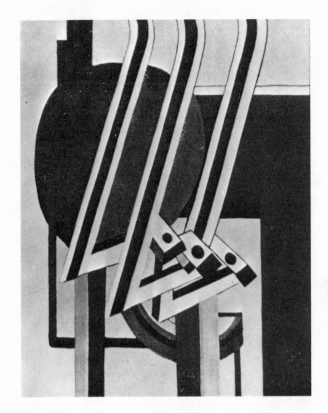

Fig. 36. Fernand Léger, *Contrastes des Forms*, 1924.

the summer of 1923, shortly before Léger's work for *L'Inhumaine*. That he was familiar with this German art periodical is most certain; Léger's important article, "L'Esthétique de la Machine," was published in *Querschnitt*, in 1923, even before it appeared in the Parisian *Bulletin de l'Effort Moderne*. The editor of *Querschnitt*, Alfred Flechtheim, was particularly partial to French art and in 1928 installed a major exhibition of Léger's paintings in his gallery.

The master control panel of Norsen's revivification apparatus in *L'Inhumaine*, like Kiesler's backdrop for the first act of *W. U. R.* (fig. 37), was composed of multiple discs and panels connected by rods, arcs, and levers. The general similarity in design is immediately obvious. Light bulbs were all over. In the

film, these elements come alive with movement. Discs rotate or swing back and forth, lights flash on and off, mechanical arms bob up and down.

Kiesler's design, during a performance of the play, was equally dynamic. Flashing lights, mechanically moving parts, even sirens were part of the show. His own description explains how this astonishing construction functioned:

> Excuse me, this is what I did: The first attempt at a electro-mechanical stage. The frozen picture is brought to life. The stage is active, engaged. The still-life comes alive. The means of enlivenment are: movement of lines, shrill contrast of colors. Transitions of surfaces in relief into three-dimensional man (actor). Play of moving colored light and spotlights on the stage. Rhythmically accented, the speech and movement of the actor co-ordinated. TEMPO. To the left, a huge iris diaphragm, one and a half meters across. Material: sheet metal. The iris slowly opens: the film projector rattles and throws a film image onto the circle. Suddenly, it is over and the iris closes. To the right, a Tanagra-Apparat is built into the set. It turns on and off. The director controls the anteroom in the mirrored image of the apparatus. The keyboard operator at the desk organizes his commands. The seismograph in the middle rocks fitfully forward. The turbine control in lower middle rotates uninterrupt-edly. The production tabulator leaps forward. Work sirens go off. Megaphones shout orders, give answers.[57]

This vivid description of Kiesler's piece of set design in operation corresponds closely to the intense electrical and mechanical activity that pulsates from the screen during the final scene of *L'Inhumaine*. The film was additionally enlivened by dynamics of camera vision, through cutting and close-ups, but nonetheless, the images and rhythms must have been essentially the same.

One of Kiesler's most ingenious inventions here was the circular movie screen. It was covered by an iris diaphragm that

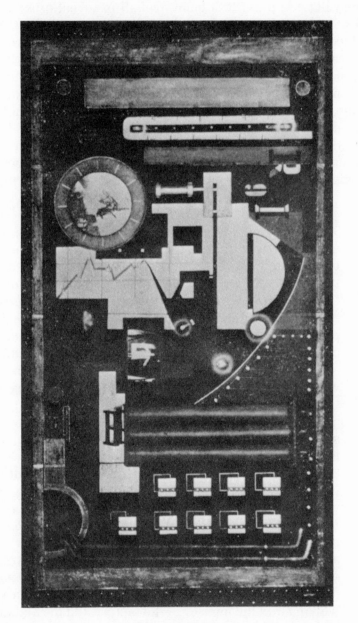

Fig. 37. Friedrich Kiesler, Set design for the play *W.U.R.*, performed in Berlin, 1922. From *Der Querschnitt*, III, nos. 1-2, 1923

opened like the pupil of a giant eyeball to reveal quick frag-
ments of film projected from behind. The same effect was
produced by what Kiesler calls here a *"Tanagra-Apparat."* [58]
This refers to the small rectangular screen, similar to a
television set and positioned approximately in the middle of
his design. It was actually a small mirror set at a right angle,
like the top of an oversized periscope, and aligned with another
larger mirror, off stage, about ten feet away. Here, hidden from
the audience, actors would perform, and their image, greatly
reduced in size, would appear in the small mirror on stage.

Kiesler added several interesting details in a recent inter-
view:

> This *R. U. R.* [its English title] play was my occasion to
> use for the first time in a theater a motion picture instead
> of a painted backdrop, and also television in the sense
> that I had a big, square panel window in the middle of
> the stage drop which could be opened by remote con-
> trol. When the director of the human factory in the play
> pushed a button at his desk, the panel opened and the
> audience saw two human beings reflected from a mirror
> arrangement backstage. The actors appeared in this
> window as a foot-and-a-half tall, casually moving and
> talking, heard through a hidden loud-speaker. It was
> quite an illusion, because a minute later you saw the
> same actors appear on stage in full size. There was,
> inevitably, a burst of applause at this moment. Then
> there was another innovation, namely a huge diaphragm
> in the back of the stage. When the director of the factory
> wanted to demonstrate to visitors how modern his robot
> factory was, he opened a diaphragm, which disclosed a
> moving picture projected from the back of the stage onto
> a circular screen, and you could see the interior of an
> enormous factory with workers walking busily back
> and forth. This was an illusion, since the camera was
> walking into the interior of the factory and the audience
> had the impression that the actors on the stage walked
> into the perspective of the moving picture, too. I men-

tion it only because these new devices to present the interplay of reality and illusion brought many artists to the theater.[59]

Both of these image-forming devices in Kiesler's design were symptomatic of an early twentieth-century desire to submit nature to an electronically manipulated, finger-tip control, to extract, as it were, a pictorial image from the natural world and to frame it in a master control panel. Precisely the same urge moved Norsen, in *L'Inhumaine,* to invent his fantastic videoscope machines, designed of course by Léger, that could instantly produce an image of any scene on the globe at the flick of a switch. And by 1927, in *Metropolis,* Fritz Lang's film of the city of the future, the television apparatus had become a standard piece of science-fiction equipment.

Lang's use of videoscope or television in *Metropolis* can hardly be attributed to the influence of *L'Inhumaine*—the invention of television dates from 1921 and by mid-decade was firmly fixed in the public mind as a promise of things to come—yet, in *Metropolis,* the larger complex of futuristic technological fantasies were quite possibly modeled after Léger's sets in *L'Inhumaine.* Specifically, Lang's *Herzmaschine,* the giant control panel that regulated the electronic pulse of a totally automated underground city inhabited, as in *W. U. R.,* by subhuman creatures who in the end revolt in an orgy of destruction—it is this machine erputing at the conclusion in a dazzling display of movement and light that is so like the feverish activities of Léger's laboratories at the end of *L'Inhumaine.* The similarity between these two passages of film is based not on formal, or static, design, but rather on similar patterns of movement and light. The exploding machinery in *Metropolis* is like the operation of Léger's laboratories in *L'Inhumaine*—at Wagnerian scale. As one French critic of the German film observed, *Metropolis* is *L'Inhumaine* . . . the same laboratory, only *Kolossal!"*

The riot scene during Claire's concert merits further attention. It is a fascinating document of modern art, not only for film, but for painting, literature, and music as well, and, in a

curiously indirect way, may even have been responsible for Léger's decision to make his *Ballet mécanique*. The following account of the production of *L'Inhumaine* is necessary to justify this odd claim.

The role of Claire Lescot was taken by Georgette Leblanc, a former wife of Maurice Maeterlinck and an accomplished concert singer. In the summer of 1923 after returning from New York, she had approached L'Herbier with the idea of making the film. He turned her idea into a script for a film to be called *La femme de glace*. But she considered her role too caricatured, and in addition, thought the film's chances for commercial success, especially in the United States, would be enhanced if it presented a synthesis of the most up-to-date creative work in all aspects of French art. L'Herbier agreed, changed the script and its title to *L'Inhumaine,* and got Darius Milhaud to write a musical score, and, for set design, Léger and Mallet-Stevens.

But L'Herbier had overextended himself. He fell seriously behind in the production schedule for the film, so that by the end of September, 1923, the key scene of Claire's concert had not been shot. On October 10th she was booked to return to New York for a concert engagement. L'Herbier's problem, quite obviously, was how to stage a full-scale riot in a major Parisian theater—with less than two weeks notice. He spoke to Margaret Anderson, editor of the influential *Little Review,* and she arranged to have a concert held on October 4th at the Théâtre des Champs-Elysées for George Antheil—if he agreed to play his most radical compositions, the ones, she added, that had caused his concert audiences to riot in Berlin. Antheil agreed, and on the day of his concert, but without his knowledge, L'Herbier installed ten hidden cameras throughout the theater.

The plan worked. *Le Tout-Paris* attended the concert, and while L'Herbier's secret cameras consumed some three-thousand meters of film, the audience reacted to the savage dissonances of Antheil's music with outrageous indignation or unchecked enthusiasm. The shots of the riot that were edited into *L'Inhumaine* do have a curious documentary quality

about them, and they prove Antheil's description of the actual event to be no exaggeration:

> I now plunged into my "Mechanisms." Then bedlam really did break loose. People now punched one another freely. Nobody remained in his seat. One wave of persons seemed about to break over the other wave. That's the way a riot commences, one wave over the other. People were fighting in the aisles, yelling, clapping, hooting! Pandemonium!
>
> I suddenly heard Satie's shrill voice saying, "Quel precision! Quel precision. Bravo! Bravo!" and he kept clapping his little gloved hands. Milhaud now was clapping, definitely clapping.
>
> By this time some people in the galleries were pulling up the seats and dropping them down into the orchestra; the police entered, and any number of surrealists, society personages, and people of all descriptions were arrested.
>
> I finished the "Mechanisms" as calm as a cucumber.
>
> Paris hadn't had such a good time since the premiere of Stravinsky's "Sacre du Printemps." [60]

Thus, in the film (according to Antheil), rioting vigorously while Claire Lescot is singing, can be seen Erik Satie, Darius Milhaud, James Joyce, Picasso, Man Ray, Ezra Pound, the Prince of Monaco, members of the Surrealist group, and Les Six. For Antheil, the evening was a succès du scandale. Overnight, and with L'Herbier's unsuspected collaboration, Antheil's musical future was assured.

Chapter 7

Ballet Mécanique

After the success of the concert for *L'Inhumaine,* Antheil laid plans for his next move:

> A few days later I announced to the press that I was working on a new piece, to be called "Ballet mécanique." I said that I also sought a motion-picture accompaniment to this piece. The newspapers and art magazines seemed only too happy to publish this request, which interested a young American cameraman, Dudley Murphy. He had really been flushed by Ezra Pound, who convinced him.
>
> Murphy said that he would make the movie, providing the French painter Fernand Léger consented to collaborate.
>
> Léger did.[61]

Another anecdote about the origin of *Ballet mécanique* comes from Man Ray's memoirs, to which Man Ray has recently added that a few of the exterior shots he mentions here are in the final version of the film:

One day a tall young man appeared with his beautiful blond wife, and introduced himself as a cameraman from Hollywood. His wife, Katherine, had been the oldest pupil at the Elizabeth Duncan Dance School, where my step-daughter Esther had been the youngest. Dudley Murphy said some very flattering things about my work and suggested we do a film together. He had all the professional material, he said; with my ideas and his technique something new could be produced. We became quite friendly, spent a few days together discussing subject matter—I insisted on my Dada approach if we were to work together, to which he readily agreed after I had explained it at some length. We took some walks together, I bringing out my little camera and shooting a few scenes without any attempt at careful choice of people or setting, emphasizing the idea of improvisation. For the more tricky effects we planned indoors, Dudley set up an old Pathé camera on its tripod, the kind used in the comic shorts of the day. He showed me some complicated lenses that could deform and multiply images, which we'd use for portraits and close-ups. The camera remained standing in my studio for a few days, which annoyed me, as I never liked to have my instruments in view. They were generally put away until used, or discreetly shoved into a corner under a cloth. When Dudley appeared again, he announced that he was ready to go to work and would I purchase the film. I was surprised, thinking this was included with his technical equipment—that I was to supply the ideas only. He packed up his camera, took it over to the painter Léger's studio, explaining that he himself had no money and that the painter had agreed to finance the film. I made no objection, was glad to see the black box go, and relieved that I hadn't gotten involved in a cooperative enterprise. And that is how Dudley realized the *Ballet mécanique,* which had a certain success, with Léger's name.[62]

It is difficult, and perhaps pointless, to attempt to sort out the respective contributions of Léger and Dudley Murphy to *Ballet mécanique*. Because of Léger's greater fame, and because the film is so obviously related to his painted *oeuvre,* the creative contribution of Murphy is difficult to see, unless it be purely technical. Murphy had previously made a number of films, among them an interesting experimental short called *Danse Macabre* with Adolf Bolm, Ruth Page, and Olin Howland dancing to the music of Camille St.-Saëns; the film is utterly different from *Ballet mécanique,* full of gothic gloom with touches of German Expressionism.[63] Henri Langlois nonetheless believes Murphy's hand in *Ballet mécanique* was considerable, particularly in the editing where Léger would have had no practical experience.

Both Léger and Murphy have claimed they worked closely with each other on the film. Léger has stated flatly, "I made it in close collaboration with Dudley Murphy," while Murphy has said, "I was the only film-maker and I photographed and made [it] in collaboration with Léger . . . I did the photography, and with Léger, the editing."[64]

There are three written documents essential to an understanding of *Ballet mécanique:* 1) Léger's preparatory notes and sketches, 2) a short article by Léger on the film, presumably written just after the film was completed and first published in the catalogue to Friedrich Kiesler's *Ausstellung neuer Theatertechnik,* in the autumn of 1924, and 3) another note on the film by Léger, published posthumously, "Autour de *Ballet mécanique,*" of uncertain date, but probably at least several years after Léger had made his film.

Of these, the last two are quoted extensively in the following discussion of Léger's film and are helpful as *a posteriori* evaluations by Léger of his accomplishment. His unpublished preparatory notes and sketches, on the other hand, are of particular interest because they reveal Léger's first thought for *Ballet mécanique.* They consist of four sheets, two of them with line drawings in pen and ink, and two with written notes, sketches, and diagrams, also in pen and ink and

Fig. 38. Fernand Léger, Preparatory sketches for *Ballet Mécanique*, pen and
ink, 1923-24 (Collection Pierre Alichinsky, Paris). Courtesy Pierre Alichinsky

with a few additional remarks in pencil (figs. 38 to 45). The notes are quick jottings, short enough to be quoted in full:

Sheet One, first page:

> A little ballerina appears, light, graceful (white tights, sharply set off by black background)
> Engulfed by mechanical elements.
> Transpositions of pictures.
>
> Constructed objects.
> Introduction of typewriters.
> Fountain pen.
> (Use of advertisements), etc.
>
> All of this in constant opposition of violent contrasts.
> Projection of a whole page of newspaper's advertisements.
>
> Pendulum with silhouetted figure [with diagram of figure]

Fig. 39. Fernand Léger, Preparatory sketch for *Ballet Mécanique*, pen and ink,
1923-24 (Collection Pierre Alichinsky, Paris). Courtesy Pierre Alichinsky

Sheet One, second page:

Divide the screen into equal sections, and project the same picture—absolutely similar—in different rhythms.

In squares, in circles [with diagrams]
Project with effects, one white on black, black on white.

Enlarge details.
Silhouettes put into perspectives in depth. [with diagram]

Mechanical elements. Advertising pictures such as the Cadum Baby, etc.

Play of forms in close-up. (animated cartoons) [with drawing]

Fig. 40. Fernand Léger, Preparatory sketch for *Ballet Mécanique*, pen and ink, 1923-24 (Collection Pierre Alichinsky, Paris). Courtesy Pierre Alichinsky

Sheet two, first page:

Metal sphere (full screen with projectors on it—.
Film screen disappears.
Sheet metal in background, white, either flat or pleated.

Effects of color projectors. [with diagram]
Multicolored wheel, spinning.

Fragments of film: a dog, a cat, a foot, an eye—all mixed
together with objects—

Play of mirrors. Projection on mirror effects—
Moving mirror.

Use of sheet metal in all these forms.

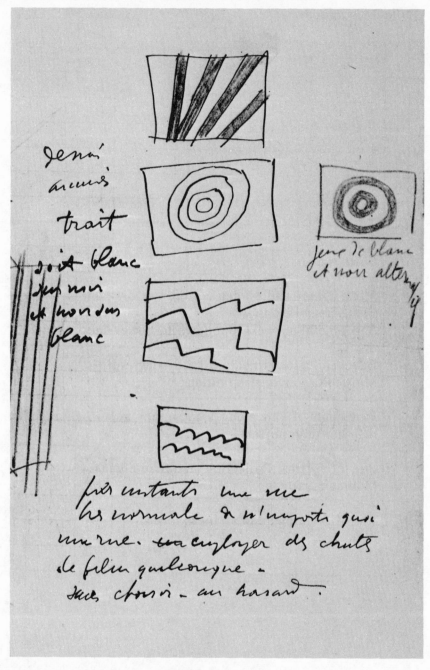

Fig. 41. Fernand Léger, Preparatory sketch for *Ballet Mécanique*, pen and ink, 1923-24 (Collection Pierre Alichinsky, Paris). Courtesy Pierre Alichinsky

Sheet Two, second page:

Animated cartoons. [with four sketches for designs]
Line, either white on black, or black on white.

Alternate play of black and white [with design of con-
centric circles]

At sudden intervals, a perfectly ordinary view of
anything.
A street
Use any film clip—with choosing—at random.

Fig. 42. Fernand Léger, Preparatory sketch for *Ballet Mécanique,* pen and ink, 1923-24 (Collection Pierre Alichinsky, Paris). Courtesy Pierre Alichinsky

Fig. 43. Fernand Léger, Preparatory sketch for *Ballet Mécanique,* pen and ink, 1923-24 (Collection Pierre Alichinsky, Paris). Courtesy Pierre Alichinsky

Fig. 44. Fernand Léger, Preparatory sketch for *Ballet Mécanique*, pen and ink, 1923-24 (Collection Pierre Alichinsky, Paris). Courtesy Pierre Alichinsky

Fig. 45. Fernand Léger, Preparatory sketch for *Ballet Mécanique*, pen and ink, 1923-24 (Collection Pierre Alichinsky, Paris). Courtesy Pierre Alichinsky

Several of Léger's thoughts were not incorporated into the final form of *Ballet mécanique*. For instance, his idea of dividing the screen into equal sections and projecting identical images in each at different rhythms was not realized, probably because of the considerable technical difficulties he would have encountered here. Nonetheless, the idea is a fascinating one, and similar to many of the split-screen techniques widely used by present-day experimental film-makers. Another touch of proto-Pop art can be seen in Léger's desire to insert advertising images, not actually done, however, in the film. Nor are there, strictly speaking, any animated cartoons, despite Léger's frequent mention of them in his notes and his sketches. Marcel Gromaire's prophecy of a new aesthetic form based on animation techniques was not realized by Léger, who apparently had no idea of the prodigious technical complexities entailed in this process.

But still, many of these thoughts were developed in *Ballet mécanique*—his use of constructed objects, mirror effects, enlarged details, mechanical elements, metal spheres and shiny sheet-metal, sudden interjections of ordinary film shots —and, most significantly, a note that perfectly describes the base line *modus operandi* of the film: "all of this in constant opposition to violent contrasts."

Since, by nature of the medium, film has a linear development, since too *Ballet mécanique* is a relatively short film in which all of the questions of analysis are generated by the film itself, the most satisfactory procedure would be to examine the film from the beginning to end, taking cues from the film as they occur to explore the many aspects of analysis. This procedure necessarily involves many digressions in many directions, and yet only by this method can we examine all aspects of the film, more or less simultaneously, without losing sight of any of them.

Time, in *Ballet mécanique* and unlike the normal fiction film, is never geared to the narrative event. It is rather experienced through the medium of a purely visual happening, long or short in duration, quick or slow in its rhythm, and constantly intercut and interacting with other images and

movement of corresponding and highly contrasting nature.

This accounts for the extraordinary richness and vitality of *Ballet mécanique.* Yet surely Léger meant to do more than simply dazzle the eye. We know how logically constructed his paintings are, and we would expect even a tighter rationale to direct his first essay into the new and unexplored medium of film. And indeed, after the initial shock of experiencing *Ballet mécanique* has worn off, we can perceive its structural organization into a number of clearly defined temporal units. But—and here is the problem—this composition in time is impossible to align with Léger's own description of how the film is organized. In July of 1924, Léger wrote:

> The film is divided into seven vertical parts. (Closeup, without depth, active surfaces) which go from slow motion to extreme speed.
>
> Each of the parts has its own unity due to the similarity of clusters of object-images which are visually alike or of the same material. That was the goal of construction and it prevents the fragmentation of the film.
>
> To assure variety in each part they are crossed by horizontal penetrations of visually similar forms (color). From one end to the other the film sustains an arithmetical law that is rather precise, as precise as possible (number, speed, time).
>
> An object is projected at the rhythm of:
> > 6 images a second for 30 seconds
> > 3 images a second for 20 seconds
> > 10 images a second for 15 seconds.
>
> We "persist" up to the point where the eye and the mind of the spectator "can't take it any more." We exhaust its visual power at the very moment when it becomes unbearable.[65]

Accompanying this note is a diagram by Léger (fig. 46), a "graphique de constructions," showing seven vertical blocks and short wavy lines which represented the "horizontal penetrations" running between and into them.

Fig. 46. Fernand Léger, Graph of the construction of *Ballet Mécanique*, July, 1924. Courtesy University Library, University of Wisconsin

This is part of Léger's manuscript for his article on *Ballet Mécanique* published in *The Little Review* (Autumn-Winter issue, 1924-25). The annotations are not Léger's.

On the surface of it, this note seems to explain Léger's intentions with admirable clarity. The film, Léger tells us, is divided into seven parts, each part possessing its own unity through the similarity of objects or images contained therein. To introduce variety within each of these parts, they are crossed with "pénétrations très rapides horizontales de formes semblables (couleur)." The film was designed to generate a constantly mounting tension towards speed, as indicated by Léger's diagram of the graphic construction of the film. Here, an upward slanting dotted line charts the increased movement in each successive part.

Thus far, Léger's note is a valuable guide to our understanding of the construction of his film. In viewing the film, we can identify several major clearly defined passages, and these are interrupted from time to time by passages of extremely quick cutting. There is an undeniable mounting of tension towards more and more rapid montage as the film progresses. But beyond these rather general guidelines, this written document by Léger confuses rather than illuminates our understanding of the construction of *Ballet mécanique*.

His notion of "vertical" units and "horizontal penetrations" is an intriguing one, and has obvious affinities with the rectilinear grid on which his paintings of the period were composed. Yet in viewing the film, it is often very difficult to determine which passages are part of a major vertical block and which are interpenetrating horizontal movements. Possibly, as his notes suggests, these horizontal elements were distinguished in the original print by the addition of color. This could easily have been accomplished by printing them on a tinted film stock, a common practice in the commercial entertainment film of the day, but whether this was actually done or even intended is not known. Moreover, it is difficult to determine exactly how the film divides into Léger's seven mass units. Are they equal in length? Are they progressively shorter as their interior rhythm accelerates? Why, when Léger's *graphique de constructions* was published by Kiesler a few months later, were there changes in this diagram (fig. 47)?[66] An examination of the film does not answer any of these questions

with certainty. Perhaps after all, these notes were meant to be
no more than general thoughts on the film, possibly even com-
posed after its completion. Perhaps it is unreasonable to expect
an exact and unambiguous correspondence between Léger's
statements and his accomplishment. In any event, we can come
closer to an understanding of the film by examining its *ap-
parent* division into seven parts, whether or not they corre-
spond precisely to Léger's own compositional scheme:

Part:	Principal Content:	Stills:	Number of Stills	Duration in Seconds:
Introduc- tion	"Charlot" and Title	8–12	181	11
I	Mechanical Movement of Objects in Motion	13–40	1073	67
II	Prismatic Fracturing	41–106	2113	132
III	Exercises in Rhythm	107–148	1663	104
IV	External Rhythms: Men and Machinery	149–200	3879	242
V	Titles and Numerals	200–240	1732	108
VI	More Exercises in Rhythm	241–278	1594	100
VII	"Ballet mécanique" of Common Objects	279–300	1576	97
Epi- logue	"Charlot" and the Woman in the Garden	—	782	49

There are 14,591 frames in the print of *Ballet mécanique* used
for this analysis (a 16mm print from the Department of Film,
Museum of Modern Art). Screening time is fifteen minutes and
twelve seconds when projected at the normal projection speed
for silent film of sixteen frames per second.

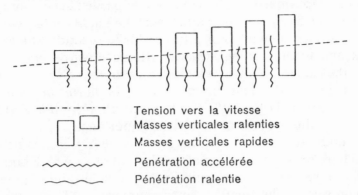

GRAPHIQUE DE CONSTRUCTIONS

Tension vers la vitesse
Masses verticales ralenties
Masses verticales rapides
Pénétration accélérée
Pénétration ralentie

Fig. 47. Fernand Léger, Graph of the construction *Ballet Mécanique* as published in Friedrich Kiesler's *Internationale Ausstellung neuer Theatertechnik*, Vienna, 1924.

Introduction: "Charlot" and Title:

(Still nos. 8–10; screening time: eleven seconds)

The first title (nos. 1–12) is modern, the second (nos. 3–7) earlier, but not original and was probably added to the film about 1930.

To introduce *Le Ballet mécanique*, there appears on the screen Léger's Cubistic marionette figure of Charlie Chaplin, and not, as Léger's notes called for, a "little ballerina, light and graceful." Charlot moves his mechanical limbs, doffs his hat, and collapses as if the joints of his body had suddenly dissolved.

Part I: Mechanical Movement of Objects in Motion:

(Still nos. 13–40; screening time: one minute and seven seconds)

The structure of this part corresponds exactly to Léger's *graphique de constructions* for the film; that is, a coherent block of filmic imagery interrupted, as indicated in Léger's diagram (fig. 46), by the horizontal penetration of a flurry of quickly cut shots. This first part is a study of the mechanical movement of objects in motion.

But its opening shot is a surprise (nos. 13–15). It reveals not

Léger's mechanized world but a lovely garden scene, and instead of the figure on a pendulum sketched in his notes, we see a fair lady on a swing. For a full eighteen seconds, she rocks back and forth, smiling sweetly, gliding towards and away from the camera in a windshield-wiper rhythm almost hypnotic in its effect. The function of this *carte postale en mouvement,* as Léger calls it, is to establish a rhythm, and the content of the image is of incidental importance.

Suddenly, a cascade of images (nos. 18–27) flashes before us—a horizontal penetration of quickly cut shots which bounce off the screen in a jolting rapid-fire succession—and in powerful contrast to the regular metronomic pulse of the moving image of the girl on the swing. Shots of a straw hat, some numerals, three wine bottles, a white triangle, a girl's head, all appear as if rushing on top of each other, each persisting on the screen for no longer than a quarter of a second.

The regular, mechanically measured rhythm returns. A girl's mouth rhythmically breaking into a smile, a series of painted rotating discs rolling past the camera, a swinging reflective sphere, then the girl on the swing again—but this time upside down—and once again the reflective sphere swinging back and forth, and then, without a break in rhythm, switching abruptly to a swinging movement to and away from the camera—all these objects in motion are unified by the same strong metrical beat marked out by decisive movements that surge across the screen and beyond it. This regular beat is then carried into the following shots with such insistence that, in fact, the rhythm becomes the content, the base line of visual interest on which thematically dissimilar visual images are strung like so many variegated beads on a string.

In this opening part then, the fundamental expressive means of the film are introduced: "no scenario—reactions of rhythmic images, that is all." It might be mentioned that the "cast of characters" of the film is also introduced in this first section: the girl on the swing is Katherine Murphy, a dancer, former student of Isadora Duncan's, and the wife of Dudley Murphy; the girl whose mouth we saw flashing her teeth in regular cadence was "Kiki of Montparnasse," a model and

intimate friend of several painters of the 'twenties in Paris; she had appeared earlier in Man Ray's Dada short, *Retour à la Raison,* 1923. And Léger and Murphy themselves appear in this opening section, if somewhat inadvertently: they can both be seen reflected in the metal sphere, Léger standing at the right, and less clearly discernible, Murphy behind the camera.

Part II: Prismatic Fracturing:

(Still nos. 41–106; screening time: two minutes and twelve seconds)

Two important elements of *Ballet mécanique* are introduced in Part II: 1) Léger's use of an optical prism to fracture the filmic image, and 2) his use of common household objects, isolated in space, enlarged by the close-up, and photographed for their pure plastic beauty.

By holding a prism over the lens, the camera's field of vision is shattered in such a way that forms appear to overlap and interpenetrate each other. The device suited Léger's mode of vision to perfection, for, through a prism, perspective was totally destroyed and space flattened. Moreover, any movement of an object photographed in this manner took on a curiously jerky and mechanical quality. This happens because the same object is seen simultaneously in several different positions on the screen, and each optically replicated and overlaid image performs the same movement in mechanical unison with all its other identical images.

For instance, in the opening shot of this second part (nos. 41 to 45), we see an arrangement of highly reflective Christmas tree ornaments against a background of geometric elements. Through prismatic fracturing, their number is multiplied on the screen and, when set in motion, the elements of this truly Cubist composition move about in syncopated rhythm as if linked together by invisible tie-rods (figs. 48 and 49). The importance Léger placed on the device of the prism is signaled by his note of thanks: "And important contribution due to a technical novelty of Mr. Murphy and Mr. Ezra Pound—the multiple transformation of the projected image." [67]

Fig. 48. Fernand Léger, *Contraste de Formes*, 1924.

Fig. 49. Fernand Léger, Frame enlargement from *Ballet Mécanique*.

Fig. 50. Fernand Léger, *Elements Mécaniques*, 1925. From *Bulletin de l'effort moderne*, no. 17, July, 1925

Fig. 51. Fernand Léger, Frame enlargement from *Ballet Mécanique*.

In this second section of the film we first witness Léger's magical transformation of ordinary objects into images of pure plastic beauty. Sheets of corrugated metal (nos. 46 to 54), kitchen funnels (nos. 55–58, 81–83), fluted gelatin molds (nos. 74–77), another culinary utensil (no. 84) all lose their identity and become fascinating patterns of movement. Had Léger not discovered the device of the prism to mollify the immutable realism of the camera eye, he might have made an even greater use of such highly reflective metal surface *(tôle)* and mirrors to break up the image, for his working notes call for "a background of bright sheet metal, either flat or corrugated," elsewhere for a "play of mirrors. Moving mirrors. The use of metal in all its forms."

While Léger's manipulation of the prism animates this shiny striated surface, a sudden interruption by another of his horizontal penetrations appears. Now, a rapid alternation of white circle and triangle against black background flashes across the screen (nos. 61–70). These bold geometric forms gradually decrease in size, from full screen image to tiny and distant points in a black void. This device, used later in the film as well (nos. 155–157; 168–169; and 254–257), has a curious effect. It is experienced as a kind of visual punctuation mark. That is, it appears to be less a part of the film proper, even though other shots are equally non-objective, than it does a transitional device to lead the spectator from one section of the film to the next, and in a language totally consistent with the sharp-edged forms and quick rhythms of the film as a whole. It is—to mix descriptive vocabularies of painting and cinema—a "Cubist dissolve."

Additional shots of prismatically moving metallic patterns appear, followed by the saucepan lids and gelatin molds we have seen before, again transformed into a weightless crystalline composition by the prism. These shifting transparent planes recall Cubist paintings of course, but they are even more closely related to Cubist-derived abstract photographs. Indeed, these shots in *Ballet mécanique* are animated versions of both the Vortoscope photographs by Coburn (fig. 52), made in 1916, and certain of the cameraless photographs of Man Ray,

1921–25, made by placing crystals directly on enlarging paper, which, then briefly exposed to light and then developed, would reveal a fractured pattern of the light it had received.

By this time—and the film has been running for almost three minutes now—we have become immersed in a highly active, semi-abstract pattern of moving forms. Many of the compositions in these first two sections of *Ballet mécanique* recall those of Léger's paintings. The rhythm of movement coming from the screen seems to spring out of his painted *oeuvre*—a staccato mechanized pulse, abrupt shifts of accents, constantly in motion. Significantly, Léger's only means of shot transition throughout the film is the cut. There are no dissolves, fade-in or fade-out transitions, wipes, or iris shots—all of these more fluid transpositions from one shot to another Léger must have detested as much as he did the frothy imprecision of Impressionist painting.[68]

Now suddenly, a new element appears: a highly polished, rapidly-spinning machine element (no. 85), photographed directly without prismatic distortion. Where did this beautiful glistening object come from? As if to share our surprise, a huge pair of eyes pops onto the screen, wide-open in wonder (nos. 86–87). They slowly close, appear upside-down, and then slowly open, again watching this machine element. This passage strikes one as a bold intrusion into the film's Cubistic and decorative patterning of motion. The enormous staring eyes come as a shock, but one which our knowledge of Léger's artistic temperament should have prepared us for. Léger was never myopically interested in form alone; the forms and rhythms of his painting were drawn from the images and activities he experienced in life about him, particularly, of course, the mechanization of modern life. With this insight, we can understand this passage as a whimsical comment on the excitement of visually experiencing machinery in motion. The eyes are meant to react to what they see, and we are meant to understand those eyes as our own. Later in the film Léger makes increasing use of such images, images which are unrelated in form and content to the general Cubistic texture of the film. These, like Kiki's eyes watching machinery, are in the

Fig. 52. Alvin Langdon Coburn, *Vortograph*, 1917 (George Eastman House). Courtesy George Eastman House

Fig. 53. Fernand Léger, Frame enlargement from *Ballet Mécanique*.

film, Léger explains, "for variety and contrast." In a sense, these eyes function like Léger's famous washerwoman (nos. 188–192) who endlessly climbs a flight of stairs as if driven by a clockwork motor, shots which "have no value in themselves, but only in the context of the images which follow them."

The prismatically fractured shots return. Amidst suspended sheets of corrugated metal (nos. 93–94), the head of a young man (Dudley Murphy) rises up, as if mechanically elevated by the machinery we have just previously been observing. Then comes a long and continuous shot (nos. 95–97) of miscellaneous objects, predominantly geometric in form, animated by both camera movement and rotation of the prism. The result is a composition in motion that seems to spring

directly from Léger's canvases of the period. Indeed, such a painting as his *Contrastes de formes* (fig. 36) of about 1924 strikes the eye as a working sketch, a compositional diagram for this shot. In the painting, a series of large discs, obliquely linked to other pieces of precise geometry, appear to float in a shallow space as if their mechanical gyrations were momentarily arrested.

The other shot of interest in this section, one again representing prismatically fractured gelatine molds (nos. 100–102), has less affinity with Léger's painting, and, for this reason, is almost unique in the film. Here, through underexposure and perhaps special lighting techniques, the object is transformed into a glowing iridescent form. It appears to be made of crystal, illuminated from within.

Three more shots come on the screen (nos. 103 to 106)—a row of saucepan lids, a somewhat bewildered-looking parrot, and a Cubistic composition of geometric fragments against a metallic background—all characterized by the prismatic fracturing that has provided the *leit-motif* of this section, designated as Part II of the film.

Part III: Exercises in Rhythm:

(Still nos. 107–148; screening time: one minute and forty-four seconds.)

This section is perhaps the most difficult to describe verbally. Its content is almost entirely rhythm.

In Part I, as we have seen, Léger unified his images by a strong and regular rhythmical beat created by the movement of forms set in motion and placed before his camera. But here, in Part III, his concern is to explore a wide variety of filmic rhythms, fast and slow, within and between images.

The subject of cinematographic rhythms and movements was a burning issue in the early 'twenties among writers on film theory, not only with those infected by the new spirit of the times, but with the traditionalists as well. An amusing example of a nineteenth-century academic concept of

movement as an expressive element of the visual arts, perfectly mummified and transposed from bad Salon painting into film, can be seen in an article by Marianne Alby that appeared at the end of 1922, "Le mouvement au cinéma." The essence of movement on the screen, in the eyes of this forgotten critic, was best communicated by static shots of several dozen young ladies, all dressed in diaphanous veils like little Loie Fullers dancing about by the open sea.

And in the following year, in the same periodical, *Cinéa*—actually a more enlightened and advanced journal than this one sample of its writing suggests—there appeared one of the most important theatrical film essays of the decade: Léon Moussinac's "Théorie de cinéma." Moussinac's central thesis on movement in film, so obvious and yet till then never so clearly formulated, provided the theoretical basis of Léger's experiments with filmic rhythm in Part III of *Ballet mécanique*. Moussinac writes:

> Cinema has an interior rhythm, that of the image, and an exterior rhythm, *between* the images; that means they are created by the order of succession of the images and their fixed durations.[69]

In distinct and separate passages Léger articulates both types of filmic rhythm defined here by Moussinac. These rhythms are distinguished from each other by their utterly different means of formation. Interior rhythms, on the one hand, result when the camera records the physical movement of things within its field of vision. This most fundamental type of filmic movement, dating back to M. Lumière's first films of locomotives charging at the beholder, is extended, elaborated, and psychologically charged, but not basically altered when the camera itself, rather than the subject of its vision, is set in motion, as in the films of L'Herbier or René Clair—*L'Inhumaine* and *Entr'acte* are obvious examples—or in the German cinema at mid-twenties, as in Murnau's *The Last Laugh* where subjective vision with the moving camera became an obsession. On the other hand, the exterior rhythm of a film is generated by

the pace and pattern of cutting from one shot to the next. Exterior rhythm is created in the cutting room, with scissors, film cement, and, most important, a feeling for the visual rhythms, the cinematic choreography of images brought to life through editing alone.

The opening passage of Part III is another horizontal penetration, as Léger calls them, a rapid flurry of shots contrasting strongly with the less active shots of gentler rhythm and longer duration. Like the previously examined horizontal penetrations, this one too is an exercise in pure interior rhythm. It is also the longest, and contains the most rapid cutting and the most varied images, including a short passage of total darkness (between nos. 116 and 117). It begins with an eye-splitting sequence in which a bright white circle and a dim triangle alternately flash on the screen, each image lasting for the same split-second duration. Ten times these insistent signals flip back and forth in a rapid-fire regular rhythm, like a luminous alarm system of geometry gone berserk. Again, as Léger's note on the film has warned us, it "persists up to the point where the eye and the mind of the spectator 'can't possibly take it any more.' "

Then this rapid regular rhythm shifts gears, so to speak, to a series of shots more irregular in their rhythm, in actual frame count: 2-3-1-2-3-2-3-2-3-1-3-3, and so forth. If there is a controlling rhythm here, it is difficult for the eye to perceive. The images, too, are more varied. All are strong geometric shapes, some are totally abstract forms like circles and triangles, some are objects like bottles, crankshafts, a typewriter, and numerals. With a characteristically witty touch, Léger inserts in this montage a three-frame shot (no. 110) of an overturned chair and some scattered papers on the floor—hardly even *poésie de quotidien,* and yet it flashes by so fast that this utterly commonplace subject matter cannot be recognized, and only the Léger-like geometry of its design can be perceived. This horizontal penetration, which had begun with a series of rapidly alternating large circles and triangles, ends in the same manner, only this time the forms are smaller in size, the

sequence in which they appear (nos. 125 and 126) shorter in duration.

If this horizontal penetration, this introductory passage to Part III, was Léger's most extreme example of exterior rhythm in film, that is, a rhythm generated from the rapid and rhythmical succession of contrasting graphic images, then the following passage typifies his use of interior filmic rhythm. With the exception of the shot of Charlot which concludes *Ballet mécanique,* this is the longest uninterrupted shot of the film (nos. 127–130). Its basic elements have been seen before (in no. 117), a sparse arrangement of objects—a straw hat, a wooden rod, a few metal or plastic discs, and a few sheets of paper, black and white—all flattened out and broken apart by Léger's prism. Its movement—and hence its rhythm—is created by continuous manipulation of both the prism and the camera itself.

Suddenly, an eye appears, closed and framed off by a black cardboard mask (no. 131). It slowly opens. Again, as earlier in the film when that giant pair of eyes opened to stare in wonder at whirling mechanical elements (nos. 86–89), here too this single eye is an anatomical fragment revealed for the beauty of its own plastic form. And moreover, it functions as a metaphor of vision. Another gentle hint of Léger's wit shines through as a quick shot of the other eye is interjected (no. 132): the effect is strangely like one eye winking at the other. Then, seemingly caught up in the brisk mechanized movement it has been observing, this huge isolated eye now performs its own mechanical ballet. Each time the eye lid snaps open and shut, the eye is looking in a different direction. In a certain sense, this little exercise recalls "a valve opening and closing creates a rhythm as beautiful but infinitely newer than that of a living eyelid," except, as Léger had discovered, a living eyelid, *on film,* becomes isolated, magnified, abstracted from nature through loss of color and context, so that as an intimate piece of human anatomy and unlike a man-made machine valve, it possesses, in fact, infinite newness.

A few more shots of this third section follow (nos.

138-141), very similar in their imagery and rhythm to those already discussed; one of them (no. 141) possesses a design of considerable beauty, yet, surprisingly, is no more than a small kitchen funnel inserted into a wire beater, its image inverted and broken into three parts by the prism.

Then, a new form of imagery appears: shots of pieces of kitchen crockery neatly lined up in a row, like a single object reflected endlessly between two mirrors, the rotating wheel of fortune in an amusement park, more shots of the crockery, and then a detail of another funhouse game of chance (nos. 143-148). These images—photographed with brutal directness, smacking of commercial advertising and the frivolous lower-class amusements of the fairground—have profoundly modern overtones, and are closer to the spirit of Pop art and Pop culture of the mid-sixties than anything in the years between Léger's time and our own.

Part IV: External Rhythms: Men and Machinery.

(Stills nos. 149-200; screening time: four minutes and ten seconds.)

This section, much like the preceding, is distinguished by its unusually dynamic patterns of movement. But there are major differences, for not only are the external rhythms of this section more vigorous than elsewhere in the film, but, more importantly, they are experienced as distinctly *external*.

The point becomes clear if we consider how the previous examples of external rhythm were created. Almost invariably, these were Cubist compositions made from bits of cut-out geometry, Christmas tree ornaments, kitchen implements, corrugated sheet-metal, and the like. These semi-abstract images were animated by three different means, used singly or in combination: movement of the objects, movements of the camera, and manipulation of a prism. Since the objects themselves were difficult to identify, frequently deformed by a prism and with no strong associative values, either emotional or intellectual, we were more conscious of the pattern of

movement they created on the screen than their physical presence before the camera's eye. To use the critical vocabulary of Etienne Souriau, we experience the presence of an *"image écranique,"* rather than an *"image profilmique."* Their extra-referential meaning as "realistic images" was reduced, their significance as pure patterns of two-dimensional movement correspondingly intensified; hence what we perceived was predominantly a sequence of Cubistic objects. As in Cubist painting, these images contained only the barest reference to the external world, and—here is the fundamental distinction from the images of Part IV—this external world was limited to the artist's studio and its pre-stylized or prismatically formed Cubist compositions.

But in the first shot of Part IV (no. 149), we find ourselves suddenly released from a Cubist world and thrust into a carnival world of high-key sensations of speed and movement. Here, Léger takes his camera out of the studio and into the street. The opening six shots of Part IV (nos. 149–154) form a brilliant and tightly constructed filmic essay on movement in the modern urban world.

First we see a man at the top of a long curved wooden chute. As he slides down and reaches the bottom, Léger cuts to a ground-level view of feet marching past, then an automobile racing towards and over the camera, followed by a mechanical car at the amusement park, and then the spinning machine element we have encountered before through Kiki's eyes.

These shots are linked together with perfect continuity of filmic rhythm and image content. The rhythm is maintained by a powerful *mouvement écranique* carried from one shot to the next; the image in each shot cues the one following it:

> *Man* at the top of the *chute,*
> *Chute* guiding his descent to the *street,*
> *Street* and marching feet, seen from *below,*
> *Below* in the street, over-run by a *car,*
> *Car* at the carnival ride rapidly *spinning,*
> *Spinning* machine element. . . .

Thus, with Léger's sharp eye and sense of rhythm, the passage is fused together from seemingly random shots which lose their autonomy as independent images to become a continuously unfolding visual transformation of imagery. Film was a new medium to Léger, but nonetheless we can sense here the same creative mind at work that had formed *The City*, his dynamic cityscape painting of five years earlier.

Another horizontal penetration of Léger's alternating circles and triangles (nos. 155–157) signals a transition to a new section, this one also linking the movements of man and machinery (nos. 158–163). Again we see figures sliding along the wooden chute. But now, viewed from above and with a long shadow preceding each figure, a rhythmical pattern of black forms zipping horizontally across the screen is created. This is undercut with shots of a piston pumping up and down, equally mechanical in its rhythm but with movement in contrasting direction. More figures slide by on the chute, against which Léger plays the movement of vertically plunging and lifting tie-rods.

The effect of these contrasts between human and machine activity is curious. Actually, it is less of a contrast than an integration, for by rapid undercutting of similar movements by men and machinery, the images begin to speak to each other. Each becomes tainted, as it were, by close reference to the other, so that the machinery becomes anthropomorphized, the figures mechanized. Thus, Léger is using the medium of film here to elaborate a basic principle that he had developed in his paintings of this period: "I perceived the human figure not only as an object, but since I found the machine so plastic, I wanted to give the same plasticity to the human figure." This principle, so perfectly illustrated by such paintings as his *Grand Déjeuner* (1921; Museum of Modern Art), is now extended, through the expressive powers of filmic vision and montage, to embrace "the same rhythm" as well as "the same plasticity."

Most of the remaining shots of Part IV also represent machinery in motion. For the most part, they contain even more explicit demonstrations of machines endowed with human qualities and *vice versa,* as in the long passage that

follows (nos. 165–172). This shot, prismatically fractured, interrupted only by a horizontal penetration of circle and triangle (this time not as a transitional device but as a harsh visual irritant interjected into a relatively impressionistic passage) represents a highly polished piece of machinery with several long and thin shiny rods thrusting diagonally back and forth, like Léger's painting, *Elements mécanique,* 1925, undoubtedly inspired by just such a machine (fig. 50). Now, as these gleaming metal rods lift and sink, the image slowly shifts sideways: the effect is like a machine moving itself along by reaching out and pulling in with its long metal arms. It is difficult not to respond kinesthetically to this image, for its gestures and movements are distinctly humanoid as it laboriously inches itself along by this mechanical rowing action. The lateral movement of the machine is an illusion created by a sideways movement not of the machine but the camera; such is the nature of camera vision that we instinctively interpret what we see on the screen to be the most plausible substitute for human vision.

In stark contrast to the passage just discussed, there appears now a single shot of the monumentalized machine element, a pump of some sort (no. 173). Its motion, too, is perceived as a mechanical parody of human muscular efforts. This powerful mechanism consists of a rounded arch from which extend two long curved arms grasping a short vertical plunger. With agonizing slowness, its arms lift the plunger. It rises up a very short distance, and then suddenly plops down. Again, this movement, etched in pure black against the sky, evokes a feeling of Herculean human exertion; one can almost hear this heavy black form grunting from the strain, and then sighing with relief as its burden is released.

Then, leaving this factory-like environment, Léger returns to the studio to insert two shots of his beloved kitchen implements: a large wire form with a funnel inside it and three wire beaters (nos. 174–175). In addition to their purely visual appeal as handsome objects, their movements are clearly choreographed in dance patterns, in the first twirling about like a pirouetting ballerina, and in the second, the three beaters

bobbing and weaving as if performing for our benefit, like Charlie Chaplin's dancing dinner biscuit in *Gold Rush* (1925).

If the foregoing interpretations of "humanized" machinery seem farfetched, the following example should dispel these doubts. The celebrated scene of the washerwoman who endlessly ascends the steps from the river.

But first, as an introduction to this, we are shown a magnificent shot of a machine in operation (no. 176). Is it a dynamo, a pump, a motor, part of a factory production line? Léger does not tell us, nor is it relevant, for, as he remarked, "every object, created or manufactured, may carry in itself an intrinsic beauty." Its strikingly handsome form alone merits its inclusion in the film. The polished and precision-made shaft of this machine, in the following shot (nos. 177–179) is photographed head-on, so that it fills the screen with pulsating energy, lunging forward, withdrawing, lunging again, and so forth. To underscore this celebration of machine energy, Kiki's wondrous eyes appear (nos. 180–185), as they previously did to admire a lovely piece of machinery. And then, the washerwoman arrives.

At first, she seems strangely out of place, this incongruous intrusion of an ordinary woman in an inhuman industrial world. But her function in Léger's mechanized montage soon becomes clear. Like Sisyphus, the Greek god eternally condemned to roll a boulder up the mountainside only to have it slip from his grasp each time he approached the summit, she mounts the steps, laden with laundry, climbs to the top—only to reappear instantly below, where she started, again to repeat her tiresome chore. Her function in the film, Léger has written, was first of all to "astonish the public, then to make them slowly uncomfortable, and finally to push the adventure to the point of exasperation." Each ascent is identical. She climbs and reclimbs twenty-one times, interrupted only by two other shots that neatly comment on her plight: 1) Kiki's lovely mouth mechanically breaking into smile to share with us her amusement in observing this strange scene (thus revealing not only Léger's sense of rhythm but his sense of humor as well),

and 2) the plunging crankshaft of a machine, its regular back and forth movement obviously echoing and reenforcing the washerwoman's endlessly repeated clockwork movements. She is Daumier's *Washerwoman* at once more realistic, by virtue of the veracity of the photographic image, and yet less so, for she betrays not a trace of weariness or annoyance in performing her treadmill task.

Part V: Titles and Numerals:

(Stills nos. 200–240; screening time: one minute and forty-eight seconds.)

This part is the most internally consistent of Léger's film. We are back in the studio again, for none of the following shots are anchored in the physical actuality of the real world. Rather they have the character of an animated cartoon, of images taken from the drawing board, not photographs of real objects. Almost all are brought to life through interior rhythms, so that the sensations of movement are generated by rapid cutting from shot to shot. As an exception to this, however, the most notable example of *exterior* rhythm occurs in the opening shot.

It begins with a blank screen of total darkness. Then, at the edges, short curved white forms appear. They slowly float towards the center and combine into a large, static "zero," which then recedes backwards into the blackness, decreasing in size. It is a slow, deliberate exercise of the creation of a perfect geometric element out of its fragments, and then, once assembled, withdrawing it from our field of vision (nos. 200–205).

Now, suddenly, a title bursts on the screen (no. 206): *On a volé un collier de perles de 5 millions.* This mysterious message, like a newspaper headline, a statement of minimum information delivered with maximum graphic force, is then playfully dissected. In rapid alternation, zeros flash, singly or in groups of two or three, then fragments of the message, "on a

volé," more zeros, more fragments, *"de 5 millions,"* and so forth, all bouncing off the screen in a rapid-fire sputtering rhythm.

In a general sense, the passage recalls the Cubist's fascination with typography. Léger, of course, had introduced fragments of words and sentences in his earlier paintings, such as *The City,* and in his illustrations for Cendrars' *La Fin du monde,* both of 1919. But a more important source here was commercial advertising. Léger was intensely aware of its force in symbolizing and expressing the modernity of urban life: "the most common example," he noted, "is the hard and dry billboard with violent colors and bold letters." The city street, with its noisy billboards and flashing advertising lights all competing simultaneously for one's visual attention, created those sensations of temporal discontinuity and spatial disorientation that characterize the experience of city life—and of Léger's painting, carried here into film.

His working notes for *Ballet mécanique* call for even more obvious references to commercial advertising: *"images de publicité comme Bébé Cadum,"* [70] and elsewhere, *"projection de page entière de publicité de journaux."* The notion of projecting an entire newspaper page onto the screen possibly derived from a remarkable set design executed by Gerald Murphy [71] (no relation to Dudley Murphy) for a 1923 production of the Ballet Suédois, *Within the Quota,* which consisted of an enormous front page of a mock American tabloid, full of florid headlines (fig. 54). Fortunately, Léger discarded this idea, suitable enough for a static image like a ballet backdrop but too rich in its informational content for a filmic image. Instead he selected a single headline, and then disassembled it, played with it, breaking it into fragments, stretching them out through space and time, as it were, like an eye scanning a newspaper, overlapping image and afterimage.

Part V continues in this playful fashion. After this lengthy barrage of zeros and headline fragments, Kiki's eye appears and opens to see, not a *"collier de perles"* but an old-fashioned horse collar! Monumental and symmetrical in design, it fills the

Fig. 54. Gerald Murphy, Set design for the Ballet Suédois production of *Within the Quota,* with music by Cole Porter, Paris, 1923. From Fokine, *et. al., Les Ballet Suédois dans l'art contemporain,* Paris, 1931

screen and remains there for almost six seconds, a long time for anything to stand still in *Ballet mécanique*. Then, darkness, image again, darkness, image, flickering on and off, its visual pulsation slowly accelerating like a steam engine gathering speed. Finally the collar begins to move. It bounces up and down, then sideways and diagonally. Its little dance is created entirely by interior rhythm; the collar itself never actually moves across the screen, only its relative position between successive shots.

Part VI: More Exercises in Rhythm:

Still nos. 241–278; screening time: one minute and forty seconds.)

This part has much in common with Part IV. Using com-

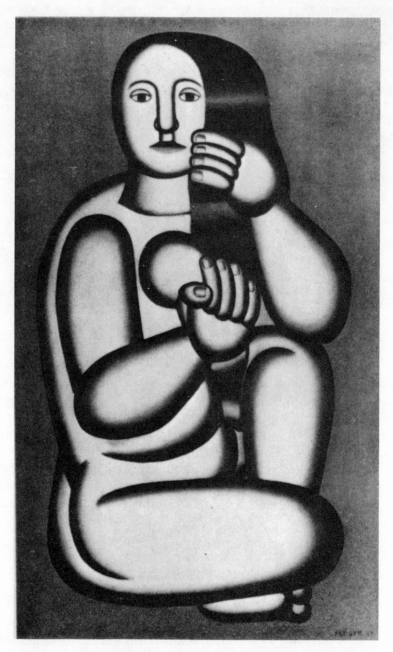

Fig. 55. Fernand Léger, *Nu sur fond rouge*, 1927.

Fig. 56. Fernand Léger, Frame enlarge from *Ballet Mécanique*.

monplace objects, abstract geometric forms, and anatomical fragments, it weaves these images into a quick montage animated by both interior and exterior rhythms.

Part VI can be divided into two sections. The first (nos. 241–259) is a precisely articulated passage in which human figures and objects are contrasted. As it opens, we see for the first time Kiki's face in full image and without prismatic dis-

tortion. With eyes closed, her boyish haircut carefully combed back, and her lips and eyebrows cosmetically delineated, she remains totally expressionless and revolves slowly like a piece of sculpture on a turntable (nos. 241–244). Indeed, she appears to be more of a department-store mannequin than a human being. This, obviously, was Léger's intention, to depersonalize her image as much as possible, like the robot-like figures of his paintings (figs. 55 and 56), while, at the same time, exposing her to merciless photographic scrutiny.

To counterpoint this concept of human figure-as-sculpture, Léger then cuts to a shot of real sculpture, a wooden polychromed figure of "Uncle Sam," who swings towards and away from the camera (nos. 245–247). Again, as with his intercuttings of man and machinery in Part IV, the images automatically refer to each other. Kiki becomes like a sculpture, "Uncle Sam" like a real person on a garden swing.

For variety and contrast, another shot of Kiki is inserted, bracketed by Léger's own unique means of filmic punctuation—a white circle increasing in size to introduce her and, afterwards, an alternation of circle and triangle, decreasing in size (nos. 248–257). Unlike the directly photographed and emotionally incommunicative visage of Kiki we have just seen, this one is full of playful facial expressions—smiling mouth, coquettish glances, open-eye stares—and yet, to drain the image of its photographic realism, to destroy our psychological identification with this person on the screen, Léger resorts to the prism, transforming it into a play of flattened overlaid planes, once again like his paintings, only this time recalling not his robot figures but his Cubist interpenetrations of space.

To conclude this sequence, Léger then gives us a shot of yet another element, a multi-leveled gelatin mold, different in form, but linked to the earlier shot of "Uncle Sam" by its swinging movement to and from the camera.

This first portion of Part VI is an excellent example of Léger's filmic structure, an interlocking arrangement of elements whose relationship can be summarized as follows:

Nos.:	Content:	Image Formation:	Movement:
241-244	Face	Straight Photography	Rotation of Object
245-247	Object	Straight Photography	Swinging to and fro
248-249	Geometric	Animated Design	Increasing in Size
250-253	Face	Prismatic Fracturing	Facial Gesturing
254-257	Geometric	Animated Design	Decreasing in Size
258-259	Object	Straight Photography	Swinging to and fro

Thus, no less than in his paintings, Léger has constructed this passage from a few simple elements, each one rigidly defined in terms of form, content, means of image formation, and rhythm. On at least two of these counts, each of the elements is similar to others within the passage, insuring the internal unity of the sequence and yet without relying on a narrative interest for its cohesion. Again, "no scenario—reactions of rhythmic images, that is all."

The second portion of Part VI is structured with equal clarity. Here, the internal unity is maintained by constancy of subject matter from one shot to the next, while its diversity comes from variations of rhythmical movement, both interior and exterior.

Léger's raw material, his subject matter for this passage, is a number of kitchen implements. Thus in the opening shot, we see a double row of soup ladles and pot lids, neatly lined up, their polished metallic surfaces gleaming brightly against a black void (no. 260).

Léger had long been intrigued by the phenomenon of light playing on reflective metallic surfaces; in *Ballet mécanique* these images of glistening metal forms are direct descendants of the artillery pieces that so impressed him as a soldier—*"les culasses des canons, le soleil qui tapait dessus, la crudité de*

l'object en lui-même"—and are related also to his paintings of
the immediate post-war period, such as *Cylindres colorés*
(1918; Collection Louis Carré, Paris; fig. 22), paintings whose
principal content was the play of light on rounded metal forms
suspended weightlessly in space.

Such objects held a double fascination in Léger's eye: in
their immutable visual values as pure plastic form, and, addi-
tionally, in their changeable appearance under varying light
conditions—or, in his words: "That fantasy which you might
miss, that state of geometrical dryness which might prejudice
you, finds its compensation in the play of light on white metal.
Every machine brings with it two material qualities—one, often
painted and absorbing light (architecture value), remains con-
stant: the other, most often white metal, reflects the light and
plays the role of free fancy (painting value). Light determines
the variety in machines." [72]

These images of commonplace objects, abstracted from
their everyday kitchen context by isolation and enlargement,
are then brought to life on the screen, first by editing various
shots into a montage of interior rhythm—in reversed image,
upside down, with different camera angles, intercut with shots
of total darkness (nos. 260–266)—and then by exterior rhythms,
by swinging them violently in front of the camera, again to the
apparent astonishment of Kiki's huge eye which briefly comes
on the screen, and by moving the camera as well, in a swooping
motion over diagonal rows of these objects (nos. 267–274).

Part VI closes with a short curious shot, bracketed, as Léger
had previously done, by advancing and receding white circles
(nos. 275–278). This shot represents a store window with its
display of merchandise, seen motionless and at considerable
distance. Why? What is it doing in *Ballet mécanique?*

Léger inserted this image as a way of paying homage to an
art of central significance in modern city life and yet virtually
unrecognized as an art:

> ... the art of window-dressing which in the last few
> years has assumed so great an importance.
> I have witnessed this ant's task, in company with

my friend Maurice Raynal (who should have given this talk). Not on the boulevards in the brilliance of arclights, but in the depths of a badly lighted passage. The things were modest—in the famous hierarchic sense—they were waistcoats in the little show window of a haberdasher. This man, this artisan, had to show in his window seventeen waistcoats, as many cufflinks and neckties. Watch in hand, he spent about 11 minutes on each. Raynal and I left, tired out after the sixth, we had stood there an hour watching the storekeeper, who having moved some article the fraction of an inch would come out to study the effect. Each time he would come out in front to study the effect, so absorbed that he did not see us. With the care of a watchmaker, of a jewel setter, he organized his show, his face tense, his eye hard, as though his whole future life depended upon this. When I think of the negligence, the looseness in the work of certain artists—renowned painters whose pictures bring high prices—we should admire profoundly that brave artisan working so hard and so conscientiously. His work to him is worth so much more than the other, work which must disappear and which every few days he must renew with the same care and study.

Among such men, among such artisans, there is an incontestable conception of art, closely connected with the commerical purpose, a plastic fact of a new order equal to existing artistic manifestations, whatsoever they may be. We find ourselves face to face with an entirely admirable renaissance, of a world of artisan-creators who bring pleasure to our eyes and transform our streets into a permanent spectacle, a spectacle of infinite variety.[73]

In a similar declaration of recognition of this humble but omnipresent art form, the *Bulletin de l'effort moderne*, that stronghold of classicism during the Surrealist revolution in Paris of the mid-twenties, published a photograph of another

store window, somewhat fancier than the one that caught
Léger's eye (no. 162), in between their reproductions of can-
vases by Léger, Gris, Ozenfant, and other artists of the purist
tradition in painting of the 'twenties.

Part VII: "Ballet mécanique" of common objects:

(Stills nos. 279–300; screening time: one minute and thirty-
seven seconds.)

In this final section of the film, Léger's aim was to create
dance-like patterns of movement with ordinary objects, using,
for the most part, interior rhythms of animation.

The opening passage (nos. 279–289) is very similar to the
dancing horse-collar that we observed earlier in Part V, for
here again, these images, in their simplified graphic design and
flattened space, seem closer to annimated cartoons—the French
dessin animé is a more accurate term—than they do directly
photographed objects.

Two mannequin legs appear on the screen, static and in
profile image. Unlike Kiki's eye or mouth, they are true ana-
tomical fragments, legs without a body, and so simplified in
shape that they represent neither specifically a left leg, nor a
right one. They are supported by a wire brace at the heel and
festooned with a garter above the knee. Suddenly, they appear
upside-down, clicking their heels together, then back down,
then up again. Now, they slowly revolve about, like Kiki's
revolving head we had previously seen. Several short shots
follow, with the legs in a different position on the screen in
each shot and intercut with such rapidity that they appear to
be human and alive.

After the legs have finished their little dance, Léger inserts
a four-second shot of two Christmas tree ornaments swinging
back and forth in accelerated motion. This is one of the few
shots in which an abnormal speed of movement is perceptible,
although Léger's notes frequently have referred to the expres-
sive potential of slow-motion and accelerated speed pho-
tography.

The following sequence (nos. 291–293) is one of the most extraordinary moments of the film. For almost half a minute, two simple static images—a straw hat and a lady's shoe, apparently also made of straw—alternately flash on the screen, each image persisting for only a split-fraction of a second. In the course of this prolonged visual barrage, a surprising transformation takes place. At first, the images speak with that intensely expressive power Léger understood so well: "enormous enlargement of an object, of a fragment, gives it a personality it never had before and in this way it can become a vehicle of entirely new lyric and plastic power." But then, as these flashing images continue, back and forth—hat, shoe, hat, shoe, hat, shoe, etc—the thinking eye of the spectator becomes exhausted by the continued repetition of these images delivered in percussive rhythm, with such visual insistence, and containing such minimal informational and no emotional content.

Eventually, as the associative values of these images begin to wane, they appear more and more as pure shapes of white on black, calling forth the surprising illusion that they are merely the *same* form physically pulled and pushed, back and forth, from one shape to another. That is, it is no longer an alternation of shapes that we perceive but a fluid metamorphosis from one to the other at lightning speed. The eye supplies all the intermediary stages of this plastic transformation: we see a long horizontal white form with a black central hole (the shoe) swelling up, redistributing its area of white to become a design of two concentric white circles (the hat), all realized in a flash, and then instantly reversed, again and again.

Much of the same illusion is generated in a slightly later passage (nos. 297–298), a rapid intercutting of Kiki's face, first shot from below, and then from head on. Here again, these separate images create the illusion of a head physically nodding up and down, with a rapid staccato movement.

Part VII concludes with a characteristically witty touch. The passage (nos. 245–300) consists of numerous static shots of wine bottles, from one to five in number and placed in varying positions. Again, by rapid cutting from shot to shot, they

become animated, and appear to perform a "mechanical ballet," skipping about with sprightly movements on a uniformly illuminated white stage. This short amusing scene of dancing wine bottles may well have derived from advertising films of the day in which commercial products would perform in a similar manner to catch the eye of a potential customer. [74] Given Léger's interest in the techniques of commercial art, such films would undoubtedly have caught his eye for rhythm as well.

Epilogue: "Charlot" and the Woman in the Garden:

(Not illustrated; screening time: forty-nine seconds.)

Léger's Cubistic marionette of Chaplin comes back to conclude the film. He performs his jerky mechanical dance again, his body falls apart, its members float off, leaving behind only his head suspended in mid-air. With one final touch of wry humor, Léger finishes his *Ballet mécanique* with a monumentally incongruous image. Katherine Murphy, the girl who introduced Part I by her mechanically rhythmical movements on the garden swing is shown here back in her garden—as if this brilliant exercise of filmic form and rhythm in *Ballet mécanique* had never occurred—sniffing an apple blossom with an elegantly mannered nineteenth-century gesture. The film ends.

What, in short, are the major characteristics of *Ballet mécanique*? What are its principal means of expression? Actually, they are not too hard to define. Not only are they expressed with admirable clarity in the film itself, but Léger's own writings give them further articulation. In capsule form, they are:

1. *Non-Narrative Form.*

 "The screen novel is a fundamental error."
 This is, of course, a negative means of classifying *Ballet mécanique*—it merely indicates what it is not. But the term

nonetheless points out a single innovation of the film, namely Léger's use of the camera eye, not as a story-telling device, but as a means of extending one's power of vision. *Ballet mécanique* is not a work of dramatic film art but a visual experience. From images created by uniquely cinematic means—close-ups, shifts in space and scale, manipulation and fragmentation of time, prismatic deformations of the object, to mention only the most obvious—Léger has assembled a work which is sustained purely by its visual rather than narrative interest. Like Analytical Cubism, the film is a metaphor of vision, it recalls the process of vision itself rather than the thing seen.

2. *Speed, Movement, Rhythm.*

"Speed is the law of the world. Cinema will win out because it is lively and swift."

Léger had long been fascinated by a mobile art; his decor for the ballet *Skating Rink* used moving parts, and his easel painting, like Cubism in general, implied kinetic activity through disjointed and interacting forms. In *Ballet mécanique,* he liberated the potential dynamism of his painting into a brilliant display of vision in motion. The separation of these patterns of movement into interior and exterior rhythms is a handy tool for analysis, but inadequate for evoking an awareness of the richness and variety of movements on the screen. For *Ballet mécanique* is experienced as a kind of high-speed visual happening which floods our minds with a seemingly inexhaustible supply of images, infinitely variable, in new and surprising combinations, dynamically interacting with each other, and pouring off the screen with the apparent inexorable necessity of a natural phenomenon.

Most of *Ballet mécanique* unfolds at such a breathless pace that it invokes the threshold of comprehension. The most vibrant patterns of movement are generated by the rapid cutting of Léger's "horizontal penetrations," those incredibly rapid-fire visual volleys discharging several images a second. Yet movement, in *Ballet mécanique,* also comes from another

source, from the photographic rendering of modern life "on the go." Here, like the very first film-makers for whom kinetic activity in any scene of life was reason enough to photograph it, or like the Russian Constructivist directors whose charging locomotives were perfect expressions of the dynamism of modern life, so too, Léger quickens the pulse of his film by placing his camera at the very heart of such activities and inserting these images for our kinesthetic as well as visual response.

3. *The Close-up.*

"*Cinema makes 'the fragment' personal; it circumscribes it and it is a 'new realism,' the consequences of which could be beyond measure.*"

The close-up, for Léger, was the most powerful element in the language of filmic expression. It was a way of seeing what normally remains unseen. It enabled him to isolate objects and fragments from the commonplace realism of their normal environment, to present them magically transformed through enormous magnification into images of unexpected plastic beauty. Hence, throughout the film, pieces of kitchenware and machinery, pots and pans, hats, and shoes, the most ordinary objects are seen at intimate range to fill the screen with images of bold graphic design in uncompromising statements of their physical presence.

4. *Contrast.*

"*Everything is a constant opposition of violent contrasts.*"

Contrast is both the life-blood and the binding force of *Ballet mécanique.* The film is composed not from separate shots which link to each other as in most films, but from disparate ones which clash and collide. In fact, in the entire film, there is only *one* cut which provides a smooth unobtrusive transition from one image to the next: this is the cut from still no. 149 to no. 150, from 1) the man at the top of the chute, to 2) the man descending, seen now from below—a cut worthy of

any Hollywood hack film editor and containing a logical shift of camera position for fluid continuity of narrative action.

But fluid continuity was not Léger's interest. Rather he sought to create in film the same discontinuous, fragmented, kaleidoscopic world that his paintings described. Each shot of *Ballet mécanique*, like the hard-edged self-contained forms of his canvases, stands clearly apart from those preceding and following it, and thus, when viewed sequentially, these shots created patterns of continually exploding contrasts—in graphic design, movement, means of image-formation, representational content, and emotional overtones.

5. *Modern Urban Life.*

"On a main street two men carry gigantic golden letters in a wheelbarrow; the effect is so startling that everyone stops to look at it. There is the origin of the modern performance ... The street thought of as one of the fine arts?"

Such an observation by Léger—and the emphasis is his—demonstrates his acute awareness of the spectacle of the city. The pulsating energies of modern urban life, its rhythms and its forms, even its flashes of amusing incongruity, all can be felt in *Ballet mécanique*. His film is a spectacle in constant movement, infused with presence of modern machinery in motion, rushing pell-mell from and to nowhere, full of fragmented images and aggressive signals of advertising—a hard, intense, and vitally alive man-made environment, like the city, like his painting *The City.*

Chapter 8

Dulac and Seeber

Ballet mécanique embodied a new concept of filmic expression, disregarding narrative interest in favor of the visual rhythms created by the action and interaction of graphically expressive images. But after the film had been realized, what then? Was it only a private experiment carried out by Léger to satisfy his own curiosity or was it part of a larger artistic phenomenon? There were, of course, other avant-garde films of the 'twenties that experimented with non-narrative imagery along the lines of *Ballet mécanique*—in Europe, the films of Richter, Eggeling, Ruttmann, Duchamp, Dulac, Chomette, and Moholy-Nagy were the most interesting. While a sweeping survey of the avant-garde film movement is not our concern here, nonetheless, a brief consideration of some of these films will serve to place Léger's accomplishment in a more meaningful context.

Hans Richter had been greatly impressed with *Ballet mécanique* when it was shown in Berlin in 1925. Richter had just finished another short, *Rhythm 25,* today unfortunately lost, and like his earlier studies this one was also totally abstract and geometric, but with the addition of color applied to the film by hand (figs. 57 and 58). Thus far, Richter had used the camera essentially as a mechanical instrument to produce, as it were, animated abstract paintings. His rhythm studies were

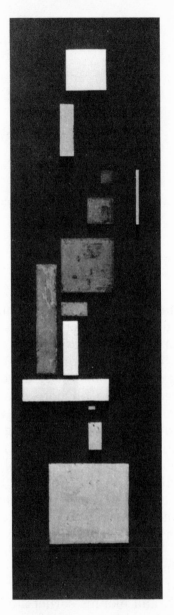

Fig. 57. Hans Richter, *Orchestration of Color*, 1923 (Museum of Modern Art, Tokyo). Courtesy Hans Richter (R)

Fig. 58. Hans Richter, Color sketches for his unrealized film, *Rhythm 25*, 1923-24. Courtesy Hans Richter (L)

Neoplastic compositions in motion—that is, precisely controlled orchestrations of geometrically pure forms moving through time and space.

Ballet mécanique opened Richter's eyes to the possibility of using the camera to extract images from the physical actuality of the real world, images which could then be used as a kind of semi-representational counterpoint to abstract images of similar design. In his next film, *Film Study,* Richter put this concept to the test. His three earlier abstract shorts had sharpened his sense of visual rhythms, and now, in 1926, he inserted photographic images of objects into a play of rhythmically animated geometric forms. Although *Ballet mécanique* undoubtedly provided Richter with the stimulus for this idea, his *Film Study* developed it in a totally different and original way.

First of all, Richter consistently distorted these "realistic" images to distance them from the commonplace realism of the everyday world. Léger's *nouveau réalisme,* the plastic beauty of ordinary objects seen at intimate range, was not Richter's goal. If Kiki's statuesque head (fig. 56) demonstrated Léger's passion for "le crudité de l'object en lui-même," then the multiple free-floating and semi-transparent heads in Richter's *Film Study* were meant to evoke that inner twilight state between reality and fantasy, a dream image seen with the eyes open—in short, essentially a Surrealist image and one which forecasted Richter's later forays into Jungian psychology in such films as his *Dreams that Money Can Buy,* 1944–47.

There is another important distinction between *Ballet mécanique* and *Film Study.* Léger's film is built from multiple shock contrasts between shots, Richter's from their fluid integration. Whereas Léger's film dazzles the eye, Richter's mesmerizes the mind. Léger's is an intense visual discharge, Richter's is a continuous melodic evolution of form. Hence, in *Film Study,* the alternation of photographic images with abstract designs emphasizes their similarity, not their contrast. In one passage, for example, a composition of white diagonal wedges sweeping across a field of black, like the patterns of moving searchlights in the night sky, is intercut with shots of a man wielding a sledge hammer, photographed from below to

produce similar graphic designs and printed in negative to underscore this similarity. Or in Richter's recurring passages of white disks which float and gyrate weightlessly in a black void, this mobile composition is played against similar movements of like forms, forms which, however geometric they may be, are not abstract but instead represent disembodied eyeballs rolling restlessly about. Again, this close intermingling of the real and the non-real fuses them together to produce a strange and dream-like state, all of a whole, and far removed from the clatter of Léger's hard industrial world.

Ballet mécanique belongs to that tradition of experimental film-making that consciously attempted to create a visualized music. The underlying idea of equating visual images with musical sounds was, of course, an old one. In painting, it grew out of the nineteenth-century theory of synesthesia and *Gesamtkunstwerk* to form the basis of Kandinsky's famous statement that "color is the keyboard" (1910), and to inform, in large measure, the paintings of artists like Kupka, Delaunay, Russolo, and Kandinsky himself. In film, music frequently provided a convenient analogy for the structure and articulation of forms in movement; witness the titles of Richter's *Rhythm 21*, Eggeling's *Diagonal Symphony*, Ruttmann's *Berlin—Sinfonie einer Grossstadt*, and even the pre-war unrealized film projects of Léopold Survage *(Rythme coloré)* and the proposed Schönberg-Kandinsky filming of *Die glückliche Hand*.

By the second half of the 'twenties, the notion of film as visual music was common currency, due in part to the example of *Ballet mécanique*. Among the film-makers who experimented along these lines, the most faithful practitioner was Germaine Dulac. Indeed, as we shall see, Dulac developed the theory of visualized music with such dogged insistence that the results have the character of pedagogical demonstrations in which the theory is the theme of the film rather than the underlying basis for it.

Dulac's most explicit demonstrations of film as visual music were made at the end of the decade. Her earlier films, by

Fig. 59. Germaine Dulac, *La Coquille et le Clergyman*, 1928. Courtesy Ciné-mathèque Française

contrast, were melodramatic and literary in flavor, often heavily tinged with Surrealism, and realized with imaginative, poetic touches. In her *Mort du Soleil* (1922), a film apparently lost today, she used a negative image to express the death of the sun's light; in *La souriante Madame Beudet* (1922), an ingenious shot into a three-way dressing-table mirror beautifully catches the anguished introspection of a woman contemplating the murder of her husband; and in *Le Diable dans la Ville* (1924), a scene of violent emotion is rendered in double imagery, as if observed through a fit of rage. One of Dulac's most famous works was her filming of *La Coquille et le Clergyman* (1928) after a scenario by the Surrealist poet Antonin Artaud. The film is a veritable catalogue of avant-garde camera tricks, ranging from weirdly elongated images of the sexually frustrated clergyman moving in slow-motion, to shots of his hands grasping at the mirage of a lovely lady's bare neck, to an almost painfully literal discription of a split-personality neurotic, his head dividing in two (fig. 59). *La Coquille et le*

Clergyman remains the first real Surrealist film, and deserves
to be classed with the subsequent hallucinatory confections of
Buñuel, Cocteau, Maya Deren, and Hans Richter. But Artaud
was furious with the result, and he publicly denounced the film
as a perversion of his script. The judgment was endorsed by
Artaud's fellow Surrealists, and, until Alain Virmaux's recent
study of the entire incident, the film has been the subject of
much misunderstanding. To add to the confusion, and to the
film's notoriety, it was rejected by the British Board of Film
Censors in about 1929 on the grounds that it "is so cryptic as to
be almost meaningless. If there is a meaning, it is doubtless
objectionable."

After her unfortunate encounter with the Surrealists over
La Coquille, Dulac abandoned these essays in surrealist film-
making, and instead created a number of short films of purely
visual rhythm composed on the model of music. Three such
films were apparently produced by her in 1928 or 1929:
Arabesques, Disque 957, and *Thèmes et Variations.*

Dulac regarded these films as experiments in "cinéma
pur," by which she meant "a cinema free from literary subjects,
and whose only subject would be lines and volumes."
Although the statement could serve as a succinct definition of
the early experiments in abstract film by Richter, Eggeling, and
Ruttmann, and as an echo of Léger's famous dictum that
"l'erreur du cinéma, c'est le scénario," in the light of Dulac's
actual accomplishment in "cinéma pur," it must be interpreted
somewhat differently. For Dulac never really believed in a
non-objective art and, moreover, she clearly lacked a feeling
for the purely graphic rhythms that distinguish *Rhythm 21* and
Ballet mécanique. Painting was not her model or inspiration.
Rather, it was music—and she was a gifted musician—which
she attempted to translate into film, and above all, it was the
mood generated by a piece of music that she sought to render
by silent images, insofar, that is, as mood can be separated
from musical rhythm.

Thus in *Arabesques,* she assembled a series of images that
would bring to mind the emotional overtones of the Debussy
composition of the same title. Reflections dancing on the water,

Fig. 60-61. Germaine Dulac, *Arabesques*, 1928-29. Courtesy Cinémathèque Française

Fig. 61. Germaine Dulac, *Arabesques*, 1928-29. Courtesy Cinémathèque Française

patches of sunlight filtering nervously through a tangle of trees,
and even man-made objects like clusters of bright glass beads
with points of light flickering from their rounded forms, all
served to evoke the light and twinkling strains of Debussy's
music (fig. 60). An interesting device used by Dulac in the film
was a honeycombed mirror that fragmented the camera's view
of nature into multiple identical images, yielding an image of
tiny, endlessly repeated notes (fig. 61). This optical distortion
technique was ideally suited for Dulac's visual interpretation
of Debussy's music, just as, five years earlier, Léger's jagged
prismatic fracturing echoed in visual form the restless dis-
sonance of Antheil's music in *Ballet mécanique*.

To make the point abundantly clear that *Arabesques* was
meant to be an exercise in visualized music, Dulac oc-
casionally inserted shots of hands playing a piano. These
literal references to music-making strengthen our intellectual
awareness of Dulac's intentions but, on the whole, they
weaken the film. Dulac's uncomfortable mixture of both
specific and poetic references to Debussy's music results in a
film that is neither documentary nor pure film poetry, almost as
if she took the metaphorical definition of avant-garde film,
coined by Louis Delluc—a leading film critic and avant-garde
film-maker whose influence on Dulac was considerable—as a
flat literal fact: "Est-ce un film? Non, c'est un piano."

In *Thèmes et Variations* Dulac reversed the emphasis of
Léger's comparison of men and machines. Ballet dancers and
machines are metrically intercut; their patterns of movement
are carried from shot to shot. In a similar fashion, slow motion
studies of plant growth are echoed by graceful movements of a
dancer's hands. In her aspiration toward creating a cinematic
tone poem, Dulac humanized and softened the form and
rhythms of both the human figures and the machines in her
film. Just as the piano playing in *Arabesques* made the musical
analogy overly specific, the prestylized movements of the
dancers in *Thèmes et Variations* attempted to do the work
Léger assigned to external rhythms. Dulac also made use of
superimpositions in this film where combined images of the
dancer's head and shots of water and flowers attempt to con-

vey a state of mind at peace with nature. Unfortunately, her third film of this period, *Disque,* has not been located for the purpose of this study.

The greatest impact of *Ballet mécanique* was within the avant-garde movement itself; the quality of the film and the fame of its maker assured its reputation as a masterpiece of avant-garde film-making. Richter, Dulac, others of this movement as well, shared Léger's interest in using the medium of film to create formal patterns of imagery, organized rhythmically rather than narratively. Yet no avant-garde film can be called a slavish imitation of *Ballet mécanique,* its influence within this movement was general and inspirational, not specific. There is, however, one film, a commercial advertising film, the so-called *KIPHO-Film,* made by Guido Seeber in 1925, in which the direct influence of Léger's film is clearly discernible and which merits brief examination here for two reasons. First, it documents a specific instance of Léger's innovations being picked up by a commercial art form at a surprisingly early date. And secondly, perhaps more importantly, it reminds us once again of the images and rhythms of commercial design that were such a vital ingredient in the formulation of *Ballet mécanique.*

Seeber (b. 1879) began making films with his father, a professional photographer, as early as 1898. He developed a fascination with trick photography and implemented many ingenious technical innovations to realize these effects. A capsule summary of Seeber's magical camera-work will indicate something of the range of his accomplishment.[75] In the filming of Paul Wegener's first film, *Der Student von Prag,* in 1913, Seeber created for the first time in film a *Doppelgänger-Aufnahme* in which an actor appears in a scene together with himself. In another Wegener film now apparently lost, *Lebende Buddhas,* 1921, with sets by the German Expressionist architect Hans Poelzig, Seeber managed to create a number of ghostly effects including the illusion of a spirit escaping from its body. Together with Erno Metzner, as Jay Leyda has pointed out, Seeber developed his most spectacular trick effects for G. W. Pabst's *Secrets of the Soul* (1926). This film, a kind of

Freudian case history full of wonderfully weird apparitions and distortions, was shown at an early date at the Studio des Ursulines in Paris. It is an important but little-known prototype of the Surrealist film.

Guido Seeber must have first seen Léger's film during its showing at the UFA Palast in May of 1925. He was the most experienced, the most ingenious and facile cameraman in Berlin—this during an era when Germany possessed the best studio cinematographers anywhere—who loved nothing more than producing astonishing trick effects, whatever their artistic justification within the context of a film. At the time, the entire German film industry was preparing for a huge technical and commercial exhibition in Berlin, the *Kino- und Photo-Aus-stellung*, or *KIPHO* in its popular abbreviation, to be held in the Haus der Filmindustrie on the Kaiserdamm, September 25 to October 4, 1925. To advertise the event, a film was commissioned from Julius Pinschewer (1883–1961), whose studio had produced advertising films for commerce and industry as early as 1910. With his shrewd commercial instincts, Pinschewer was alert to developments in the avant-garde film and had, in fact, hired Walter Ruttmann in 1925 to create a short hand-colored film, *Das Wunder*, combining his play of abstract forms with slogans and images extolling the praise of Kantorowicz liquor. But for a cameraman to make his *KIPHO-Film*, Pinschewer turned to Guido Seeber, who it is obvious, turned to *Ballet mécanique* for many of his ideas for the film.

Several stills from the *KIPHO-Film*, published in the trade periodical edited by Seeber himself, *Die Filmtechnik*, serve quite adequately to illustrate the style and content of his short film (fig. 62). As a preview of the objects awaiting our attention at the Ausstellung, we are first given glimpses of the latest model 35-mm cameras (fig. 62, no. 7), some 19th-century Praxinoscopes, an optical toy that produces the illusion of movement through Roget's principle of the persistence of vision (fig. 62, no. 8), and a few other pieces of museum-vintage cameras and magic lanterns (no. 12). This introduction is followed by a sprightly little pictorial essay about the production of a film. As typewriters peck away (nos. 3 and 15), the title

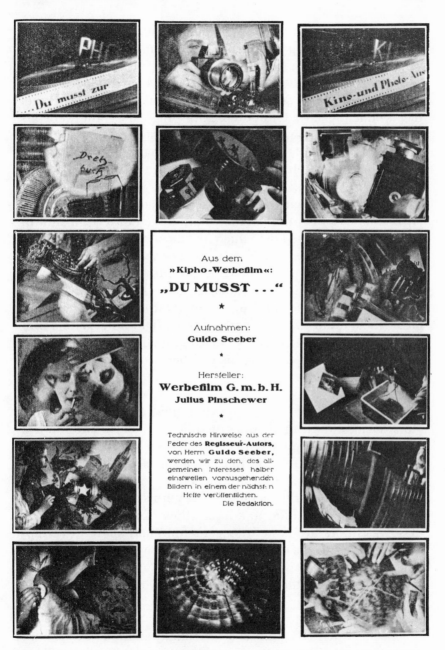

Fig. 62. Advertisement for the *KIPHO Film* by Guido Seeber, Germany, 1925. From *Die Filmtechnik*, I, 1925

Drehbuch, or "shooting script," appears (no. 2). Then a number of scenes illustrating various phases of film studio activity are intercut with explanatory titles. "Make-Up" flashes on, and we see an actress applying lipstick in a prismatically-fractured triple image that seems to come directly out of *Ballet mécanique* (no. 294). Or upon the title "Lights!", giant rheostats are shown (no. 14), photographed and distorted to emphasize their shiny corrugated metallic surfaces, again recalling *Ballet mécanique* (no. 72). Then, "Achtung! Aufnahme!", and the cameras are cranked (nos. 5 and 11).

A few more surprises follow. Suddenly there appears, with a shock effect that Léger would have enjoyed, a shot of Emil Jannings in *The Last Laugh,* the most popular and famous German film of the previous year. Then, finally, after some spectacularly beautiful underwater shots animated by liquid distortions, the title unwinds across the screen: "PHO-TOKINO. *Du musst zur Kino- und Photo-Ausstellung kommen!"* (nos. 1 and 10). The film ends on a light note, with a film clip from yet another famous German film: Dr. Caligari in front of his carnival tent inviting his prospective audience to come inside for the show.

Whereas *Ballet mécanique* attempted, as Léger has stated, "to create the rhythm of common objects in space and time, to present them in their plastic beauty," Seeber's film is composed of specific objects, that is, articles of film and photographic equipment, that are presented to tell a story about film-making. The jerky mechanical rhythms of Léger's film give way in the *KIPHO-Film* to a liquid flow of images created by dissolves (there are none in Léger's film) and spatial overlapping through the use of prisms and mirroring devices. Thus the film lacks the harsh contrasts of form and rhythm which characterize *Ballet mécanique* and creates instead a constantly evolving kaleidoscope pattern of distorted images unified only by common thematic content.

Seeber's *KIPHO-Film* is an excellent example of pseudo-modern work of the highest quality, composed with brilliant technique and using the most advanced artistic vocabulary of

its day. His results are unmistabkably modern, technically excellent, but only superficially impressive. Nonetheless, the film is a fascinating foil to Léger's film, even though less impressive as a work of art.

Moreover, it points to an interesting interchange of styles within the development of the commercial advertising film that are linked to Léger's film: 1) its source partly drawn from earlier advertising films, as in the scene with Léger's dancing wine bottles, 2) the film itself the inspiration for undoubtedly the most modern advertising film of its day, the *KIPHO-Film*, and 3) the extraordinary similarity of style between *Ballet mécanique* and so much of present-day commercial advertising film. Indeed, if shown without introduction or explanation on television today, the casual viewer would instinctively mistake *Ballet mécanique* for an advertising commercial, inexplicably too long and curiously lacking a product to be sold by its snappy insistent message.

Chapter 9

The Avant-Garde Film and Its Public

Like other performing arts, the physical existence of a film cannot be separated from its performance. Its "art" exists not in the film itself but on the screen. For this reason, the study of any work of film art must also consider the history of its screenings.

Ballet mécanique made its first public appearance in late September or early October of 1924 in Vienna at the *Internationale Ausstellung neuer Theatertechnik* organized by Friedrich Kiesler. The film itself is not listed in the catalogue, yet we know it was shown at this exhibition from witnesses who today recall the event and from an essay of 1925 by the French film critic, Georges Charensol, who complained: "But who would believe it? *Ballet mécanique* was a great success at the Theatre Exposition in Vienna last year, and it still hasn't been shown at home!"

Ballet mécanique continued to make a greater impression on the German-speaking art world than it did in Léger's Paris, and the next public presentation of Léger's film must have been in Berlin on May 3, 1925. The occasion was a matinee program of experimental films, probably the first full program of experimental films to be shown to a general public, at the UFA Palast on the Kurfürstendamm; the event was sponsored

jointly by the Novembergruppe (an organization of radical artists and architects founded in 1918) and the Cultural Department of UFA, who had demonstrated an early interest in such experiments through the technical assistance they gave to Hans Richter and Viking Eggeling in 1921.[76]

Léger's *Ballet mécanique* received further attention from the Berlin Art circles when his essay on the film, first published by Kiesler, appeared in a special film issue of Hans Richter's "G," this time in German translation, and later, in 1926, the film was illustrated and discussed by Rudolf Kurtz in his *Expressionismus und Film,* the first book in any language devoted to the expressionist and experimental film. Kurtz pointed out the stylistic affinity between Richter-Eggeling films and Léger's: "Fundamentally, Léger agrees with Eggeling and Richter. Together they have formed an alliance . . ." and Richter himself recognized the force of this alliance: "the existence of *Entr'acte* and *Ballet mécanique* . . . proved that we belonged to something."

The "something" that Eggeling and Richter felt they belonged to in 1925 was the avant-garde movement. Up till then there had been avant-garde films but no movement in the proper sense of the term. There were only a number of isolated artists working with film as a new art form. By mid-decade, however, as more and more experimental films were being made, in Paris, Berlin, and in Russia, there developed among these film-makers a mutual awareness of their goals and accomplishments. The principal force which gave these disparate experimental films a common identity was the *ciné-club.* Its role in forming the avant-garde film movement is comparable to that played by the art gallery in the development of modern painting, for without a means of exhibiting their films, there was no possibility of cultivating a public, nor could there by any cross-fertilization of ideas, so essential to the vitality of any new art.[77]

Ballet mécanique became a standard repertoire item for the *ciné club.* In this manner the film reached its largest audience, although it must have also been shown privately by Léger and other artists and film-makers who managed to

acquire a print. But as far as can presently be determined, it was not in Paris that the film was first shown to a *ciné-club* audience. This honor must be given to two *ciné-clubs* in distant cities where, by strange coincidence, *Ballet mécanique* was presented on the same day, March 14, 1926.

In London, it was presented by the *Film Society* at the New Gallery Cinema on Regent Street where it was shown with England's première screening of *The Cabinent of Dr. Caligari,* and in New York by the *Film Associates,* together with L'Herbier's film, *L'Inhumaine (The New Enchantment),* for which, as we have seen, Léger had designed some notable sets.

The reason for double première in London and New York, even before it had been shown by a *ciné-club* in Paris, was Dudley Murphy. He had left Paris shortly after the completion of the film and undoubtedly deposited a print with the London *Film Society* on his return to this country. In New York, Murphy joined forces with Symon Gould, the founder and director of *The Film Guild,* probably America's first *ciné-club,* or "Little Cinema" as they became known. *The Film Guild* soon expanded its title into the loftier designation of *The International Film Arts Guild,* for most of their early programs were composed of foreign films, and *Ballet mécanique* was first shown by them at the Cameo Theater on Broadway on March 18, 1926, only a few days after its première showing by the *Film Associates.* Due to Murphy's assistance in the scheduling of films at *The International Film Arts Guild,* it is not altogether surprising that *Ballet mécanique* appeared regularly on their programs.

With Hans Richter as a friend of Léger's and the most active avant-garde *cinéaste* in Berlin, and Dudley Murphy representing his own interests in New York, the film was assured of being known in these two capitols during the late 'twenties. But what of Paris? Less is known about when and where the film was shown there. Yet enough information is available, even though annoyingly imprecise, to demonstrate that the film soon became widely known in Léger's own city. In fact, by 1930 the film had probably found its largest and most critical audience in Paris.

Léger's first attempt to have *Ballet mécanique* shown in Paris was a failure. Shortly after the film was completed, an avant-garde film theater was being established in Paris by a young writer and critic named Jean Tedesco. He had rented the *Vieux-Colombier,* which earlier had been an important theater under the direction of Jacques Copeau. But by 1924, the theater had fallen on bad times and was reconverted by Tedesco into a cinema house with the view of assembling and presenting a repertoire of artistically interesting films. Tedesco's eyes had first been opened to the expressive potential of film by *Caligari,* and, although a sympathetic and articulate spokesman for all experiments in cinema art, he privately preferred films of a psychologically or lyrically poetic nature. Thus his unfortunate hesitation when he first experienced Léger's amazing film:

> It was in 1924, a few days before my opening.* I was alone in the theatre one morning when I was approached by a man who had slipped in through a side door. I did not know him. He had a metal can under his arm and he told me right off that he was bringing me an authentic avant-garde film. I ordered a projection right away. It was a film of "animated objects," unquestionably ingenious but edited without titles so that it left me perplexed. I was perhaps that morning in no mood to get excited about it. I deliberated much too long whether or not I should accept it and by the time the projectionist came down with the can I decided not to show it. I saw then that the man grabbed it back, passionately. "If the Vieux-Colombier doesn't take my *Ballet mécanique,*" he said curtly, "then it has no reason to exist . . ." This man was Fernand Léger. Before I could answer him he slammed the door, red with anger. Perhaps he was right, but he had come a little too soon.[78]

* The *Vieux-Colombier* opened as a film theater on November 14, 1924.

Despite this initial disappointment, Léger's film was almost certainly shown at the *Vieux Colombier* later in the 'twenties when Tedesco began to include a wider range of experimental films in his program. Paintings by Léger were hung in the lobby of the theater, along with those of Man Ray and others, and it would seem strange it his film was never exhibited inside.

Probably the first Parisian *ciné-club* to show *Ballet mécanique* to the public was the *Studio des Ursulines,* a major avant-garde film theater housed in a former Ursuline convent and founded in January of 1926 by the actor Armand Tallier. Other *ciné-clubs* that exhibited Léger's film were the *Studio 28,* so named for the year it was founded (on Feb. 10) by Jean Mauclaire and perhaps best known for its presentation of the Buñuel-Dali surrealist films, and *Le Ciné-Club de France,* an outgrowth of Canudo's original *Club des Amis du Septième Art,* the first to show *Potemkin* in Paris.

Numerous other *ciné-clubs* proliferated and flourished in Paris during this second half of the decade. Many were ill-organized and short-lived, and their membership, their activities, and the films they exhibited are only sketchily known, for the *ciné-club* movement has never been studied at all. Was *Ballet mécanique* shown, for example, at the *Tribune Libre du Cinéma, Le Club de l'Ecran, La Lanterne Magique, Le Phare Tournant, Les Spectateurs d'avant-garde, L'effort, L'Oeil de Paris, Les Agriculteurs, Les Amis de Spartacus, Regards,* or any other avant-garde Parisian film clubs of the late 'twenties? The answers to these questions must await considerable further research.

For all the known and recorded showings of *Ballet mécanique,* there must have been a great many more, both public and private. Eisenstein, for example, saw the film and praised it highly, calling it one of the rare masterpieces of the French cinema. During his visit to Paris in 1930 he met Léger, and Kiki too, who drew a charming portrait of him. Eisenstein may have seen *Ballet mécanique* even earlier, in Russia, if it was included in the assortment of avant-garde films brought back from Paris and exhibited in 1926 by the novelist Ilya

Ehrenburg. It is even more likely that Ehrenburg's collection included that important prototype for *Ballet mécanique,* Gance's montage of machinery from *La Roue.* Ehrenburg had been given "fragments of films" by Gance, René Clair, Jacques Feyder, Jean Epstein, Jean Renoir, and Dimitri Kirsanoff, and these he showed in Moscow in 1926 upon his return from Paris. Given Ehrenburg's friendship with Léger, Cendrars, and Gance, and in the light of Gance's fondness for assembling rhythm studies from *La Roue* for *ciné-club* audiences, it seems likely that this early example of French montage found its way to Russia in 1926.

It is tempting to see in Eisenstein's *Old and New* of 1929 certain echoes of *La Roue* or *Ballet mécanique.* In the cream separator scene, for instance, the patterns of machinery in motion—seen through the eyes of skeptical peasants who ask, "Will it work?"—are transformed into a dazzling arabesque of light playing on metallic surfaces. Even closer to the spirit of Cendrars and Léger is the freedom with which Eisenstein edited this visually sensuous passage, for intercut with these poetic images are spectacular shots of pirouetting shafts of light which, on closer inspection, can be seen to be nothing more than a spinning chrome-plated bicycle wheel! This passage in Eisenstein's film is by far the most "abstract" he ever made, and quite likely he was stimulated to experiment along these lines by the European avant-garde films that Ehrenburg had shown him in 1926.

As far as the pre-war film is concerned, Léger must have viewed it with far more interest than did Eisenstein, for whom the story, in the last analysis, retained considerable importance, and who never used abstract imagery except in the service of narrative exposition. Léger's first thoughts for an opening shot to establish the rhythm of *Ballet mécanique,* a man swinging on a pendulum, as indicated by his notes, recalls an early American film, *The Dream of a Rarebit Fiend* (1906), in which a gluttonous slob, groggy from excess food and drink, grasps a swinging lamppost for support. The connection between the two films cannot be established, yet René Clair's Dada film, *Entr'acte,* is a clear-cut example of borrowing from

the pre-war film; the chase after the runaway hearse comes directly from a Mack Sennett comedy of 1913, *Heinzie's Resurrection*, shown in France in 1917 as *Les deux copains*.

The Dada and Surrealist film-makers, who have been examined here principally as a foil to Léger, understood the early film to be a "terrible and magnificent flag of life," as Soupault had told us. Their films overflow with the same supercharged fantasy used by the earliest film-makers for pure entertainment value. The ghoulish monsters who invade the *Haunted Hotel* (1907), or the sliding panels and trick stairways of *Protéa*, a French comedy of 1914, are revived in French avant-garde films of the 'twenties.

Other Dada and Surrealist films of the late 'twenties contain surprising echoes of the pre-war film of fantasy. Hans Richter's *Ghost before Breakfast* features a collar that inexplicably detaches itself and rebels against its daily sartorial function, as in *The Troublesome Collar*, a British comic short of 1903. Similarly, Cocteau, in his first film, *Sang d'un Poète*, defies forces of gravity through trick photography in a manner that recalls, and probably derives from early trick films, or in the masterpiece of the Surrealist cinema, Buñuel and Dali's *L'Age d'Or*, the shock juxtaposition of cow and bed, like the camel in the living room from a playful films or in the masterpiece of the Surrealist cinema, Buñuel and Dali's *L'Age d'Or*, the shock juxtaposition of cow and bed, like the camel in the living room from a playful film of Jean Durand's *Onésyme* series, shatters the rational continuities of everyday life, not for comic effect, but to fabricate a palpable hallucination through the disquieting combination of familiar objects in improbable surroundings and revealed with the cool veracity of the camera eye.

The art of the film—direct, overpowering, in constant movement, allowing no time for reflection, evoking kinesthetic reactions and poetic evocations with equal ease—has rather little to do with the traditional world of aesthetic contemplation generated by static works of art. But modern art in general, from Cubism to the present day, has been increasingly concerned with precisely those characteristics of filmic expres-

sion, most notably movement and the elimination of aesthetic distance between the art object and the direct experience of life itself. And so while film uses neither the means nor the materials of the traditional visual arts, it unmistakably symbolizes and expresses a major function of art in the twentieth century.

Appendix

Shot Analysis
of "Ballet Mecanique"

Still No.	Frame Count	Screening time, in seconds	Description of image content, camera movement, or action of subject
1-5			Titles and credits
6-7			Introductory note: "Le BALLET MECANIQUE a été composé par le peintre Fernand Léger en 1924. C'est le premier film *sans scénario*. Il a été présenté dans toutes les capitales d'Europe et plusieurs fois à New-York. Jusqu'ici on ne l'avait vu à Paris que dans des réunions privées. Il nous a paru intéressant au moment où les haut-parleurs écartent de l'écran tout possibilité de rêve, de présenter ce film dont S. M. Eisenstein a dit qu'il était un des rares chef-d'oeuvres du cinéma Français."
8-10	108	6 3/4	Chaplin figure raises his hat and nods his head. Pan shot moving upward to reveal:
11-12	72	4 1/2	Title: "Charlot présente le Ballet Mécanique."
13-15	289	18 1/16	Girl on swing in garden. Camera static. Girl swings with regular rhythm back and forth, to and away from camera, several times.

16	2	1/8	Straw hat, photographed from above.
17	1	1/16	Numbers and round metal object diagonally placed against black ground.
18	4	1/4	Three wine bottles.
19	3	3/16	White triangle.
20	35	2 3/16	Straw hat, as in shot 16.
21-23	118	7 3/8	Upper half of image masked off. Mouth of female model breaking into a broad smile several times in a regular rhythm.
24	35	2 3/16	Straw hat, as in shot 16.
25-27	111	6 15/16	Smile of model, as in frames 21-23.
28	47	2 15/16	A series of radially-striped painted wheels roll by. Camera static.
29-30	101	6 5/6	A number of white geometric objects seen against a black background. Between them and the camera, a large highly reflective metal sphere swings from side to side. The same rhythm is carried over to:
31-33	181	11 5/16	Girl on swing, same figure and setting as in stills 13-15. Here she is upside down and closer to the camera. Regular rhythm established as she swings back and forth. Same rhythm is carried over to:
34-38	161	10 1/6	Reflective sphere swinging back and forth. The reflected images of Léger (no. 34) and Murphy (behind camera, nos. 35 and 37) can clearly be seen.
39-45	210	13 1/8	Arrangement of highly reflective Christmas tree ornaments and geometric background elements. Prismatic fracturing of image moves from right to left.

46-50	96	6	Corrugated sheet metal, highly reflective. Black rectangle with lopsides "T" drawn upon it, moved rhythmically from side to side.
51-54	87	5 7/16	Close-up of shiny corrugated sheet metal. Rhythmically moving image is fractured by prism.
55-58	94	5 7/8	Background of white stripes against black. Across this moves a rotating and gyrating saucepan lid. Entire image fractured by prism.
59-60	65	4 1/16	As in stills 51-54.
61-70	78	4 7/8	A rapid alternation of white circle and triangle against black background. Each image is of two or three frames duration. Size of these geometric forms gradually diminishes.
71-73	94	5 7/8	As in stills 59-60, but with moving prism in different position.
74-77	94	5 7/8	Undersurface of a kitchen utensil, apparently a gelatine mold of the type used for salads and desserts. Moving image is prismatically fractured.
78-80	92	5 3/4	As in stills 71-73.
81-83	228	14 1/4	As in stills 56-58. Saucepan lid, held by a pair of tongs (no. 83), is moved back and forth with abrupt rotary motion. Image prismatically fractured.
84	78	4 7/8	Another kitchen utensil, a multi-tiered cake form? As in previous shot, this object is moved about with a jerky rotary motion and image is prismatically fractured.
85	16	1	A highly polished, rapidly spinning machine part.
86-87	38	2 3/8	Close-up of model's eyes, at first open, then slowly closing.

88-89	32	2	The above scene but upside down and reversed in time.
90-92	120	7 1/2	As in still 85. Camera slowly moves away from spinning object to reveal more of machine.
93-94	64	4	Sheet metal image prismatically fractured. Camera moves down to reveal man's head (Dudley Murphy).
95-97	53	3 5/16	Several objects, including the gelatine mold and an egg cup, against black background. Rotary movement of prism.
98-99	85	5 5/16	As in stills 93-94.
100-102	257	16 1/16	Several closely similar shots of the undersurface of the gelatine mold seen previously in stills 74-77. Iridescent lighting. Continuous and rhythmic movement of both camera and prism.
103	84	5 1/4	As in stills 81-83.
104	91	5 11/16	Head of a live parrot. Image prismatically fractured.
105-106	74	4 5/8	Camera subject is as in stills 46-50, but here image is prismatically fractured.
107-109	60	3 3/4	Rapid alternation of circle and triangle, decreasing in size.
110	2	1/8	Straw hat, as in stills 16, 21, 25.
111	3	3/16	Chair, papers and book lying on floor.
112	2	1/8	Row of metal saucepans and ladles.
113	3	3/16	As in still 17. Numbers and round metal object diagonally placed against black ground.
114	2	1/8	Numerals "1," "2," and "3," written three times.
115	3	3/16	Highly polished crankshaft, static image.

116	2	1/8	Large inverted triangle.
NI	2	1/8	Straw hat, as in still 110, very over-exposed.
NI	1	1/16	White circle.
NI	1	1/16	Straw hat, as in still 100, very under-exposed.
117	3	3/16	Various objects (white rod, three small metal spheres, large piece of white paper with straw hat and smaller piece of black paper) against black ground.
NI	3	3/16	Large white circle, as in still 107.
118	2	1/8	Six wine bottles lying on their side.
119	3	3/16	Small circle.
120	2	1/8	Two pairs of wine bottles, standing and symmetrically disposed.
121	2	1/8	Three standing wine bottles.
NI	3	3/16	Numerals "1," "2," "3," as in still 114.
NI	3	3/16	A single wine bottle.
122	4	1/4	Typewriter, image very dim, possibly copied from an illustration.
123	4	1/4	Three wine bottles.
124	2	1/8	Numerals "1," "2," "3."
NI	41	2 9/16	Rapid alternation of small bright circles and triangle, one to three frames for each image.
125-130	522	32 5/8	Long passage. Scene is that of still 117, of various geometric forms against a black background. Image is fractured prismatically. Continuous and rhythmical movements of both the camera and the prism.

131	19	1 3/16	Left half of image is masked off. The right eye of a female model is shown in extreme close-up. At first eye is closed, and then it slowly opens with eye looking upwards.
132	6	3/8	Right half of the image is masked off. The left eye of a female model is shown in extreme close-up. Eye remains closed.
133-137	78	4 7/8	Right eye opens and closes. Each time eye opens it is looking in a different direction.
138	70	4 3/8	As in stills 125-130.
139	234	14 5/8	Background elements are the same as in still 117, but here the image is inverted. In front of the camera swings the highly reflective sphere, as in stills 29-30. This metrically regular movement is abruptly changed from a side-to-side movement to the towards-and-away movement in the following shot.
140	75	4 11/16	Highly reflective metal sphere swings towards and away from camera. The shot is identical with that in stills 34-38 but the image is inverted.
141	119	7 7/16	Moving and gyrating kitchen implement of wire spirals with funnel inside it. Image prismatically fractured. Two shots of slightly different camera angle.
142	138	8 5/8	Mouth of female model, rhythmically breaking into smile, as in stills 21-23.
143	28	1 3/4	Static image of rows of crockery, viewed on side. Presumably copied from an illustration.
144	53	3 5/16	Rotating roulette wheel.
145	25	1 9/16	As in still 143.
146	56	3 1/2	Close-up of revolving object, apparently an amusement park game of chance, like a pin-

			ball machine. Rows of circular hooded apertures arranged concentrically around an illustration of two cupid-like angels.
147	27	1 11/16	Same image as in stills 143 and 145, but here inverted and reversed.
148	61	3 13/16	Same as in still 146.
149	91	5 11/16	A rapid pan shot with violent camera movement, showing man in amusement park chute as he moves around curve towards descent.
150	22	1 3/8	A rapid pan shot following man in descending chute.
151	43	2 11/16	Feet marching by in parade. Camera placed close to ground.
152	56	3 1/2	Camera placed on street, two automobiles drive over at high speed.
153	94	5 7/8	Mechanical ride at amusement park. Several cars are attached to revolving central wheel. Camera static as three or four cars spin past.
154	219	13 11/16	Revolving machine part, as in still 90.
155-157	93	5 13/16	As in stills 61-70. Rapid alternation of circle and triangle shapes, gradually diminishing in size. Each image two or three frames.
158	63	3 15/16	Wooden slide at amusement park, camera directly above. A series of quick shots of figures sliding past, each figure preceded by a long shadow. Direction of movement is reversed between each shot, creating a back-and-forth movement whose rhythm is carried over to:
159-160	320	20	Cross section of a piston pumping up and down, rapid movement.
161	90	5 5/8	Same scene as in still 158. Several figures slide past.

162-163	147	9 3/16	Close-up of machine in operation, possibly a pump. Effect of light glistening off of pistons, tie-rods, etc.
164	14	7/8	Static image of heavy metal structure, possibly an automobile chassis.
165-167	219	13 11/16	Close-up of machine in motion. Some parts rotate, others are long thin metal elements which move back and forth. Image prismatically fractured. Machine, or perhaps the camera itself, moves slightly sideways.
168-169	132	8 1/4	Alternation of circle and triangle gradually increasing in size. Most of them six frames each.
170-172	256	16	As in stills 165-167. Machine moves farther to right.
173	78	4 7/8	Large and powerful shape of pump silhouetted against sky. Mechanical elements move slowly up and down.
174	105	6 9/16	Wire kitchen implement with funnel inside. Object is spinning eccentrically.
175	139	8 11/16	Three wire beaters dancing about.
176	146	9 1/8	A large and powerful machine in motion, with piston moving slowly.
177-179	189	11 13/16	The same shot is photographed obliquely from front. Piston moving to and from camera, creating strong patterns of light.
180-181	67	4 3/16	Eyes of female model slowly opening.
182-183	184	11 1/2	Same machine as in stills 177-179, in motion and photographed from another angle.
184-185	40	2 1/2	Eyes of female model, at first wide open, then slowly closing.

186-187	172	10 3/4	A shining rotating machine part, photographed from above.
188-192	219	13 11/16	A washerwoman climbs a flight of stone steps from Seine with a load of laundry upon her shoulder. As soon as she reaches the top step (no. 191), she immediately reappears at the bottom (no.192). She repeats this motion seven times in this sequence. Each ascent takes between twenty-nine and thirty-five frames to complete.
193-195	144	9	Top half of image is masked off. Mouth of female model rhythmically breaking into smile.
196	345	21 9/16	The washerwoman sequence (nos. 188-192) is repeated eleven times.
197-198	122	7 5/8	Close-up of machine part in cranking operation. The machine is the same as in stills 176-179 and 182-183.
199	164	10 1/4	The washerwoman sequence, repeated five times.
200	21	1 5/16	No image: total blackness.
201-203	65	4 1/16	White curved forms, prismatically fractured, gradually come into view. They float towards center to form a large figure of "zero."
204-205	66	4 1/8	Zero slowly decreases in size.
206	84	5 1/4	Title: "ON A VOLÉ UN COLLIER DE PERLES DE 5 MILLIONS"
207-209	133	8 5/16	Rapid alternations of one, two, and three zeros in irregular rhythm.
210	16	1	Title: "ON A VOLÉ"
211-212	219	13 11/16	As in stills 207-209, an alternation of one, two, and three zeros.

213	27	1 11/16	Title: "DE 5 MILLIONS"
214-215	124	7 3/4	Alternation of one, two, and three zeros in varying sizes: large (no. 214), and smaller (no. 215).
216	27	1 11/16	Title: "ON A VOLÉ"
217	71	4 7/16	A single zero decreasing in size.
218	25	1 9/16	Title: "UN COLLIER DE PERLES"
219	141	8 13/16	Irregular alternation of one, two, and three zeros, all the same size.
NI	29	1 13/16	Title: "DE 5 MILLIONS," as in still 213.
220	61	3 13/16	Right eye of female model, opening and closing slowly.
221	88	5 1/2	Static image of an old-fashioned horse collar, photographed from an illustration.
222-223	95	5 15/16	For fifty-six frames an alternation of blank screen (no. 222) and collar (no. 223). Then, for forty frames, stop-frame photography of the collar to make it appear to be bouncing up and down.
224-231	126	7 7/8	Collar moves back and forth, up and down, and at slight angles, interrupted once by the title: "UN COLLIER" for four frames, and once by a detail of a machine (no. 230) for a duration of two frames.
232	29	1 13/16	Title, in reverse: "DE 5 MILLIONS"
NI	9	9/16	No image: as in still 222.
233	22	1 3/8	Title in reverse: "UN COLLIER DE PERLES"
234	9	9/16	In reverse: The numeral "5."
235-236	39	2 7/16	A single zero, increasing in size.

237-238	102	6 3/8	In irregular rhythm, an alternation of the numerals "3," "5," and "0," and also short shots of fragments of the title in still 84, and short shots of the horse collar in still 221.
239	26	1 5/8	A diagonal arrangement of the letters V-O-Z, but with "Z" reversed.
240	24	1 1/5	The preceding still in reverse mirror image.
241-244	137	8 9/16	Head of female model rotating from left to right profile. Her face is absolutely motionless and expressionless.
245-247	101	6 5/16	Polychromed wooden statue of Uncle Sam (?), swinging back and forth in front of the camera.
248-249	76	4 3/4	White circle, increasing in size.
250-253	152	9 1/2	Head of female model prismatically fractured. Hand passes across face, her facial expression changes, and then cardboard masks with cut-out circles and squares are passed over her face.
254-257	139	8 11/16	Alternation of circle and triangle in decreasing size. Each image is of two to four frames.
258-259	113	7 1/16	Stack of fluted pie plates or similar kitchen object. Rhythmical changes in size by shots alternating camera distance.
260-262	124	7 3/4	Row of shiny pot lids and soup ladles, alternated with blank dark screen.
263-266	55	3 7/16	Rows of lids and funnels. Alternation of shots, each of four or five frames, switching into upside down and reversed images.
267-269	106	6 5/8	Row of lids hanging from rack, swing violently at an angle in front of camera.
270	54	3 3/8	Left eye of female model, slowly opening and closing.

271-274	196	12 1/4	Varied shots of rows of shining kitchenware: saucepans, ladles, and cake molds are spread out against black ground. Camera movement back and forth from objects. Some shots are inverted or reversed.
275-276	74	4 5/8	White circle, increasing in size.
277	83	5 3/16	Display in show window of store.
278	186	11 5/8	White circle growing larger, then smaller, then larger again.
279	34	2 1/8	Two mannequin legs, with garters above knees and held at heel by wire brace. Static image.
280	40	2 1/2	Mannequin legs, upside down and framing clock.
281-289	360	22 1/2	An animated dance by the mannequin legs. They revolve around, moved by the wire brace at the heels (nos. 283-285), and then jump from a profile position (no. 285) to an inverted position (no. 286).
290	64	4	Two highly reflective Christmas tree ornaments, hanging from strings and swinging back and forth.
291-293	410	25 5/8	Rapid alternation of straw hat and shoe, four to six frames each image. In middle of this series, shoe is seen in reversed position (mirror image) for two shots of four frames each.
294-295	222	13 14/16	Prismatic fracturing of the image of face of female model, with masks, as in stills 250-253.
296	101	6 5/16	Rotation of head of female model from right profile to three-fourths left as in stills 241-244.
297-298	51	3 3/16	Rapid alternation between two close-up shots of head of female model, photographed from below (still 297) for five frames and straight ahead (still 298) for six frames, in multiple alternations.

299-300	314	19 5/8	A series of shots of wine bottles, from one to five in number and placed in varying positions and groupings.
NI	572	35 3/4	Film concludes with reappearance of the figure of Charlot. He dances about, becomes completely disjointed and falls apart. He then disappears leaving only his head suspended in the air.
NI	218	13 5/8	Final shot of the film shows girl in garden (as in stills 13-15), sniffing a blossom with an elegant and mannered gesture.

1

1924

BALLET MÉCANIQUE

directed by Fernand Léger

acquired through the courtesy of Mr. Léger

2

An abstract film of objects in motion and rhythmic patterns, made by the cubist painter, Fernand Léger.

3

SYNCHRO-CINE présente

4

UN FILM DE

FERNAND LEGER

5

BALLET MÉCANIQUE

6

...a été composé par le peintre Fernand Léger en 1924. C'est le premier film sans scénario. Il a été présenté dans toutes les capitales d'Europe et plusieurs fois à New-York. Jusqu'ici on ne l'avait vu à Paris que dans des réunions privées.

7

ne l'avait vu à Paris que dans des réunions privées. Il nous a paru intéressant au moment où les haut-parleurs écartent de l'écran toute possibilité de rêve, de présenter ce film dont S.M. Eisenstein a dit qu'il était un des rares chefs-d'œuvres du cinéma Français.

8

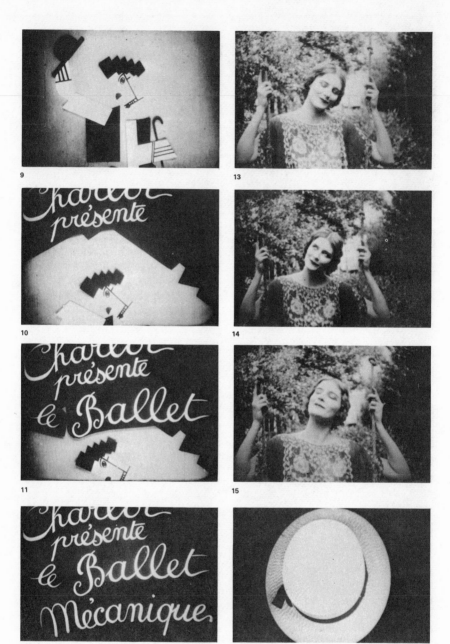

9

10

11

12

13

14

15

16

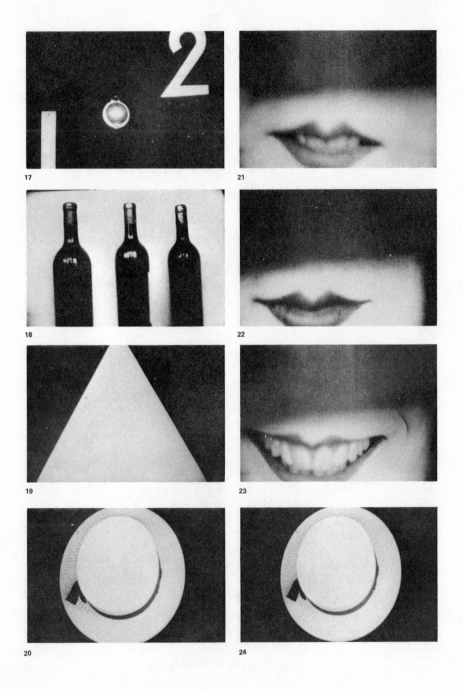

17

21

18

22

19

23

20

24

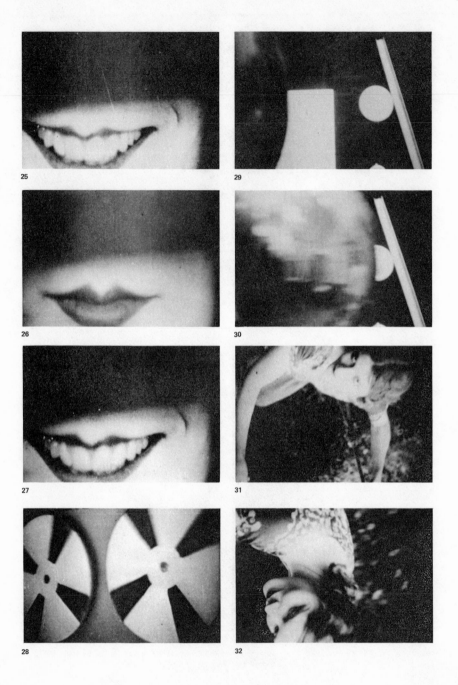

25

26

27

28

29

30

31

32

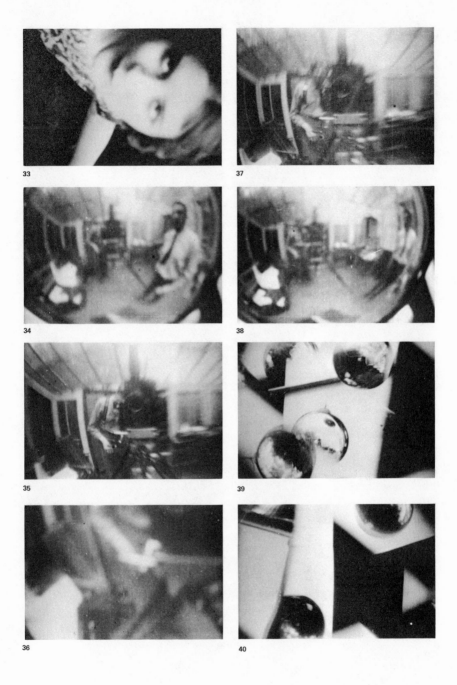

33

37

34

38

35

39

36

40

41

45

42

46

43

47

44

48

49

50

51

52

53

54

55

56

57

58

59

60

61

62

63

64

65

69

66

70

67

71

68

72

73

77

74

78

75

79

76

80

81

85

82

86

83

87

84

88

89

93

90

94

91

95

92

96

97

101

98

102

99

103

100

104

105

109

106

110

107

111

108

112

113

114

115

116

117

118

119

120

121

125

122

126

123

127

124

128

129

130

131

132

133

134

135.

136

137

141

138

142

139

143

140

144

145

146

147

148

149

150

151

152

153

157

154

158

155

159

156

160

161

162

163

164

165

166

167

168

169

173

170

174

171

175

172

176

177

178

179

180

181

182

183

184

185

186

187

188

189

190

191

192

193

194

195

196

197

198

199

200

201

205

202

ON A VOLÉ
UN COLLIER DE PERLES
DE 5 MILLIONS

206

203

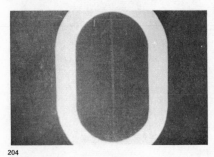

207

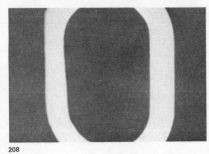

204

208

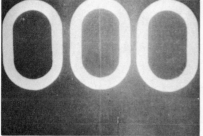

209

210

211

212

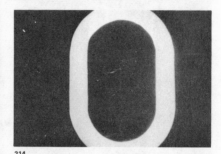

213

214

215

216

UN COLLIER DE PERLES

217

221

218

222

219

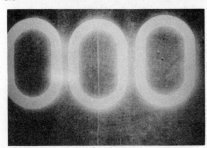

223

220

224

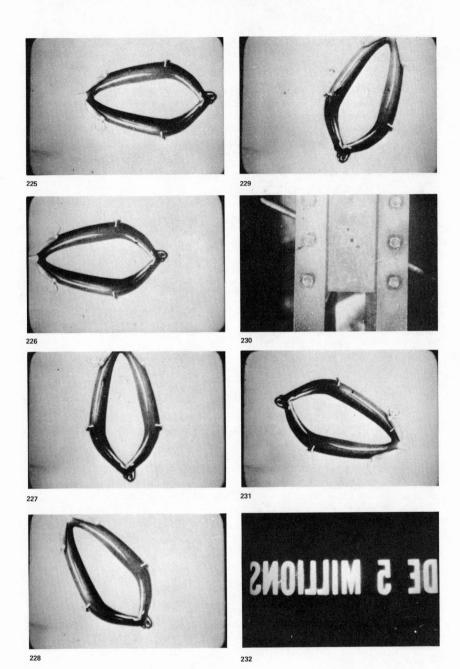

225

229

226

230

227

231

228

232

233

234

235

236

237

238

239

240

241

242

243

244

245

246

247

248

249

253

250

254

251

255

252

256

257

261

258

262

259

263

260

264

265

266

267

268

269

270

271

272

273

277

274

278

275

279

276

280

281

285

282

286

283

287

284

288

289

290

291

292

293

294

295

296

297

298

299

300

Notes

1. George Bernard Shaw, "The Cinema as a Moral Leveller," *The New Statesman—Special Supplement on the Modern Theatre,* III, no. 64, June 27, 1914, p. 1.
2. René Doumic, "L'âge du cinéma," *Revue des Deux Mondes,* 15 Aug. 1913, p. 920.
3. Cf. the following note published in *Hommage à Jules-Etienne Marey* (exhibition catalogue), Cinémathèque Française, Paris, 1963: "Lorsque nous avons approché Severini, Max Ernst et Marcel Duchamp pour leur faire l'aveu de notre souhait d'associer certaines de leurs oeuvres à l'hommage que nous désirions rendre à Marey, nous ne rencontrâmes que bienveillance et enthousiasme. L'idée de confronter leurs oeuvres aux chronophotographies, leur apparaissait toute normale. L'idée d'associer le dynamisme du futurisme aux travaux du père de la locomotion animale qui certainement aurait fait hausser certaines épaules parut au contraire être une légitime association à Severin. Ainsi tout se lie, tout se tient, et, l'explosion de l'art du 20° siècle, ne rejette rien de l'univers qui lui donna le jour et certainement pas le cinéma et sa génèse." Severini's paintings, *Pam Pam al Monico* (1911–1912; formerly Collection Walden), *Self Portrait* (1912; Collection G. Sprovieri); Marcel Duchamp's *Les*

joueurs d'échecs (1912), *Nude Descending a Staircase* (in reproduction), and Max Ernst's *Les oiseaux* (1925) were included in this exhibition. Marcel Duchamp, speaking of his *Nude Descending a Staircase,* noted that "Chrono-photography was at the time in vogue. Studies of horses in movement and of fencers in different positions as in Muybridge's albums were well known to me" (see J. J. Sweeney, *The Bulletin of the Museum of Modern Art,* VIII, no. 4-5, 1946, p. 19).

4. Henri Bergson, *Creative Evolution,* New York, 1911, p. 302.

5. For Picasso's pre-World War I movie habits, see note 29.

6. David-Henry Kahnweiler, *The Rise of Cubism,* New York, 1949, p. 22; in his book *Juan Gris,* London, 1947, p. 88, Kahnweiler has dated these conversations with Picasso about 1912.

7. *Les Soirées de Paris,* nos. 26-27, July-August, 1914, pp. 426-429, under the name "Leopold Sturzwage." This translation is by Mike Weaver, published in *Image* (Cambridge), October, 1965, pp. 11-12. I am grateful to Mr. Weaver for allowing me to study his file of documents on Survage obtained from the artist himself.

8. Gaumont had developed a color process in about 1911 which worked in the following way. Three synchronized images, identical in their pictures but tinted in complimentary colors, were projected simultaneously. If the images were exactly congruous and their registration on the screen exactly aligned—as in multiple-block color printing—the result was a colored moving picture. The film itself, that is the strip of celluloid bearing the image, was black and white; its projected image colored by filters. (A true colored film was not invented until 1917 by Tech-nicolor, but its development languished until the late 'twenties when the invention of sound stimulated Hollywood to perfect color as yet another step towards total naturalism; its first commercial success was in the animated cartoons of Walt Disney in 1932; see Lewis Jacobs, *Rise of the American Film,* New York, 1939, p. 446.)

A system similar to Gaumont's was developed at the same time in England under the trade name "Kinemacolor"; it used two projected images instead of three, and although criticized for its "un-naturally vivid colors" (Talbot, p. 296, see below), this would perhaps have pleased Survage who doubtless valued intensity of color over its representational accuracy. These early experimental efforts toward a color film were shown from time to time, for, despite their imperfections, they delighted the public by the promise they held for an all-natural film of the future. The early techniques and formulas for colored movies were jealously guarded by film producing companies, and, unlike other innovations more easily pirated (and thus more quickly disseminated), the development of color was slow and somewhat compartmentalized. For the early history of color in film see: "Kinemacolor," *Moving Picture World*, Dec. 11, 1910, p. 831; Hugh Hoffmann, "The Gaumont Chronochrome," *Moving Picture World*, June 28, 1913, p. 1346; Frederick Talbot, *Moving Pictures*, London, 1912, pp. 287–300; Geo.-Michel Coissac, *Histoire du Cinématographe*, Paris, 1925, pp. 319–328; Terry Ramsaye, *A Million and One Nights*, New York, 1926, pp. 562–572.

9. George Lukacs, "Zu einer Aesthetik des Kinos," *Frankfurter Zeitung*, September 10, 1913; reprinted in *Filmstudio* (Johann Wolfgang Goethe Universität Frankfurt), no. 35, May–July, 1962, pp. 4–7.The translation is mine.

10. See *Arnold Schoenberg—Letters*, ed. by Erwin Stein, New York, 1965, no. 18, pp. 43–44. I am grateful to Mr. Kermit Champa for bringing this letter to my attention. Mrs. Maria Harwood, daughter of the late Erwin Stein, has informed me (letter of November 12, 1965) that no additional unpublished correspondence on this subject is known to exist.

11. *On the Spiritual in Art*, trans. by Hilla von Rebay, New York, 1949, p. 35. Almost forty years later Kandinsky still maintained his belief in the kinship between painting and music: "Je voulais seulement dire que la parenté entre la

peinture et la musique est évidente," in his article, "L'art concret," *XX Siècle,* no. 1, 1938 (reprinted in *XX Siècle,* XXI, no. 13, 1959, p. 10).

12. See Johannes Eichner, *Kandinsky und Gabriele Münter,* Munich, 1957, p. 91. (Eichner's source of information here was almost certainly Gabriele Münter, according to Dr. Erika Hanfstaengl, Curator of Paintings at the Städtische Galerie, Munich, in letter to me of Aug. 24, 1966.) A German film produced by Cserépy-Film, released in 1920 under the title *Der Blaue Reiter,* apparently lost today, surely had nothing to do with Kandinsky.

13. In his article, "Uber Bühnenkomposition," which introduced *Der Gelbe Klang* in the *Blaue Reiter Almanach,* Munich, 1912.

14. *XX ième Siècle,* I, 1938; reprinted *ibid.,* XXI, no. 13, 1959, p. 25.

15. "Easel—Scroll—Film," *Magazine of Art,* Feb., 1952, p. 79.

16. Hans Richter, "Dada and the Film," in Willy Verkauf [ed. by], *Dada—Monograph of a Movement,* Teufen, Switzerland, 1957, p. 64.

17. Taut, writing under the romantically assumed *nom de plume* of *Glas,* discusses the project in a letter to his collaborators in the *Gläserne Kette* group, reprinted in *Die Gläserne Kette, Visionäre Architekturen aus dem Kreis um Bruno Taut 1919-1920* (exhibition catalogue of the Leverküsen Museum, Berlin), Berlin, n.d. [1963], p. 64. *Die Gläserne Kette* group included Hans Scharoun, Walter Gropius, Vassily and Hans Luckhardt, and Max Taut, all more or less under the leadership of Bruno Taut, whose idea for a filmed utopian drama was then modified to a film of "reine künstlerische wirkung, wie sie die Maler Eggeling und Richter ausarbeiten."

18. "Abstracte Filmbeelding," *De Stijl,* IV, no. 5, June, 1921, pp. 71 ff. The translation from the Dutch is by Kathleen Richardson.

19. "Der Film als Kunstwerk," *Sozialistische Monatshefte,* 15 Dec. 1921, p. 1118.

20. Friedrich Kiesler, in an interview with Thomas H. Creigh-

ton published as "Kiesler's Pursuit of an Idea," *Progressive Architecture,* July, 1961, p. 106.

21. "Expressionismus und Kino," *Neue Züricher Zeitung,* no. 1453, July 27, 1916, p. 1108.

22. To Albrecht Hasselbach, today of Munich-Rheim, owner of the painting and close friend of the artist at the time of its execution.

23. I am grateful to Ruttmann's sister, Frau Ritter, today of Frankfurt, for allowing me to study programs and clippings of this event. For reviews of his Frankfurt presentation, see: Bernhard Diebold, "Der gemalte Film," *Frankfurter Zeitung,* Feb. 1, 1920; for the Berlin presentation, see *Lichtbildbühne,* XIV, no. 18, Apr. 30, 1921, p. 61; "Berliner Filmneuheiten," *Der Kinematograph,* XV, no. 742, May 8, 1921. The most interesting review is by Herbert Jhering, who, writing in *Berliner Börsen-Courier* (May 6, 1921), makes the perplexing assertion that the film was not photographed but painted directly on the celluloid. However, Ruttmann's companion in those years, Frau Wally Schultz, tells me that Ruttmann used an animation table which would imply the use of photography.

24. Herman George Scheffauer, *New Vision in the German Arts,* New York, 1924, pp. 145–147.

25. From a manuscript, "Wie ich meinen 'Berlin-Film' drehte," that Ruttmann's former wife Frau Christel Witthelm kindly allowed me to study.

26. See Karl Löwenlöffel, "Bemerkungun über die sozial-psychologische Wirkung des Films, mit besonderer Berücksichtigung auf ihre Bedeutung während der Kriegsdauer," *Ekran—Kinematographenzeitschrift für den gesamten Kinohandel von heute und morgen,* III, no. 17, Sept. 28, 1948, pp. 32–47.

27. From an interview with Pierre Albert-Birot, "Les tendences nouvelles," in *SIC* (for sons-idées-couleurs"), nos. 8, 9, 10, Aug.–Sept.–Oct., 1916, p. 1. Apollinaire's first use of vocabulary of film to describe modern painting may have been in his review of Metzinger's work at the "Salon des Indépendents:" "Cet art cinématique, en quelque sorte, a

pour but de nous montrer la vérité plastique sous toutes ses faces . . ." (in *L'Intransigeant,* April 21, 1911).

28. Huntly Carter, *The New Spirit in the Cinema,* London, 1930, pp. 54–55.

29. Raynal, whose first significant essay "Qu'est-ce que le cinéma," had appeared only the year before (in *Comoedia Illustré,* Dec., 1913), has indicated the popularity of film among the Cubist painters: "D'autres éléments, un peu démodés aujourd'hui chez les artistes, connaissaient une vogue persistante: les pitreries des clowns, les petits films de Charlie Chaplin, les drames cocasses des première bandes cinématographiques, les chanteurs comiques, toutes manifestations qui entretenaient une opposition constante à la sensiblerie traditionnelle au profit d'une recherche tenace de la notion surprise." (Maurice Raynal, "Montmarte au temps du 'Bateau-Lavoir,' " *Médecine de France,* no. 35, 1952, p. 26.) See also Max Jacob, "Printemps et cinématographe mêlés," *Les soirées de Paris,* April 15, 1914, p. 219. Film held a powerful fascination for Max Jacob; his vast autobiographical novel, *Cinématoma,* 1920, bears a strong mark of its influence. André Warnod, writing on the birth of modern art in Paris, recalled "les soirs que Picasso suivant son fidèle Max Jacob au petit cinéma de la rue de Douai, spécialisé dans les films de cow-boys ingénument frénétiques" (*Ceux de la Butte,* Paris, 1947, p. 109).

30. Since its first issue in 1919, this little-known and rather zany journal of the arts agitated ceaselessly for the film as modern art; two special cinema numbers were published, in March, 1920, and November, 1932.

31. The most important film article in *L'Esprit Nouveau* appeared in the first issue, B. Tokine, "L'Esthétique du Cinéma" (no. 1, Oct., 1920, pp. 84–89), pointing out film as the only international art, using movement, light, simultaneity, and absence of words to express ideas by visualizing thought, "Le cinéma," noted Tokine, "est une création plastique à travers la durée."

32. See Louis Aragon, "Charlot Sentimental," *Le Film*, March 1, 1918; Philippe Soupault, "Note 1 sur le cinéma," *SIC*, III, no. 25, Jan., 1918; Paul Eluard, "Ecoutez . . . ," *391*, no. 14, Nov., 1920.

33. Francis Picabia, "Cinéma," *Cinéa*, no. 52, May 5, 1922, p. 9. Picabia later wrote a beautifully illogical film scenario (on two pages of stationery from "Maxim's") to form the basis of René Clair's celebrated Dada film, *Entr'acte*, 1924.

34. Published in English translation in *Transition*, no. 19–20, June, 1920, pp. 70–83.

35. Groz and Heartfield actually made a film together in 1917. Heartfield had been appointed director of wartime documentary and scientific films by UFA, and under his guidance a department for the production of animation films was established. Their first film *Pierre in Saint-Nazarine*, was intended to ridicule the oncoming allied invasion and to extol the power of the Kaiser's artillery, "Big Bertha" in particular. Heartfield enlisted the aid of his friend George Grosz to produce drawings for the film. Both artists hated the war and the Kaiser, and after considerable stalling the film was finally finished, but by then the allies had already invaded and their propaganda film was worthless. *Pierre in Saint-Nazarine* was never released and appears to be lost today. See Wieland Herzfelde, *John Heartfield, Leben und Werk*, Berlin, 1962, pp. 19–20. Additional details have come from recent conversations between Wieland Herzfelde and Jay Leyda, who kindly passed them on to me.

36. Originally published in six installments in *La Crapouillot*, I, nos. 1 to 6, April 1 to June 16, 1919. Reprinted in *La Crapouillot*, Nov., 1932; and in Marcel L'Herbier, *Intelligence du Cinématographe*, Paris, 1942, pp. 239–249.

37. From Cendrars' essay, "A.B.C. du Cinéma," written in 1921, published in Blaise Cendrars, *Aujourd'hui*, Paris, 1931. This translation by Serge Gavronsky, in *Film Culture*, no. 40, Spring, 1966, p. 20.

38. Ilya Ehrenburg, *Men, Years-Life, vol. III (Truce: 1921–1933)*, London, 1963, p. 93.

39. Blaise Cendrars, "Construction," no. 19 of *Dix-Neuf Poèmes Elastiques*, Paris, 1919.

40. Written in Paris, July 3, 1919, published as "Modernités—Fernand Léger," in Blaise Cendrars, *Aujourd'hui*, Paris, 1931, p. 122.

41. Blaise Cendrars, *La Fin du Monde filmée par l'Ange N.D.*, Editions de la sirène, Paris, 1919. Later, Léger wished to make a film of this work in collaboration with Hans Richter, but the project got no further than discussions and "many sketches of how to visualize it on film on the napkins and tablecloths of 'La Grande Chaumière' where we used to eat," as Richter later recalled (see *Hans Richter*, Neuchâtel, 1965, p. 114).

42. Yvan Goll, *Die Kinodichtung*, Dresden and Berlin, 1920; reprinted in *La Vie des Lettres et des Arts*, Paris, July, 1921, pp. 534 ff.; reprinted in English translation by Clinton J. Atkinson and Arthur S. Wensinger, and with Léger's drawings, in *The Massachusetts Review*, Spring-Summer, 1965, pp. 497–514. Goll's poem, *Die Kinodichtung*, tells of a Chaplin poster that comes alive, like Pinocchio, and steps down from its kiosk and wanders about the city. It was apparently intended to be filmed, first from drawings by Léger and then probably later from the sketches by the German painter and scenic designer Gert Caden whose design for the opening scene was published in *MA—Musik and Theater Nummer*, Vienna, 1924.

43. In Léger's interview with Dora Vallier, "La vie dans l'oeuvre de Léger," *Cahiers d'art*, II, 1954, p. 160. Several of Léger's comments have come from this source.

44. Louis Parrot, *Blaise Cendrars*, Paris, 1948, p. 47.

45. Parrot, *op.cit.*, p. 47. Honegger had previously composed the music for the Rolf de Maré ballet, *Skating Rink*, 1922, for which Léger had designed sets. With his *Pacific 231*, Honegger succeeded so well in evoking the image of a mighty locomotive coming to life and gathering speed that this musical composition, in turn, inspired the Russian

director Tsekhanovsky, known principally for his animated cartoons, to make a film in 1931. The result was a seven minute experimental film, using the title *Pacific 231*, in which Tsekhanovsky assembled semi-abstract shots of racing trains to visually accompany Honegger's music. It was shown by the London Film Society on March 12, 1933, according to their program notes of the event. Gance must have been pleased with Honegger's musical interpretation of *La Roue*, for he invited the composer to write music for his next film, *Napoléon*, 1927. Honegger responded by composing several musical sketches to underscore key dramatic moments of this film. (See Willy Tappolet, *Arthur Honegger*, Zürich, 1933, p. 121.)

46. Originally in *Comédia*, Paris, 1922; reprinted in Fernand Léger, *Fonctions de la Peinture* [preface by Roger Garaudy], Paris, 1965, p. 162; not in Hannah Muller's bibliography (in Douglas Cooper, *Fernand Léger et le nouvel espace*, Geneva, 1949).

47. In reply to the question, "Qu'est-ce que le cinéma pur?" put to Gance and other film-makers by Pierre Legarde, a writer for *Cinéa-Ciné* (in n.s., no. 81, March 15, 1927, p. 9). Gance goes on to state that "quant au scénario, il tient dans le film la place que tient le sujet en peinture." For Léger, this was not an opinion, but a fact, one that lay at the source of major failings in both arts: "L'erreur picturale, c'est le sujet. L'erreur de cinéma, c'est le scénario" (Léger, "Peinture et Cinéma," *Les Cahiers du Mois—Cinéma*, nos. 16/17, Paris, 1925, p. 107).

48. Léger, "Essai critique sur la valeur plastique du film d'Abel Gance, *La Roue*," *op. cit.*, p. 160.

49. Ezra Pound, "Paris Letter," *The Dial*, March, 1923, p. 273; written February, 1923. Pound repeated many of these anti-Caligari arguments in his article, "The Editor," *The Exile* (New York), no. 4, Autumn, 1928, p. 113. I am grateful to Mr. Mike Weaver, Professor in American Literature at Exeter University, for bringing this to my attention. Herwarth Walden, the vigorous defender and promoter of German Expressionism, also attacked *Caligari* with gentle

barbs of satire by reporting the following anecdote under the deprecatory title, "Aus dritter Hand," in his periodical, *Der Sturm:* "In der Ausstellung des 'Sturm' hing ein Gemälde von Lyonel Feininger.—'Sieh mal, Lotte,' sagte ein Besucher, 'ganz wie Doktor Caligari!'≁' *(Der Sturm,* XIII, no. 6, June, 1922, p. 96).

50. Quoted in *Cinéa,* no. 56, June 2, 1922, p. 11; reprinted from *Feuilles Libres.* No source is given.

51. These bracketing dates for the creation of *Ballet mécanique* are derived in the following manner: George Antheil claims that he gave Léger the impetus to make the film early in October, 1923, and indeed there is no indication that production of the film had begun any earlier. And by early November of the following year, Léger had shown the completed film to Jean Tedesco at the Vieux-Colombier Theater.

52. Much of the credit for the post-war awakening of interest in film art must go to Ricciotto Canudo, the Italian-born avant-garde writer, critic and *cinéaste.* Canudo had long been associated with the avant-garde arts and letters in Paris. For instance, Chagall's well-known painting of 1911, *Hommage à Apollinaire* (Stedelijk van Abbe Museum, Eindhoven) is, in fact, inscribed with a dedication not only to Apollinaire but to three other major pre-war critics as well: Herwarth Walden, Blaise Cendrars, and Canudo. In 1912, in his "Lettres italiennes," in the *Mercure de France,* Canudo supported the Italian futurists in their assault on the Parisian art world, and, in the following year, he founded an avant-garde periodical with the captious title, *Montjoie—Organe de l'imperialisme artistique français,* which published Léger's first piece of writing, an article, "Les origines de la peinture et sa valeur représentative" (I, no. 8, p. 7; no. 9-10, pp. 9-10). Canudo apparently discovered film during the war, and afterwards he devoted his energies to promoting "the seventh art," a term of his invention. In 1922, he founded C.A.S.A. Its membership included an impressive sampling of artists and intellectuals, among them the painters Marcel Gromaire, André

Lhote, and Léger, the architect Robert Mallet-Stevens, and musicians Maurice Ravel and Arthur Honegger, the poets Blaise Cendrars and Jean Cocteau, and even an art historian, Elie Faure. Canudo's call-to-arms was twofold. The goal of C.A.S.A., he announced, was first to affirm indisputably that the cinema was an art, and secondly to attract to the medium the foremost creative talents of the day, in poetry, architecture, music, and painting—or more specifically, such men as Cocteau, Mallet-Stevens, Satie, and Léger. Picasso executed an Ingresque portrait drawing of Canudo about 1920. He died in the winter of 1923.

53. *Catalogue Général Officiel, Exposition Internationale des Arts Décoratifs et Industries Modernes,* Paris, April–October, 1925, p. 288.

54. Jaque Catelain, *Marcel L'Herbier,* Paris, 1950, pp. 78–79.

55. The heavily stylized make-up of Jaque Catelain in the role of Einar Norsen, although it altered his appearance in essentially a Cubistic rather than Expressionistic manner, would nonetheless have been unthinkable without the precedent of *Caligari.* Another touch of Caligarism in *L'Inhumaine* occurs in the scenes which take place in Claire's parlor. Here, in this jungle-like enclosure, the obvious artificiality of the sets, the flowers and plants playfully fashioned out of wood and paper, is an obvious quote from the exterior shots in *Caligari* which take place in a studio-made landscape of cut-out foliage forms. The importance of *Caligari* for the French avant-garde film can hardly be overestimated. An unpublished manuscript by Jean Tedesco has yielded some interesting information on the reception and influence of this film in Paris: "*Caligari* venait, in 1921, de faire éclater la bombe de l'expressionnisme allemand." Tedesco further recounts how a special matinée showing of *Caligari* on Nov. 14, 1921, at the Collisée Théâtre, its première in Paris, was organized by Louis Delluc, the most important and influential post-war film critic and promoter of film, a man best described as a *cinéaste,* a term of his own invention. Encouraged by his discovery of *Caligari,* Delluc set out to find other films of

special artistic interest, and his activities here led directly to the establishment of the first cinée-club in Paris or probably anywhere in the world. This was *Le Club des Amis du Septième Art,* or *C.A.S.A.* founded in 1922 by Dulluc's friend, Ricciotto Canudo, in whose apartment films were shown on the wall between his Picassos. I am grateful to Madame Amy Wells Tedesco for placing her late husband's manuscript at my disposal. See also for *Caligari's* première in Paris, *Cinéa,* no. 27, Nov. 11, 1921, p. 8.

56. The contribution of Mallet-Stevens to this and other films deserves further mention, for, along with André Lurçat, he was the most important French architect of the 'twenties—the claim is admissible only if we regard Le Corbusier as a Swiss and recognize the relative poverty of French architecture of this decade. (He was not Belgian as Henry-Russell Hitchcock has stated in *Architecture—Nineteenth and Twentieth Centuries,* Penguin Books, Baltimore, 1958, p. 372.) His *Pavillon des Renseignements et de Tourisme* at the entrance gate of the "Exposition Internationale des Arts Décoratifs" in 1925 was probably the most advanced design of any building at the Exposition, with the certain exception of Le Corbusier's celebrated *Pavillon de l'Esprit Nouveau* and Konstantin Melnikoff's Constructivist building for the Soviet section. Without question, his work as a cinema set designer profoundly influenced his architecture, although not necessarily for the good. He regarded modern architecture as fundamentally photogenic, characterized by "grands plans, lignes droites, sobriété d'ornements, surfaces uniés, oppositions nettes d'ombre et de lumiére; quel meilleur fond peut-on rêver pour les images en mouvement, quelle meilleure opposition pour mettre en relief la vie?" (Mallet-Stevens, "Le cinéma et l'architecture," *Les Cahiers du mois—Cinéma,* no. 16/17, 1925, p. 95). His mature and geometrically pure style dates from 1923 with his work in *L'Inhumaine* and his country house for the Vicomte de Noailles, and the latter, with its barren wall surfaces,

neatly fulfilled its photogenic function as a background for Man Ray's last film, *The Mysteries of the Chateau du Dés,* 1929.

57. Friedrich Kiesler, "De la nature morte vivant," in *Internationale Ausstellung neuer Theatertechnik* [exhibition catalogue], Vienna, 1924, p. 20.

58. The *Tanagra-Theater,* invented at the turn of the century, provides a fascinating forecast of television, although its technique is purely optical, not electronic. Its "screen," on which miniaturized figures performed, derived its name from the ancient city of Tanagra where small life-like terracotta figures were discovered in 1873. For its invention and history, see Marianne Viefhaus-Mildenberger, *Film und Projektion auf der Bühne,* Emsdetten, 1961, pp. 27ff.

59. From an interview with Kiesler published in *Progressive Architecture,* XLII, July, 1961, pp. 105–123.

60. Antheil, *Bad Boy of Music,* New York, 1945, pp. 134–135. If the title of Léger's film did not come from Antheil, perhaps it was suggested by Picabia's drawing of a machine element, the cover illustration of an issue of his *391* (no. 7, New York, Aug., 1917), bearing the title *Ballet mécanique.*

61. *Ibid.* In an interview with the author, March 10, 1965, Man Ray did not recall, however, which exterior shots in *Ballet mécanique* he had photographed. Possibly they are those representing the amusement park, for similar shots are in his film, *Retour à la Raison,* 1923.

62. Man Ray, *Self Portrait,* Boston-Toronto, 1963, pp. 266–267.

63. Murphy's *Danse Macabre* is essentially a filmed dance. Set at "midnight in plague-ridden Spain," the film opens with a ghostly image of death, a skeleton playing a fiddle, superimposed over a desolate landscape with a distant castle, and then over the dancing figures. Much of the film's expressive force comes from its use of color. There are changes in the all-over color of the image through the use of different tinted stocks—in blue, green, amber, and red—as well as isolated spots of color like the glowing purple eyes of the skeleton applied by hand to the film,

frame by frame. *Danse Macabre* opened July 23, 1922, at the Rialto Theater in New York. I am grateful to Mr. David Shepard for a screening of his original print of *Danse Macabre* at the George Eastman House. See Appendix I for additional details on the film.

64. From Léger's note on *Ballet mécanique* in *Little Review,* Autumn-Winter, 1924-25, p. 44, and a letter from Dudley Murphy, March 5, 1966.

65. Léger curiously speaks here of "un object projecté" when he obviously means the object *photographed* at these various rates of speed. No motion picture projector is capable of operating at speeds as low as three, six, even ten images per second. In his working notes for the film, Léger is guilty of the same confused use of this term.

66. The Vienna diagram (fig. 47) differs in the number and position of horizontal penetrations. Neither version accurately describes the actual construction of the film. The diagram reproduced in *The Little Review* (fig. 46), was from Léger's own hand, and possibly the changes in the Vienna diagram were due to accidents in his printing.

67. Léger, "Ballet mécanique," *Ausstellung neuer Theatertechnik, op. cit.* Pound's fascination with photographic distortions through prisms and mirroring devices originated from his involvement with Vorticism, the English avant-garde movement of 1916. Urged on by Pound, the photographer and painter Alvin Langdon Coburn (1882-1966) had produced a series of astonishing photographs by such techniques, among them a multiple image silhouette portrait of Pound which Coburn entitled, "The Center of the Vortex." Pound later wrote to Alfred Steiglitz: "Coburn I haven't seen since we rigged up the vortoscope with my old shaving mirror.—hence ultimately the Ballet Mechaniques, Antheil's, Léger's, Murphy's try." Coburn, however, never became involved in film-making as he tells me in a letter of March 17, 1965. For Coburn, see also Nancy Newhall [intro. by], *A Portfolio of Sixteen Photographs by Alvin Langdon Coburn,* Rochester, 1963;

and Coburn's *Autobiography*, Faber and Faber, London, 1967.

68. Léger's reaction against Impressionism was complete and uncompromising; he once remarked that "Seurat's lack of force is due to the fact that he submitted to the impressionistic diffuseness of his time ... Tintoretto, Veronese lose their hold on the local tone and proceed to dissolve themselves in a glowing atmospheric sensualism. They corrupt style and contribute seduction. The eighteenth century still further stresses this trend. The Impressionists develop it up to pointillism. It has fallen to the lot of modern painters to react. Our period will have a *Style* if we can manage to return to constructive local tone." (Léger, "Apropos of Colour," *Transition*, no. 26, 1937, p. 81.)

69. Léon Moussinac, "Théorie de cinéma," *Cinéa*, no. 95, July 1, 1923; see also Moussinac, "Du rythme cinégraphique," *Le Crapouillot*, March 16, 1923, pp. 9–12; and Dr. Paul Ramain, "Des rythmes visuels aux rythmes cinématographiques," *Ciné* (Geneva) II, no. 16, Jan., 1928.

70. "Le bébé Cadum" was to the art of the 'twenties what "Brillo" boxes have been to the 'sixties. It advertised a soap, mild enough for a baby, by means of whose enormous and grinning face the virtues of the product were identified. "Le bébé Cadum" was an omnipresent billboard image of monumental vulgarity, and yet it delivered its message with such powerful visual impact that it automatically came to Léger's mind as the obvious example of modern advertising. Later, in 1928, Léger complained that the image of the city street had lost much of its earlier vitality: "l'affiche n'est plus à hauteur. Seul le bébé Cadum, cet énorme objet, persiste" (in "La rue, objets, spectacles," reprinted in Léger, *Fonctions de la peinture*, 1965, p. 68). Blaise Cendrars, too, could not escape its presence; in his poem "Au coeur du monde," 1917, he wrote "un projecteur éclaire soudain l'affiche du bébé Cadum" (from Perrot, *op. cit.*, p. 153), and in 1921, Jean-

Francis Laglene, in an article, "Le peinture au cinéma," observed "C'est une trame brute de volume et de couleur sur quoi se brode tout une realité spirituelle. La moindre toile du moindre peintre concentre à fleur de pinceau un inconscient d'inexprimé: nostalgies de musée, ambiance du café du coin, affiches sourires de Bébé-Cadum, etalages de modistes" (Cinéa, no. 25, Oct. 28, 1921, p. 9). It is surely no accident that in René Clair and Picabia's film, Entr'acte, the moving camera pans across a long roadside billboard of Bébé Cadum in the chase scene of the runaway hearse.

71. Gerald Murphy (1888–1964) was an American artist who had studied at Yale (BA 1912), where his chief distinctions were social; he was voted by his class as their best-dressed member, greatest social light, and most thorough gentleman. He began painting in 1922, and studied with Léger who reportedly pronounced him the only American painter in Paris. Little is known of his artistic activities, which stopped in about 1930 as abruptly as they had begun, and about which he has "adamantly refused to supply any information" (History of the Class of 1912, Yale University, Thirty-year Record, III, New Haven, 1942, p. 179). The chief interest of his paintings lies in their precision rendering of dissected views of commonplace objects, executed on huge canvases, in a manner that strikingly foretold Pop Art; his six-foot square painting, Intérieur de Montre was published in the Bulletin de l'effort moderne (no. 14, April, 1925). See also Time Magazine, October 30, 1964, p. 44.

72. Léger, "The Esthetics of the Machine—Manufactured Objects—Artisan and Artist," Little Review, Spring, 1923, p. 47.

73. Ibid., pp. 48–49.

74. A very close parallel can be seen in an advertising short, Die Flasche, made in 1912 by Julius Pinschewer, in which bottles of "Maggi Suppenwürze" dance about on a table-top by themselves. Despite the extreme similarity here with Ballet mécanique, Léger need not necessarily have known this particular film; such advertising shorts were

commonplace by the mid-twenties. Sadly, few of these fims have survived due to their quickly out-dated commercial value. A print of *Die Flasche* is held by the Deutsches Institut für Film und Bild, Munich, but it has not been possible, at the present time, to secure frame enlargements to illustrate this film. I am grateful to Frau Charlotte Pinschewer of Bern for the information she has given me on the career of her late husband. See also *Der Bund,* Bern, July 12, 1959.

75. In addition to his work as a camera technician and operator, Seeber edited an important trade publication, *Die Filmtechnik* (1925–1943), and wrote countless articles and several books on cinematographic technique, the most important being *Der Trickfilm in seinen grundsätzlichen Möglichkeiten,* Berlin, 1927. See also G. Seeber, "Doppelgängerbilder im Film," *Kinotechnisches Jahrbuch—1922/23,* Berlin, 1923, pp. 89–98; G. Seeber, "Ein Leben für den Film," *Filmwelt,* XII, no. 37, Sept., 1937; and Werner Kohlert, "Biographische Notizen über Guido Seeber und Karl Freund," *Beiträge zur deutsche Filmgeschichte-Wissenschaftliche Mitteilungen, Film,* VI, Sonderheft 1, 1965 [East Berlin], pp. 299–319.

76. In addition to *Ballet mécanique,* which bore the title *Images mobiles* in some reviews, Eggeling's *Diagonal Symphony* and Richter's *Rhythm 23* were shown, both for the first time. Abstract films by Ruttmann, the Dada film *Entr'acte* made by René Clair from a script by Francis Picabia, and a performance by Ludwig Hirschfeld-Mack on his Bauhaus-constructed light organ completed the program. A second showing a week later (May 10, 1925), may have indicated a modest success with the public; the contemporary Berlin press reported the event with interest, but with bewilderment too. (See Louise O'Konor, "The Film Experiments of Viking Eggeling," *Cinema Studies,* II, no. 2, June, 1966, p. 30; and Hans Richter, "Avant-garde film in Germany," in Roger Manvell [ed. by], *Experiment in the Film,* London, 1948, p. 223. For contemporary reviews, see: Willi Wolfrad, "Der absolute Film,"

Das Kunstblatt, Berlin, 1925, pp. 187–188; and "Der ab-
solute Film," *Lichtbild Bühne,* no. 55, April 23, 1925.)

77. For an account of this network of avant-garde *ciné-clubs,*
 see: Léon Moussinac, *Panoramique du Cinéma,* Paris,
 1929, pp. 130–132; Germaine Dulac, "Organization de
 l'exploitation des films d'avant-garde," in Henri Fescourt
 [preface by], *Le Cinéma des origines à nos jours,* Paris,
 1932, pp. 362–364; Hans Richter, "A History of the Avant-
 garde," in Frank Stauffacher [ed. by], *Art in Cinema,* San
 Francisco, 1947, p. 7; Jacques B. Brunius, "Experimental
 Film in France," in Roger Manvell [ed. by], *Experiment in
 the Film,* London, 1948, pp. 75–76; Jeander, "Les Ciné-
 Clubs," in Denis Marion [ed. by], *Le Cinéma par ceux qui
 le font,* Paris, 1949. On Gould and his activities, see also
 Matthew Josephson, "The Rise of the Little Cinema," *Mo-
 tion Picture Classic,* XXIV, no. 1, Sept., 1926, pp. 34 ff.;
 reprinted in Pratt, *op. cit.,* II, pp. 409–413.

78. From an unpublished manuscript by Jean Tedesco.

Index